EXHIBITION DESIGN DAVID DERNIE

First published in Great Britain in 2006

This paperback edition first published in 2007
by Laurence King Publishing Ltd
361-373 City Road
London EC1V 1LR
T +44 20 7841 6900
F +44 20 7841 6910
E enquiries@laurenceking.co.uk
www.laurenceking.co.uk

A catalogue record for this book is available
from the British Library.

ISBN-13: 978-1-85669-522-0
ISBN-10: 1-85669-522-0

Designed by Mark Vernon-Jones

Printed in China

EXHIBITION DESIGN

David Dernie

Laurence King Publishing

PART 1 APPROACHES

PART 2 TECHNIQUES

Exhibition: to hold out, to offer
Manifestation (Fr): to render manifest
Exposition: to put completely on the outside
The terms are juridical, rhetorical, political and
philosophical.
Jean-François Lyotard

INTRODUCTION

Making exhibitions is increasingly recognized as a significant form of creative expression. The installation is a crucial component of any exhibition, yet the 'discipline of exhibiting', a phrase coined by the art critic Germano Celant, is only beginning to be understood. It is multi-disciplinary and its boundaries are complex. To 'exhibit' is to hold out, to offer, to display objects or works: to expose. Fundamentally, exhibition-making is focused on the content of the works to be displayed and concerns the ordering of these works as a sequence, to be understood in relation to each other and in dialogue with the conditions of the viewing environment. Today, exhibition design overlaps with artistic movements such as environment art, performance and installation art, it is closely related to interior architecture, graphic design and lighting and is increasingly engaged with film, fashion, advertising and new forms of media.

Above all, an exhibition design considers the simple dialogue between the object(s) to be exhibited and the space in which they are presented: where the objects are, and how they are arranged will determine the nature of the message they communicate. Several artists have been particularly sensitive to this question. Constantin Brancusi, for example, was deeply engaged in the question of the interrelationship between his work and studio space. His own photographs, where he carefully depicts the sculptural resonance between the spatiality of his work and that of its enclosure, depict light conditions and material surfaces: 'Brancusi's singular sensitivity to the placing of works of art in changing environments has had a profound impact on the course of sculpture and on the display of art in the twentieth century.'[1] In this observation Tate Director Nicholas Serota refers to later generations of artists who take more decisive steps using artwork to structure the space of a studio or gallery (as an extended studio).

At the heart of any exhibition is the notion of communication, and the focus of the designer is to articulate the intended messages. Through a clear sequence of spatial relationships the designer articulates the content of the work and its intended didactic interpretation. The exhibition designer formats a process of discovery, an uncovering of the world of the museum or brand image. Through an exhibition, artefacts are interpreted afresh, translated, as it were, through their new context. Scale, colour, materials, lighting, sounds and graphics will all affect the way in which the display communicates to the visitor: the reading of the exhibited object will change according to its context and presentation.

Exhibitions are traditionally divided between cultural and commercial subjects, can be either permanent or temporary, and can range from visitor centres, trade shows, brand experiences, launch events and consumer pavilions to museums of all kinds – from art galleries to science museums. Boundaries between these exhibition types are increasingly blurred, and techniques and images are now regularly transferred across all exhibition and display typologies: a retail display, for instance, will often have the appearance of a commercial gallery, while the new museum interior will be branded like any other part of the leisure industry.

Apart from formal exhibitions there are all kinds of exhibition-making going on. Exhibition-making is an innate activity: everyone's home is an exhibit in some way, and people display objects to inform themselves and others about their lives and needs. People are instinctively adept at public display: arrangements of personal possessions, clothes and gestures constantly declare a set of values, attitudes and aspirations. A market stall or street trader's cart is habitually organized to communicate vividly in order simply to make a living. Here decisions about structure, placement, colour and light are not designed as such, but are rather learned as part of a trade. These are casual exhibitions which happen as part of the textures of every day life. In contrast, what museums do is highly constructed: they clear space and make comments on objects – which all of a sudden take on a new value because of this 'construct' – because of how they are contextualized. Winston Churchill's teaspoon, for example, is just a dumb object when placed casually, but when reconstructed it can become an emotionally engaging fragment of history.

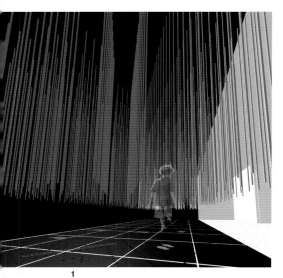

1

1. Orange Imaginarium, Bristol, Imagination, 2001. A computer rendering illustrates the way in which fiber optics are used to create a visually compelling interactive exhibit that communicates wire-free technology to children.

2. Holocaust Tower, Jewish Museum, Berlin, Daniel Libeskind, 1999. The dramatic spatial topography of the architecture itself offers visitors a powerful sequence of thematic experiences.

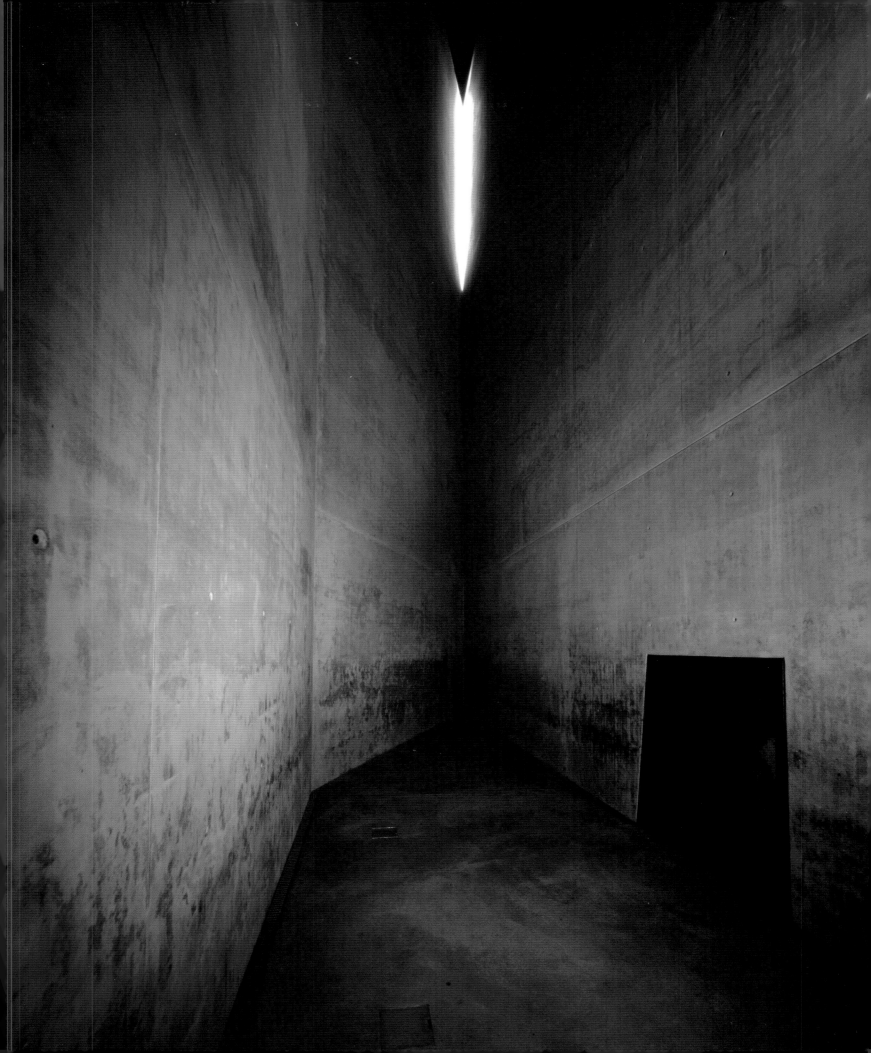

3 4

The nature of appropriate display for new art or museum objects will of course depend on the nature and content of the collection, and the character of the institution. A comparison between the very different approaches to display of the Italian architect Carlo Scarpa in his 1960s restoration of the Castelvecchio in Verona with the recent modifications to the 1930s Palais de Tokyo in Paris is illuminating, since the approach to display is radically different, yet in each case appropriate to the works. Scarpa's painstaking study of spatial scale, lighting conditions, colour, surface material and display apparatus for each object seems perfectly to express the relationship between the given fabric and the precious heritage of the town. On the other hand, the casual aesthetic of the Palais de Tokyo (see page 102), its lack of refined detail (in the conventional sense) and the sense of it being an extension of the street, seems to anticipate the nature of its contemporary, changing shows. Just as Scarpa's attention to enclosure expressed the value of this civic collection, so the blurring of boundaries between street and gallery at the Palais de Tokyo convincingly grounds the contemporary art in the field of its production.

In contrast, the display methodology of the earliest museums, such as the British Museum or the Louvre, resulted in dark, cluttered interiors and arrangements of paintings where the entire gallery wall was covered, with larger paintings 'skied' and tilted to maintain the viewer's plane. These would later be organized chronologically and according to schools, but the legacy from these early museums is the prevalence of three important display types: cabinet rooms, progressive galleries and period rooms. The cabinet is used in part because of the obvious practical need to remove objects from the visitor's reach, but it also reflects a display type well established in the tradition of private curiosity cabinets and, later, in the way in which new products came to displayed in early department stores. The spatial format of enfilade rooms was of course derived from earlier architectural types (and adopted buildings, such as former palaces). The enfilade enabled clear progress through the exhibition, provided a visual link between related rooms and sufficient spatial coherence in each room to house clusters of objects sensibly. Finally, the period room was an assemblage of various elements (paintings, architectural fragments and furniture, for example) from a particular historical time frame which contextualized a given set of objects. With the innovative use of this approach by Wilhelm Bode

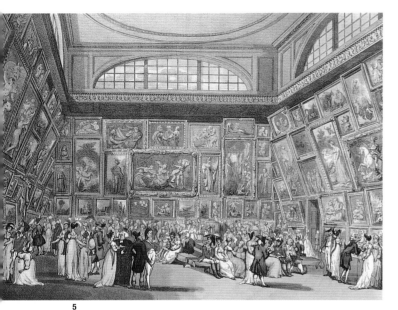

5

3–4. Castelvecchio Museum, Verona, Carlo Scarpa, 1958–64. In this project painstaking restoration was complemented by an acute sensitivity to light, scale, texture and colour to create a series of specific settings for the exhibited artefacts.

5. Early exhibitions, such as this example at Somerset House, London, in 1808, featured densely packed walls, with the larger paintings tilted downward to allow them to be seen by viewers below.

6. View of the Grand Galerie du Louvre, Paris, by Hubert Robert, 1796. An early example of the classic arrangement of enfilade, top-lit galleries.

7–8. *Bauhaus: 1919–1928*, 1938 (top right) and *Machine Art*, 1934 (right), both at the Museum of Modern Art, New York. Exhibitions designed under the direction of Alfred Barr were typified by a willingness to experiment that is rare in the gallery displays of today's mainstream institutions.

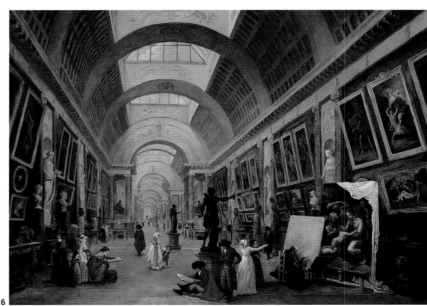

6

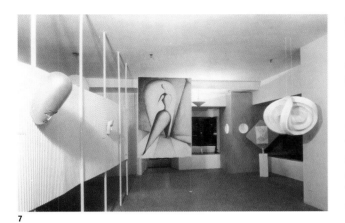

7

at the Kaiser-Friedrich-Museum (now Bodemuseum) in Berlin (opened 1904), an alternative to the mainstream taxonomic displays of the nineteenth century finally emerged.

The development of abstract art during the late nineteenth and early twentieth centuries engendered a new aesthetic, which in turn gave impetus for the art show to be part of that experience. Early modernist exhibition space was to have a 'resonance with the work' – rather than be a place for its cataloguing: the taxonometric procedures for display of the nineteenth century were usurped by individual aesthetic judgement on the part of the curator and designer. The aesthetic, first set out by art historian and Director Alfred Barr in the early years of the Museum of Modern Art, New York, has come to represent *the* conventional and marketable display environment. The white-walled space is familiar and can be relied upon. Its autonomy and dominant minimalist details accordingly determine much of contemporary installation practice, creating a kind of aesthetic chamber, a place which 'seeks to transcend specificity of time and location'.[2] For many of us the 'designed' air of the modern art gallery or museum space still represents a kind of elitism, 'designed to accommodate the prejudices and enhance the self image of the upper middle classes'.[3] The carefully tuned details of the inward-looking gallery interior – wooden floors (mostly polished), minimal surfaces, single blocks of colour (predominantly shades of white, or lately, black) and shadow gaps, are now endlessly mirrored in up-market retail spaces. The commonality of the language communicates a shared ground: art is turned into goods, consumer products are displayed with the allure of a rare art object.

Increasingly, the discipline of exhibition design is expanding beyond the design of a show or display in single media. The designer's approach tends now to consider a strategy to meet the broader development or promotional intentions of the client. When a museum is planning an exhibition, a whole set of products are created – books, merchandise, films, compact disks, clothing – and an exhibition designer might think strategically in terms of events or launches to communicate a branded message. Making the physical exhibition is only one part of a more complex, coordinated event. The strategy will inevitably involve a Web presence and other forms of media. The number of visitors to the physical exhibition will be far outnumbered by the number of hits on the website or those reached by broadcast. At the same time, the expenditure on the physical display can be justified in terms of the

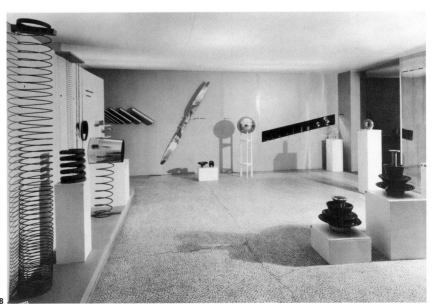

8

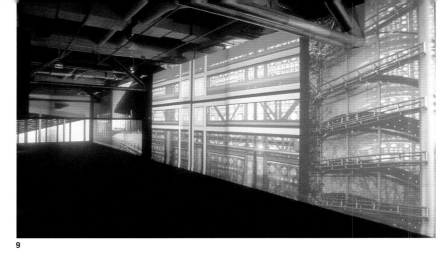

*Designing exhibitions – in practice – requires
genuinely engaging with artworks and
materials, with authors, with curators, with
institutions, with spaces, and with respective
audiences, as well as with sets of relations
between these in order to find tailored solutions.
This keeps the process fresh…'*[4]
Julie Ault

9

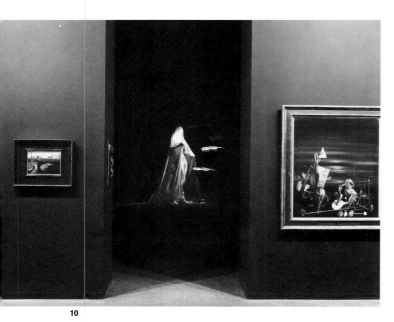

10

**9. *Jean Nouvel*,
Pompidou Centre, Paris,
2001–2002. Nouvel's
work was displayed
in an almost cinematic
fashion, using
projections that
engaged with the scale
of the museum's
architecture.**

**10. *Modern Art in Your
Life*, Museum of Modern
Art, New York, 1949. An
opening allows a view
through to a display
beyond, and establishes
a dialogue between
the pictures in the
foreground – a device
typical of exhibitions
mounted during the
directorship of René
D'Harnoncourt.**

**11. *Lucio Fontana*,
Hayward Gallery, 1999,
Claudio Silvestrin. Here
the layering of space
allows a kind of visual
comparison between
similar works of
different colours.**

**12. *Ahistorical Sounds*,
Bojmans Van Beuningen
Museum, Rotterdam,
1988. Exhibition
designer Harald
Szeemann explored
the potency of space
between disparate
objects as a means of
establishing analogies
between them.**

value of creating 'experience' and the memory of brand immersion that inevitably promotes the product subsequently.

Audiences now perceive art, fashion, film, architecture and design as a much more connected world of imagery. Technologies now transfer between film and theatre and display environments. Techniques of digital and media projection or large-scale, specialized screens are commonly used in contemporary exhibition and retail environments as a means to connect with a public in a way that is familiar. Projections and screenings (as long as the associated sound interference can be dealt with) can transform an interior, since the body of the space itself is thrown into darkness. A simulated or fictive environment can be created with a controlled use of light colour, sound and moving images. The drama of such an effect was felt in Jean Nouvel's installation at the Pompidou Centre of his own work in 2001–2002 (see page 84). Here banks of smaller screens played against other vast projects to create an immersive environment of colour and form, quite remote from the familiar interior of the Pompidou itself.

Such cinematic presentation makes for engaging viewing, and even in a gallery environment the film room showing biographical material will invariably be one of the busiest spaces. Here the works and personality of the artist can be clearly communicated with ease: often a much more comfortable procedure than addressing the work itself. And here lies the problem with multimedia presentation: overly 'cinematic' presentation risks engaging a passive visitor, in effect watching television in public. While this might be popular, it will not create a rich experience and memory of the brand immersion or museum installation. Rather, media technology should be dropped into the story line when it is appropriate – it is much more effective when it brings about a specific response from the audience.

One of the most stimulating projection and film sequences of this kind is Imagination's *Life* at the Guinness Storehouse in Dublin (see page 38). Imagination produced a suite of films which were to purvey a sense of the *craic* – the spirit of the Irish. The films are projected onto the rear of three translucent walls forming a custom-built room situated at the head of a mezzanine promenade. Having been immersed in the extraordinary ground-floor hall of brewing equipment, quite unexpectedly, the visitor finds an intimate room surrounded by local sounds, conversations, stories, music and soundbytes taken from radio archives and combined with resonant graphic images. The films are at once extraordinarily rich in their power to evoke the qualities of the Irish, but unlike many promotional films, these sequences are primarily graphics. As such, the images evoked are incomplete and demand an active and creative engagement with the show. It is remarkable how long-lasting a memory these projections create.

The subtle boundary that is defined in Guinness's *Life* sequence announces a new approach to brand immersion. The days of the product dictating to the customer are over: increasingly the process is geared towards a more flexible and open delivery strategy that allows for a custom-built interaction. Elsewhere at Guinness Storehouse, Imagination explores a fluidity of brand experience, juxtaposing complex projections and simulated environments with very simple stories or familiar images; complex constructions with primitive found objects; compact sound-filled display areas with places to simply reflect. The visitor chooses an individual route through the fabric of the building. The selective and appropriate use of technology plays an important role in the design of this audience-focused experience: for instance the remarkable inclusion of a low-tech space for visitors to make a straightforward postcard was a risky but effective strategy, emphasizing the overall approach: the visitor was to make of the exhibition what they wanted. The new medium of brand experience is now people, not television.

Narrative has been central to exhibition design in recent times. It is quite literally about an approach to ordering objects in space in a way that tells a story. In that sense exhibition design is regularly defined *as* narration. More broadly, narrative space is concerned with the contextualization of a

11

displayed object. Narrative space can be about a simple relationship between a single object and its setting in space, a question of light and shadow, reflections and material configuration which evoke visual correspondences and engagement. More often the making of narrative space involves readings between objects or the making of displays which build a background storyline to the objects on display. Recently, both in cultural and commercial displays, there is an emphasis on creating a storyline which evokes an emotional response as a key component of the experience. Clearly this is working from the psychology of advertising: colours, sounds and patterns of slow and fast movement play a key role to creating a memorable engagement with the object.

The question of the contextualization of a work of art or historical artefact in a contemporary museum is, of course, only in part a design issue, and the approach to the interpretation of content will invariably reflect the character of a the particular institution. At the same time, the way in which the exhibition installation is structured needs to facilitate the intended narrative or visual association determined by the curatorial team. The architecture of an exhibition can also open up new possibilities to the institution. Innovative spatial topographies, lighting and transparencies can build relationships difficult to envisage in traditional spatial arrangements.

New approaches to contextualization through 'visual comparison' or through 'empathy' (*Einfühlung*) between works were first emphasized by René D'Harnoncourt at MoMA in the 1940s and 1950s. D'Harnoncourt's approach to display recognized the power of visual dialogue: it was based on an acknowledgement that the field of vision of the visitor is not limited to the works that are in his or her immediate path and that at 'any given point vistas should be open to him into those sections of the exhibition that have affinities with the displays in the unit in which he stands'.[5] In effect, this process of exhibition-making acknowledges the experience of the visitor, structuring a walk-through collage where juxtapositions break barriers of time and place and narrate correlations and meanings, or theoretical 'affinities' between disparate objects.

D'Harnoncourt's method of 'visual comparison' avoided the explicit signage and didactic material of installations by his predecessor Alfred Barr, but at the same time its weakness lay in its attempt to reduce the meaning of ancient and modern works to stylistic or visual resemblance. This is an inevitable consequence of contextual interpretation of this kind. To its advantage, however, this approach structured a reading of artwork that departed from the on-going dogma of stylistic hanging. Similar examples of building a narrative in this way include the work of the Swiss exhibition designer, and designer of documenta 5 (Kassel, 1972), Harald Szeemann at the Bojmans Van Beuningen Museum in Rotterdam. His *Ahistorical Sounds* (1988), for instance, drew on the essential thematic of disparate groupings with an openness that drew particular attention to the space between the exhibits: 'the main room is the site of spiritual confusion, a vigorous appeal to human creativity, suffering and death': Bruegel's *Tower of Babel* (representing confusion) was presented with Joseph Beuys's installations of batteries and office furniture combined with older pieces of furniture (representing creativity) and Rubens' *Three Crosses* (representing suffering).[6]

Perhaps the most significant break with traditional display in terms of establishing contextual narratives for art exhibitions came of course with the early programmes at the Pompidou Centre in Paris. Despite the incoherence of the architectural strategy (both in terms of its external language and the inadequacy of its exhibition spaces, and in terms of its violent interruption of the Parisian landscape) the effect of the endeavour as a radical challenge to the aesthetic norms of modernist display was dramatic. The accent on openness, flexibility and movement was underpinned by a fundamental shift in curatorial practice. This favoured the interdisciplinary, and contextualization of artwork both in terms of its thematic interpretation and in terms of its international dimension. The success of the programme allowed a new diversity of approaches to museum and interpretative perspectives.

13

Mirroring growing tendencies by artists to work with context, this approach to contextual display concerns a collage-like narrative: arrangements of works where the 'dialogue' between them or between the body of work and its physical setting and its context opens up the horizon of the meaning of the work. Fred Wilson's 1992 project *Mining the Museum* at the Maryland Historical Society, Baltimore, illustrates how powerful a creative interpretation of this process of collage-narrative can be. Here the project is described by Martin Beck, one of New York's most perceptive artist/exhibition-makers: 'Setting out to investigate histories hidden within storage areas of the Historical Society, Wilson focused on historical inclusion and exclusion, repression and sublimation with regard to the representations of slavery... Wilson, for example, filled a vitrine with precious repoussé silver from the Historical Society's collection and labelled it "Metalwork 1793–1880". Inserted into this showcase of finely crafted silver, and labelled with the same identificatory devices, were slave shackles found in the Historical Society's storage rooms.'[7] Beck goes on to describe how the juxtaposition was able to 'point to the probability that the production of one object was made possible by the subjugation enforced by the other.'[8]

Recently this collage-narration has been developed in several ways. At Tate Modern, London, for instance, the collage of works is structured around four distinct themes (Landscape/Matter/Environment, Nude/Action/Body, History/Memory/Society, Still Life/Object/Real Life) which stress one reading of the content of the works grouped in this way to provide a guiding storyline. Exhibitions such as *Magiciens de la Terre,* organized by the Pompidou Centre at Parc de la Villette, Paris (1981), use a similar narrative structure in a very different way: living artists from around the world were invited to Paris to create a work. The thread which links the extremely diverse works produced for the show is born out of the creative drive of the work itself, not the visual judgement of the curator or designer, 'establishing relationships that could not have existed in the minds of the makers of these objects'.

The recently opened Dia:Beacon in New York state beautifully illustrates how different levels of this kind of narration can be overlaid to create a storyline which is both sensitive to the works, but which is also sufficiently directed to offer a situated reading. Works of each of the key artists are clustered in exquisitely appropriate locations around the building. Some are found places and others are specifically constructed, restored or lined. These diverse settings are at once sufficiently enclosed so as to allow contemplation of the work of a single artist without interference, but at the same time open across the space, giving onto the work of others. The difference of the spatial topography, the variety of presentation methods, and the sense of the dialogue between works being keyed to movement around the space is essential to the rich experience of the works. The understated narrative is like a subtly layered collage: very specific choices have been made concerning placements and relationships between materials, but the story is completed in the imagination of the visitor. The remarkable achievement of Dia:Beacon would seem to fulfil Nicholas Serota's commentary from 1987: 'the new museums of the future will... seek to promote different modes and levels of interpretation by subtle juxtapositions of experience. Some rooms and works will be fixed, the pole star around which others will turn. In this way we can expect to create a matrix of changing relationships to be explored by visitors according to their particular interests and sensibilities. In the new museum each of us, curators and viewers alike, will have to become more willing to chart our own path, redrawing the map of modern art, rather than following a single path laid down by a curator.'[19]

The problem of movement is most pronounced in the design of exhibitions for museums or fine-art galleries. As witness to the enlightened aesthetic opinions of the gallery or institution, the visitor experience is still reduced to one of slowly paced observation in a near silent context, removed from any reference to the outside world. Conversation is hushed and movement is reduced to that required to transfer one's gaze from one object to the next: the white gallery isolates the experience of art from the day to day movement and habitual behaviour that accompany communication. Such an institution

14

15

has not been designed to communicate, but rather to 'appreciate', as though its values and meaning were implicit.

At the same time, today's audience is increasingly distant from immediate experience of our material culture. Text and graphic information are accompanied by audio and virtual guides so that, increasingly, visitors can experience a whole show a little detached from an immediate experience – and indeed an individual interpretation – of the material artefact. Once the visitor has received the museum-certified wisdom, they move slowly on. This movement is key to the narrative experience – first in the form of dialectical engagement with the object and context, but also in terms of movement through space between exhibits. As Ralph Appelbaum describes: 'The old style of exhibit making was to place a series of black boxes around a formal great hall, with no rhyme or reason or connection between one box and the next. We try to control the sequence of experiences that visitors have. We design the spaces in between the exhibits. That does not mean that we control people. It means that we construct a strong linear experience, one that tells a clear story and that lets visitors break away to explore various aspects of an exhibit in more depth.'

The emphasis on narrative space that has characterized modern exhibition practice has recently refocused, as museums and galleries respond to an increasingly sophisticated and competitive leisure market. What is now fundamental to contemporary exhibition design is the creation of an 'experience' that is engaging, multi-sensorial and rewarding. This is an exciting departure for the discipline, as exhibitions of all kinds engage with the clarity and persuasive techniques that once belonged to the world of advertising.

The traditional image of museums as depositories of artefacts, rows of dusty display cabinets in stifling galleries, has, of course, long disappeared. But museums typically retain the character of a crowded library: there are constant barriers set up to prevent anything more than a superficial engagement with the objects on display. The visit to a museum is often simply tiring: the waiting in line, conversations, telephones, stark lighting. These aspects of museums tend to maximize distraction. What is the advantage of seeing the crown jewels on a crowded conveyor belt over the experience of a book on the same subject? To the imaginative mind the real experience would be nothing but a delusion. The scale of major institutions remains unmanageable: after the main exhibit is digested, a 'wander' will culminate in a well-deserved rest in the increasingly up-market range of retail outlets, cafés and restaurants.

By contrast, exhibition design now tends to be explicitly audience-focused. Its starting point is the relationship between the visitor and the brand/product/artefact: whether it is a collection of automobiles or the knowledge of a museum's collection, the way in which an individual experiences and engages with that element is the paramount concern of the 'experience designer'. Museums are learning experiences.

As a development of narrative practice, experience design builds a context out of the display object or product with the aim of engaging the visitor at an emotive level and in so doing attaching a personal memory to the experience of the visit. The so-called memory economy is increasingly recognized as a driving force behind successful brand-related design. And essential to the creation of a memory-rich experience is the character of the physical setting: somewhere between three-dimensional graphics, lighting, material surface and audio environment. Information needs to be compressed into interactive, multi-sensorial environments, transforming museums from depositories of cultural artefacts into vital cultural centres.

What emerged in the 1970s and 1980s as overt exhibition apparatus has now become much more restrained: often the ideas come before the objects themselves. Ralph Appelbaum's Edward Hopper exhibition at the Whitney Museum in 1995 was organized around display quotations from writers who influenced or were influenced by Hopper, and in the centre of the gallery a film was shown. This proved

13. *Magiciens de la Terre*, Pompidou Centre, Paris, 1981. Artists from around the world were invited to create work especially for the show, resulting in an exhibition of extraordinary vibrancy and richness.

14. *The Equal Area Series*, Walter De Maria, 1976–90, at Dia:Beacon, New York. A sense of openness, natural light and generosity of space allows the freedom to move around the exhibits and construct an experience that is unique to each visitor.

15. Display on the signers of the Constitution, National Constitution Center, Philadelphia, 1994, Ralph Appelbaum Associates. The drama of the narrative is made more effective by the theatrical staging of historic events.

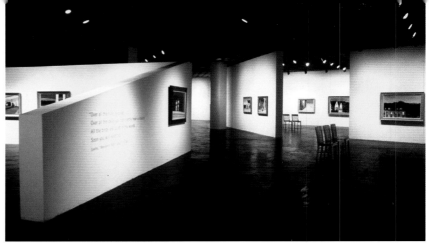

16

to be quite a radical challenge for the conservative world of contemporary fine-art display, but Appelbaum, one of the world's leading museum and exhibition designers, rightly argues that museums should be 'active forums that encourage people to talk about ideas. Our first job is to find a museum's voice, then to search for relevance. But most importantly, our job is to create wonder'.[10] Appelbaum would start with an assets review to explore the strengths of the institution: 'these are often not the artefacts or a collection but a very unexpected set of things that an institution has – wonderful explainers, great volunteers, or someone who really knows how to build ships. And we walk the client through the risk of taking on a public project, because an exhibition might not be the best solution for their needs'.[11]

In effect, this rise of the experiential museum and immersive exhibitions is an inevitable consequence of the competition with other aspects of the leisure industries in the urban environment. Museums now have to work harder for people's time and such are the attractions available now that are based on fiction, it is increasingly difficult for both commercial and museum displays to compete at the level of the spectacular. Similarly, it is increasingly difficult for brands to maintain the kind of immersive environments that typically characterize experience design; this is in part a question of budget but also an acknowledgment of the now widespread availability of interactive devices, both in the public sphere and at home. In many cases the challenge is how to maintain fresh experiences of the brand image with declining budgets and with a society already bombarded with spectacular imagery and simulated environments. A new generation of audience is emerging that differentiates less between new art and say, new music, film, fashion or design and new artistic practices eschew traditional boundaries between modes of artistic expression. The museum and brand experience need to celebrate these new trends of interdisciplinary creative investigation in order to keep this new audience engaged. At the same time, this new museum experience should not stop within the confines of the building itself, rather it must be engaged with civic, regional, national and international horizons. Experience design must be about establishing frameworks for change: forms, material and non-material, which celebrate the shifting patterns of contemporary communication.

From a study of gesture comes a clear understanding of the close relationship between movement of the body and communication. The visitor is a body in movement and contemporary exhibition design can examine patterns of movement to explore communication and exhibition experience. A performative space is one where the movement of the body is considered integral to the structuring of the environment and the landscapes of the artworks, objects or performances. It is a place where traditional boundaries between viewer and object or performance are eroded. In this approach, movement patterns and works are choreographed together to engage the visitor in the brand, museology or art production in new ways: they are incorporated in (rather than just passively viewing) the creative and intellectual life that is represented. Visitors become quasi-performers themselves, in a sense, spectators and part of the spectacle, moving through a topography of overlaying sounds and images in an architecture which is constructed by relationships between the moving bodies in the space. It is an architecture of choreographed movements. What is the aim of this movement? To create a rich and vital memory of a dynamic experience of the exhibited material.

In this manner, Casson Mann's design for the new British Galleries at the Victoria and Albert Museum, London, points towards an altogether different future for the display of historical objects (see page 30). The experience of the display is a varied sequence of carefully integrated display techniques that involve a variety of forms of movement: here cabinets and period rooms are combined with interactive screens, displays housed in drawers, games and costumes for dressing up, transforming the linear experience into a highly personal, and engaging, sequence of events. Clusters of exhibits are now brought together to recount a compelling narrative of the role of these extraordinary fragments in the social history of Britain. This landscape opens up the traditional museum experience to one involving much more

16. *Edward Hopper*, Whitney Museum of American Art, New York, 1995. Ralph Appelbaum Associates created a context for Hopper's work by using display quotations from writers who were influenced by Hopper – a radical departure at that time.

17. British Galleries, Victoria and Albert Museum, London, 2001. Using clusters of artefacts, interactive screens and integrated displays, Casson Mann reworked the traditional historical display to create a highly engaging sequence of events.

choice, variety and ways of simply getting involved. The achievement, on the part of the both the museum's staff and the designers, is the distance of the new environment from the traditional approach to these galleries, (once perceived as a series of masterpieces set against neutral walls). The emphasis on the aesthetic value of these objects has been rejected in favour of an engaging journey of discovery, which combines intellectual rigor with an understanding of the potential of the visitor experience.

Thinking about such exhibitions in terms of movement, activity and interaction challenges conventional approaches to museum and exhibition design, not as an aesthetic alternative but in terms of new strategies for communication and learning experience. It is anti-institutional in approach and emphasizes a playful aspect to learning and discovery: the architectural language of new exhibitions should eschew remnants of whitewashed walls to convey concepts of experimentation and play. Children of all ages and backgrounds should have the confidence to approach exhibitions of all kinds in a positive manner.

The success of this approach is no better illustrated than in the design for an interactive learning environment, the Imaginarium designed by Imagination for the telecommunications company Orange (see page 56). With a team of researchers, programmers and futurologists from Orange, Imagination set out to explore ways of communicating the ideas behind wire-free technology to the 4- to 16-year-old age group in 'simple, fun, surprising and stimulating ways – aimed at engaging the imagination of a child on a multi-sensory level'. Imagination installed a forest of lights in a conventional exhibition space. The dense array of fibre optic cables are housed in plastic sleeves and held on a steel structure. They stretch from floor to ceiling and so create an environment that involves playful physical engagement with a vertical field of lights. The effect of these light strings was enhanced by a black environment with a mirrored ceiling and polished floor. The intention was to create a fully immersive experience 'where the senses and the environment connect and interact'. The first stage of the visit is the Orange Story, a series of animated tales to illustrate the link between everyday needs and the three technologies featured in the Imaginarium. Then, as the children explore the extraordinary installation, they discover three pieces of interactivity embedded into the environment: Say Your Name demonstrates that machines will respond. Children interact with directional speakers that play back

17

18

their voices at different pitches. Humour is used to engage a child and maintain his or her attention. The second interactive involves different movements: in Chase the Rainbow children move through a series of touch-sensitive fibre optics turning them from white to orange 'in a representation of how technology can personalize their space, children learn how they can be the trigger to their environment, making it respond to their commands'. Finally, although the sequence is non-linear, Tell Me a Joke uses voice activation technology to recognize children's individual voices. The programme interacts by telling jokes on request.

The installation is playful and enormous fun for a whole range of age groups. It translates complex technology into an attractive field of discovery, engaging both in terms of learning and in its translation of a complex content into an intriguing field of movement, it is a model of the emerging approach to exhibition design that is performative space.

That is not to say that a consideration of the movement around public exhibitions, as a question of 'way finding', has not always been an integral part of their design. Without resorting to prescriptive routes, the designer takes a practical look at where likely lines are to arise, where the flow of the visitor is likely to be bunched, regulatory escapes and above all that there are no barriers: that the show is inclusive in terms of access and mobility. The visitor needs to be orientated and options for progress clearly comprehensible. In this respect, it is interesting to note the effective combination of large-scale graphics and refer back to the great masonry boundary walls at the Guinness Storehouse. Tools of navigation will depend on the nature of the show: in darkness we are much more drawn to indicators in the body of the space, in light-filled spaces the boundary walls are more important. In both cases, way finding is more than a question of graphic display.

Exhibition design occupies an important role in contemporary visual culture. In an increasingly complex world of persuasive media imagery, the mediatory role of 'presentation' becomes a vital tool of communication. Exhibition design is above all multidisciplinary in character and looks to graphics to create space as much as it does to architectural convention: it develops interactive software packages at the same time as acknowledging the value of simple traditional relationships between light, colour and surface, scale of a space and comfort of a human environment.

ABOUT THE BOOK

This book is organized in two parts. The first part, 'Approaches', covers major themes and procedures in contemporary exhibition design. The second part, 'Techniques', looks at the variety of techniques used in display. It draws examples from a wide variety of recent international exhibitions, from consumer pavilions to small-scale artist-designed displays.

'Approaches' is further divided into three chapters on narrative space, performative space and simulated experience. These cover traditional and emerging tendencies in exhibition design. Much contemporary exhibition practice could be contained within the first section on narrative space. Here we see ways in which contemporary exhibition design creates a storyline and a potentially emotive content in order to engage the visitor. This topic can be further divided into three smaller areas: formatting, story-telling and collage-narrative. Formatting is the simplest form of narrative, an ordering according to chronology or biographical information. Story-telling involves a more diverse interpretation that might unfold around individual objects or in the course of an exhibition. Collage-narrative involves more radical juxtapositions, where unexpected fragments cross conventional boundaries related to the subject matter.

The second chapter looks at an emergent practice – a development of narrative space – called performative space. This is an approach that incorporates experience design – it is audience-focused and recognizes the worth of investment in real, situated experience of a brand or collection. Performance space explores ways in which we use our bodies in any form of communication.

19

18–19. *Au delà du Spectacle*, Pompidou Centre, Paris, 2000–2001. The theme of the exhibition – the concept of spectacle in contemporary life – lent itself to an inventive topography of colours, displays and materials which captured the theatrical spirit of the exhibited material.

20. *Les Années Pop*, Pompidou Centre, Paris, 2001. The design of the display shown here is a complex synthesis of two- and three-dimensional graphics, objects, colour and light. A wide range of artefacts are informally laid out but are drawn together by the curved blue podium.

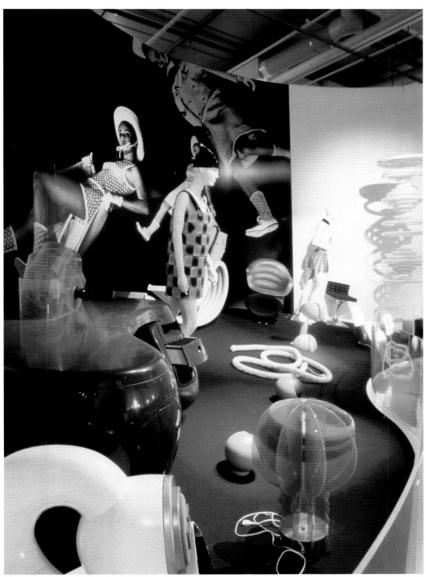

20

By focusing exhibition design on questions of movement and experience our receptivity to exhibitions will move beyond that promoted by the nineteenth-century models that still typify institutional environments.

The third chapter covers simulated, or immersive, environments – the inner worlds of exhibitions. These intense nodes of an exhibition absorb the visitor by the completeness of the design and bring the communication to the level of drama: here exhibition design moves close to theatre design on the one hand and to film on the other. The visitor is caught between fictive and real worlds, the constructed and the imaginary.

In the second part of this book attention shifts to the main techniques used by designers, and a variety of exhibitions have been chosen to illustrate particularly effective uses of each technique. This is not intended as a technical guide, nor is it exhaustive, but rather as an indication of the essential design tools that emerge from the selection of contemporary shows featured here.

The fourth chapter, which is also the first chapter in part two, analyzes the diverse ways to display work. It looks at display apparatus – approaches to presentation of individual objects and clusters of objects in space. It examines questions of scale, engagement and perception, focusing on the detail of the device that actually situates the work in a particular display space: traditional podia, hangings and cabinets to light walls, digital media, interactives, holographic projection or work that moves around a space.

This is, of course, intimately related to the topic of the next chapter, on lighting, for display apparatus will always integrate lighting into the design. Lighting strategies can be divided into those that either work from light or dark space. The nature and colour of artificial light, its relationship to any natural light, will depend on this initial decision. In general, lighting will be addressed as a vital component in the spatial structure of an exhibition, and not as a technical exercise. Lighting design in exhibition layout needs to consider the different scales that contribute to the reading of the space, between the close-up inspection of the exhibited object to the background lighting of the overall space. Lighting can meter a space, making objects appear either distant or near. It can also articulate intermediate spatial relationships and so is a vital tool, not only for navigation but to the very character of an exhibition.

And just as lighting design is inseparable from display apparatus, its effect will depend on the use of colour (and the colour will of course depend on the nature of incident light). Together with graphics, both printed and projected, colour plays an often undervalued, but vital, role in an integrated design. Communication, graphics and colour are the topics of the final chapter: exhibition design is now multi-sensorial and this chapter describes the effective use of these three major elements, which can be seen to signal a cross-over between commercial and cultural display technique.

The best of contemporary exhibition design, which is featured in these pages, is strikingly imaginative, inventing resonant connections between the subject matter of the exhibition experience and today's world. Through such environments vast corporations, museums and other institutions can communicate with today's increasingly sophisticated and cross-cultural audience.

APPROACHES

1 NARRATIVE SPACE

The effectiveness of an exhibition display depends first on the way it is structured: a badly ordered show, regardless of other qualities, can lack clarity. In this context a common analogy is now made between exhibition-making, as a form of communication, and story-telling. The classification of artefacts according to types or rigorous chronologies has given way to the more flexible construction methods of narrative. Just as a good story captivates an audience, so an exhibition conceived of as a narrative is considered to be an effective form of communication and learning.

Narrative space avoids the linearity of the encyclopaedic museum display in favour of a structure where differences of emphasis and the contextualization of material create varied rhythms and levels of intensity: its structure can be episodic rather than chronological or otherwise straightforwardly sequential.

The process of making narrative space has, broadly, three stages. The first, considered at the inception of the project, concerns a strategic planning of the story, which may not be wholly told through the exhibition alone. Other aspects

1–2. At the British Galleries in the Victoria and Albert Museum, London, by Casson Mann, sensitive arrangements of objects, colour, lighting and scale open up new directions in the design of narrative space in contemporary museums.

1

2

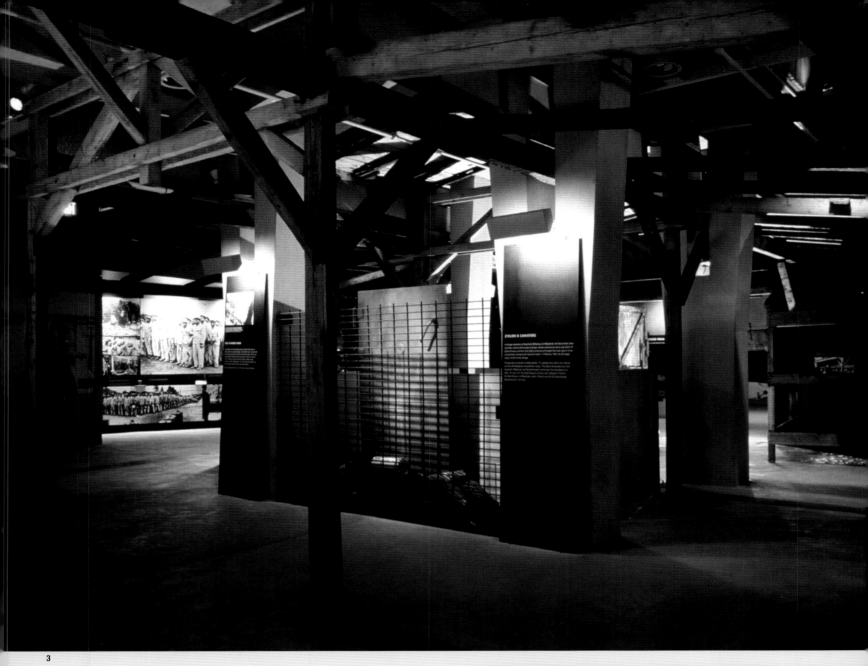

3. United States Holocaust Memorial Museum, Washington, DC, Ralph Appelbaum Associates. Visitors are taken through a series of reconstructed interiors, including this concentration camp barracks, which was dismantled in Poland by designers from Ralph Appelbaum Associates and reinstalled in the museum .

4. United States Holocaust Memorial Museum. Detail of gas canisters that were used in the camps.

4

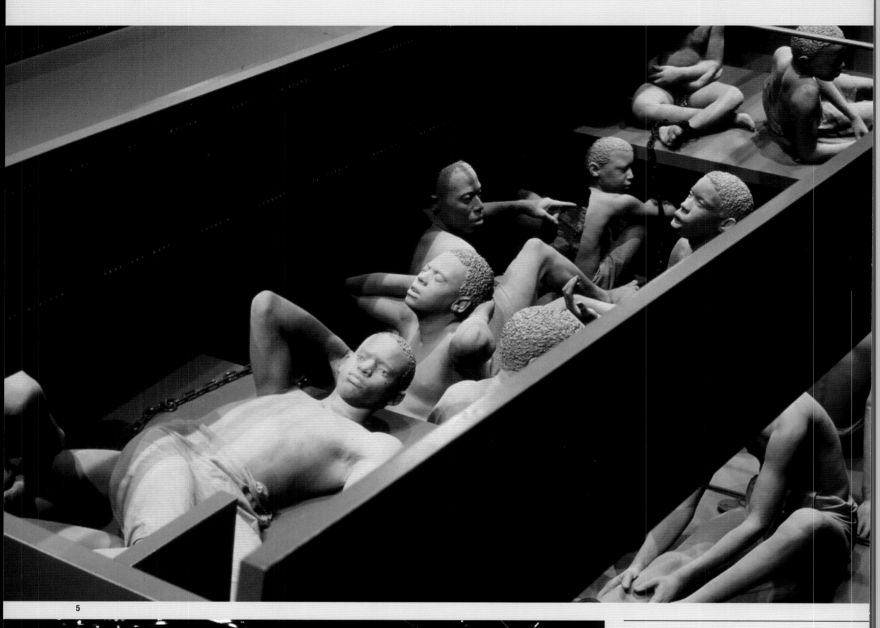

5

5–6 This permanent exhibition at the Museum of African-American History, Detroit, by Ralph Appelbaum Associates, traces the African-American experience from slavery to the present. The realistic simulation of slave transportation reveals the power of physical reconstruction over image for narrative design.

6

7

of the show or product range may be developed on web pages, in a printed catalogue, or through related events. Second, the artefacts are grouped according to the thematic structure of the proposed narrative, and from this emerges a spatial arrangement for the show. The process of story-telling may involve building dialogues between groups of artefacts, and this strategic planning will involve the invention of appropriate movement patterns and viewing lines that emphasize the thematic relationships that are important to the overall narrative. Like a text, the rhythm of narrative space will vary, and visitors' movements will reflect the unfolding narrative.

The third stage involves the design of more detailed arrangements within each room. Specific groups of artefacts can be effectively arranged as ensembles. The potential richness of such clusters is illustrated in the British Galleries at the Victoria and Albert Museum, London, by Casson Mann. Here a complex narrative is made comprehensible through these arrangements, where the individual can engage with 'a story within a story'. Such an approach is often characterized by a sense of surprise and a diversity of display techniques

7–8. *Titanic*, Hamburg, Germany, by Atelier Brückner with Götz, Schulz, Haas – Architekten (1997). The interior sequence is characterized by a theatre-like drama that emphasizes the intimacy of the experience, rather than a didactic narrative.

that is designed to engage a broad range of visitor groups.

Other projects illustrated in this chapter, such as *Titanic* by Atelier Brückner, or the United States Holocaust Memorial Museum by Ralph Appelbaum Associates, demonstrate other ways of working the content of a historical theme into the narrative structure of a visit. The temporary exhibition *Titanic* explored a theatricality of display and selected a number of 'protagonists' to engender an intimate experience of the liner's dramatic last voyage. In contrast, the immensely powerful Holocaust Memorial Museum recounts the events through raw and harrowing facts, authentic fragments that testify to the atrocities, unfiltered, as it were, by the designer.

The recent approaches to narrative design have emphasized the importance of the visitor experience. So-called 'experience design' emerged in the commercial sector. It is focused on the individual visitor and perceived as a question of 'messaging': how does the exhibition engage with the consumer or exhibition-goer so that they will spend time at the venue and return to it? Inevitably, a range of cross-over technologies tend to be employed to

generate these often theatrical environments: immersive interactives create a kind of narrative experience that can be adjusted, as it were, by the visitor.

Just as museum displays are being reformulated according to commercial pressures, so the days of a brand dictating to the consumer are over: increasingly, brand experience is geared towards a more flexible messaging strategy that allows for a custom-built engagement. The creation of a powerful spatial experience, engaging the visitor at an emotive level, is now considered to be an important partner to broadcast advertising: real experience creates a personal memory attached to the brand. Recent projects by Imagination, culminating in the Guinness Storehouse, Dublin, have pioneered this latest metamorphosis of narrative space, creating brand environments that have little or no retail space. The so-called memory economy (the economic value attributed to a memorable experience) is now sufficiently recognized as a driving force behind successful brand promotion that the design of an experience alone is a viable commercial exhibition strategy.

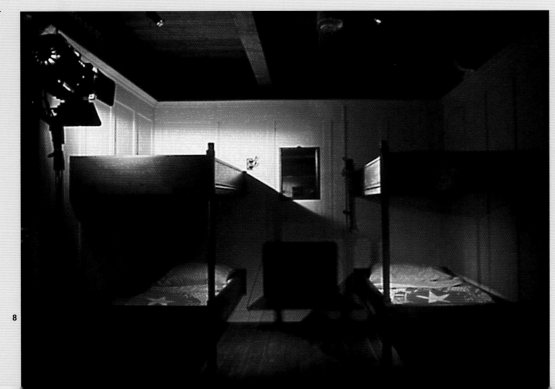

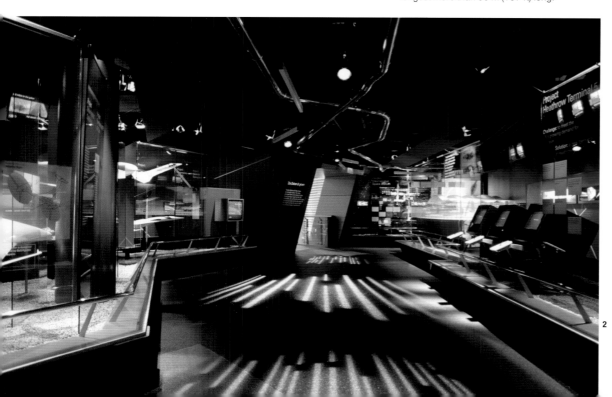

1

Ford Journey Zone

Millennium Dome
London
UK
Imagination
2000

1. The enormous fins surged with moving lights, telegraphing the zone's theme and energy.

2. The Four Futures area asked visitors to think about transport alternatives and trade-offs, rather than simply dreaming about a Utopian future.

The Journey zone in the Millennium Dome in London gave the Ford Motor Company, its official sponsor, the opportunity to communicate its intention of being the new millennium's leading provider of automotive products and services. The zone was to be about much more than cars: it would be in part a transport museum, in part a science museum and at the same time explore historical and sociological issues, rediscovering the enduring romance of journeys and demonstrating that the future of travel depends on individual choices.

These themes were crystallized as 'journey' and expressed in an overlapping, linear experience of transport past, present and future where vistas were continually changing. The zone was to be housed in three distinct parcels of land, and to unite them the Imagination design team proposed a bridging mechanism, expressed visually as a dynamic armature, moving across these three pockets of space.

Zones competed for attention across the space of the dome and the armature was articulated to deliver a distinctive presence. It appeared as a series of aluminium fins, the longest more than 60 m (197 ft) long.

Thousands of pulsing LEDs were added to the skin of the fins, enabling lights to race from base to tip. This assemblage was grounded in a 4000m³ (141,000 ft³), angular 'black box'.

This distinctive profile was not visible from the ring road around the perimeter of the dome, and a second 'signature' element was added: an icon tower that allowed vertical circulation and served as a point of orientation. A symbol of control, it carried images of journeys being undertaken in real time: periscopes linked to cameras were placed on the fins so that people could watch visitors walking around the zone. Internet points allowed them to view the Journey web site and get a preview of the zone's contents.

Bright colours differentiated the zone from a typical transport museum, and the entrance delivered a sense of embarking on a journey, its upward slope accentuated by 8-metre (26-foot) sticks of graphics that projected up towards mezzanine level.

E-motions, an introductory film at the entrance level, gave a sense of the wider meaning of travel and highlighted the human desire to make journeys. Accompanied by moving excerpts from Mozart's *Mass in C Minor*,

2

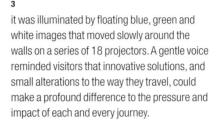

3

it effectively captured the emotional involvement of passers-by. Adjacent to this film space, a double ramp led to the mezzanine level, which was conceived as a gallery to celebrate people's ingenuity in developing ways to travel: The Ages of Discovery.

The ramp was itself a multilayered presentation of statements, facts, quotes, artefacts and models. Its design made walking up it feel like a constantly evolving series of revelations. Punctuation points like a steam engine were designed to keep attention levels high and offered glimpses of what lay ahead.

At the top of the ramp, the upward journey progressed through a more enclosed space – The Age of Optimism – that consisted mainly of images and artefacts from the 1950s and 1960s. Moving on, visitors entered a corridor flooded with harsh, red and orange fluorescent lights. Confused, chaotic and cramped graphics and audio-visual images created an atmosphere of pressure and meltdown. The optimism of the early stages turned into frustration and apprehension about the future.

The circular Decompression Chamber came after this crisis point. A noticeably cooler space,

3. The introductory film _E-motions_ provoked visitors into thinking about why – rather than how – they made journeys.

4. The chaos corridor was, just like its subject, cramped, hot and a bottleneck – a memorable experience, rather than a lecture.

5. Students from the Royal College of Art in London designed transportation for the future needs of four real families.

6. The history ramps used sound, as well as static and moving exhibits, to bring the pace of change to life.

it was illuminated by floating blue, green and white images that moved slowly around the walls on a series of 18 projectors. A gentle voice reminded visitors that innovative solutions, and small alterations to the way they travel, could make a profound difference to the pressure and impact of each and every journey.

The next phase, branded Journeys of Innovation, showed a wide range of new ideas associated with this optimistic future, and was divided into six sections. Land: Two Feet, Two Wheels presented a range of forward-looking designs, from motorized in-line skates to cutting-edge skis and concept bikes, that highlighted the growing importance of travelling under our own power. Land: Rail was announced with the nose section of the futuristic Virgin train. Land: Four Wheels looked at the future of the motor car and showed large mock-ups, each of which was keyed to a text that described the type of person who drove it.

Adjacent to this section was Sea: Sport, Passage, Food, Natural Resources, Habitat. Here the centrepiece was a full-scale 'Deepworker', an experimental research submarine. Next was Air, with models and

audio-visual footage of the Airbus A3XX. Coherency was achieved by using blue as background, with textured floor surfaces. Text was projected on glass, and other light effects incorporated fibre optics and mirrors. Towards the stair was Four Futures, an interactive programme that looked at future trends in transport. On the top floor was a large-scale model of a possible future London.

5

6

4

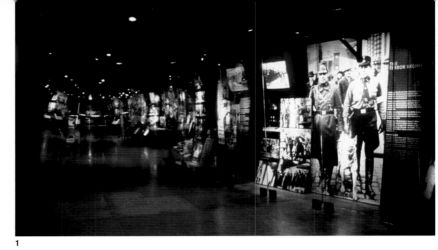

1

United States Holocaust Memorial Museum
Washington DC
USA
Ralph Appelbaum Associates
1993

1. Upon entering the fourth-floor concourse visitors encounter the section entitled The Terror Begins.

2. Before leaving the exhibition on the second floor, visitors pass a Danish fishing boat that ferried Jews and resistance fighters to safety in Sweden.

3. Photomurals of images (c. 1940–42) showing the Lodz ghetto (right) and the Warsaw ghetto (left).

4–6. Fourth-, third- and second-floor plans. Visitors enter on the fourth floor, having emerged from an elevator, and then work their way down to the second. The red arrows on the plans indicate the circulation route.

This iconic, permanent installation by Ralph Appelbaum Associates deals with the harrowing theme of the Holocaust not as a chronology but as a narrative sequence of exhibits and artefacts that tell the story of normal lives. It is organized on three floors of a Pei Cobb Freed & Partners building in central Washington. It is split into three acts – Nazi Assault, The Final Solution and Last Chapter – and the intention is that visitors should progress from an understanding of what happened during the Holocaust to an awareness of its continuing relevance for us all.

The carefully constructed journey through the museum is deliberately constrained: it is one-way. A step-by-step accumulation of the facts, and evidence ranging from graphics and photographs to historical film footage, interwoven with oral histories and artefacts, avoids imagery and design gestures that could be conceived as being emotionally manipulative. Ralph Appelbaum wanted to emphasize that 'this was a modern crime, committed with modern tools and impossible to distance from our lives by virtue of the wide temporal and cultural leaps that characterize most historical exhibitions'.

Documents on display include film stills from actual newsreels of the time or footage that was shot by the Nazis. Where possible, protective glass is avoided and there is open display of fragments of artefacts. The power of tactile experience and an emphasis on simple, everyday objects helps to communicate the unimaginable horror of the Holocaust: a tea strainer, a rusted milk can in which resistance fighters hid issues of underground newspapers, piles of scissors, kitchen utensils – suddenly history is made real.

The journey seems to be carved out of dark space, as the lighting strategy works as much with shadows as it does with object illumination. A reductive palette of exposed concrete, elemental slabs of glass on steel, inclined surfaces and erratic corridors contribute to the character of the experience.

Visitors to the museum first form a line and are then herded into a mock-industrial, black-lined elevator. Just before its door opens on the fourth floor, the electronic voice of an American soldier who helped to free Buchenwald sets the tone for what's to come: 'You can't imagine it. Things like that don't happen.' The door opens

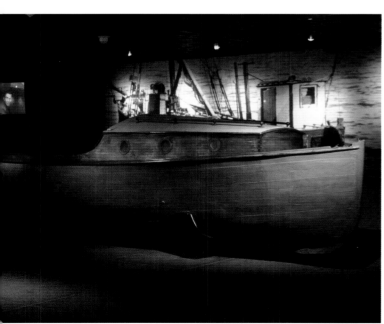

2

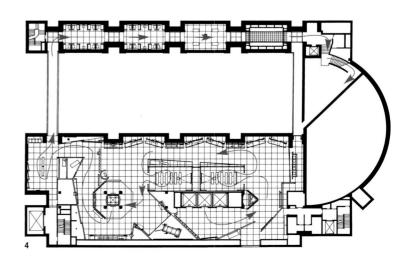

4

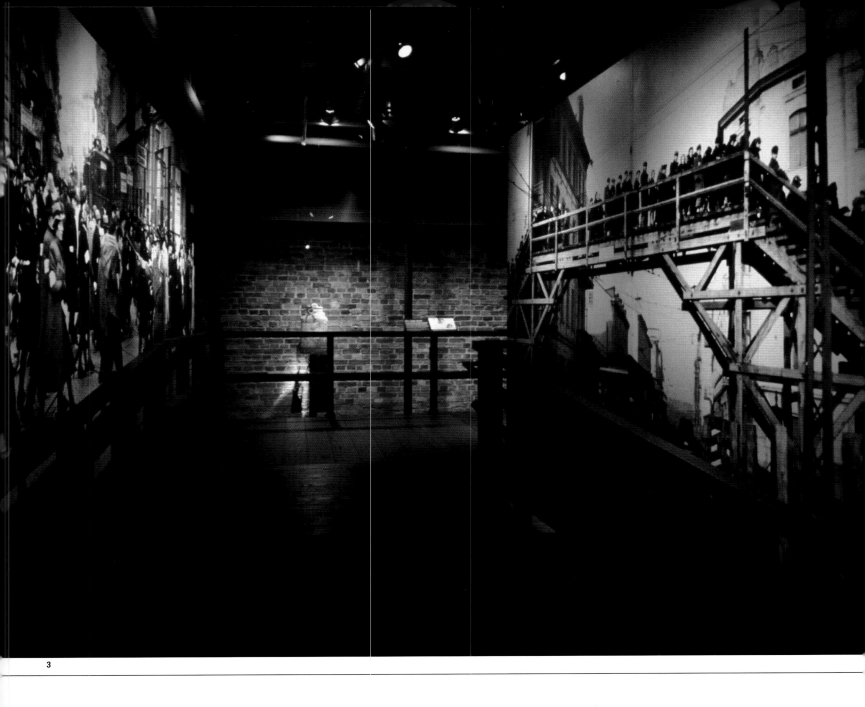

3

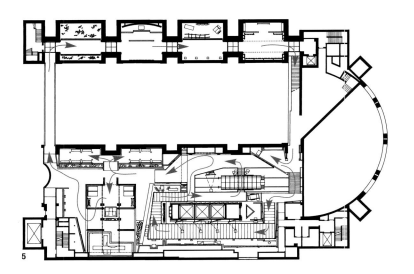

5

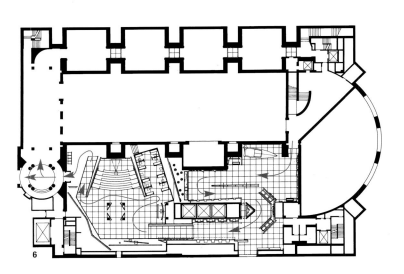

6

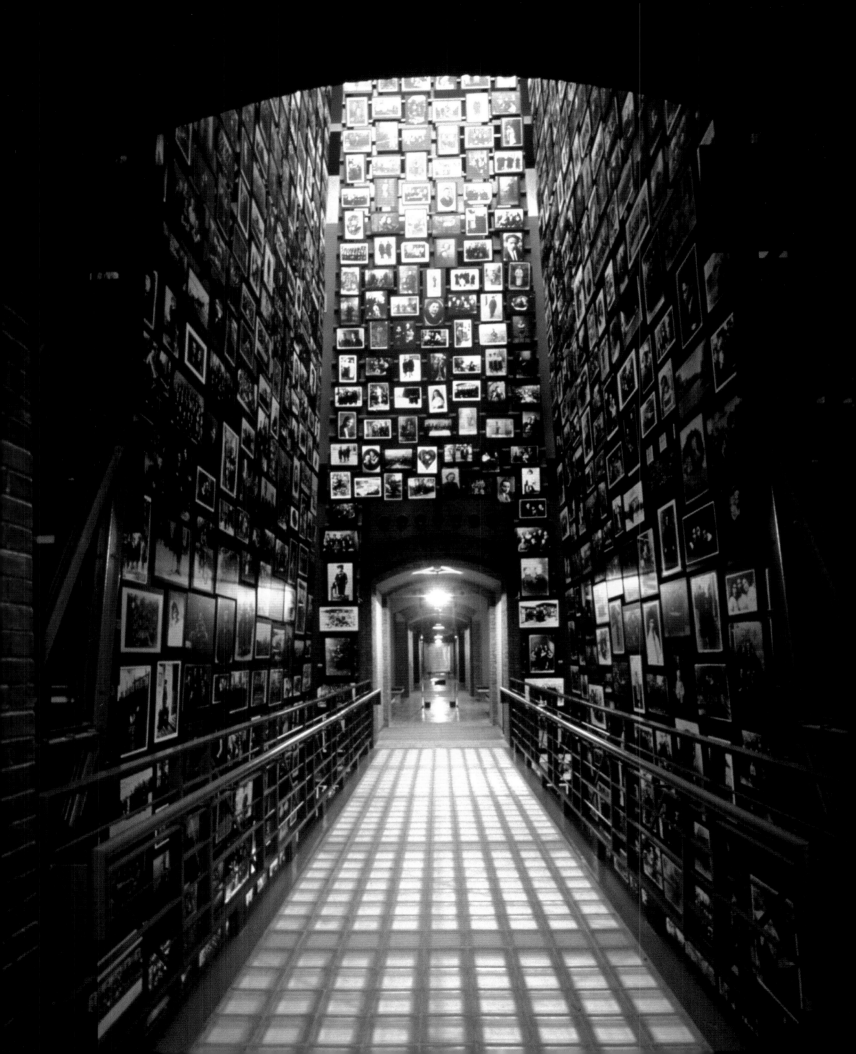

to a floor-to-ceiling photograph of what the Allies saw when they entered the camps: piles of decaying corpses. 'We needed to find a few conceptual frameworks,' Appelbaum says, 'to enable people to look into the face of evil without such a scorching of consciousness at the outset that they wouldn't be able to absorb a survey of the evidence.' As they begin their journey visitors are handed passport-like cards that tell the stories of individual victims.

One key moment that interrupts the three floors is the Tower of Faces. This is accessed by a bridge over a three-storey, top-lit shaft lined with hundreds of portraits. On entry at the upper level a caption states that these were the people of the village of Ejszyszki, in what is now Lithuania. At the end of the journey visitors walk back through the tower, at base level. There, a caption records that in two days a mobile killing squad murdered all the villagers.

7. The Tower of Faces is a skylit, three-storey display of portraits of the people of Ejszyszki, who were murdered over a period of two days.

8. Diagram showing the arrangement of pictures in the Tower of Faces.

9. A railcar of the type used to transport prisoners to the concentration camps.

10. A display of shoes that once belonged to camp inmates – the power of everyday objects was used to convey the horror of the Holocaust.

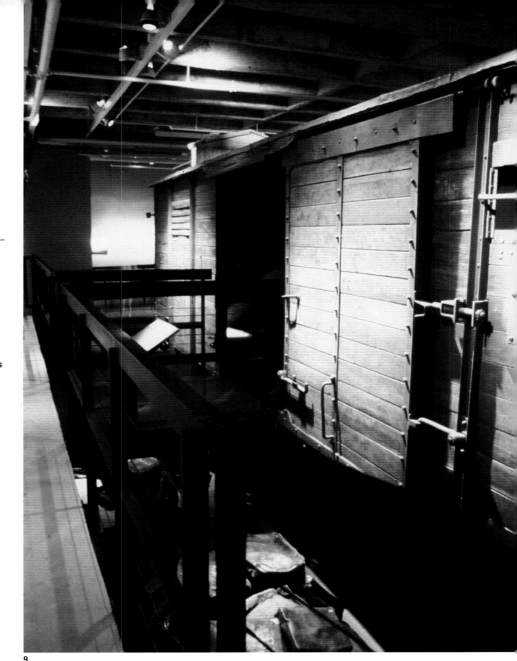

9

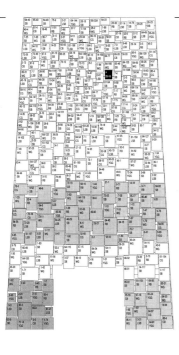

8

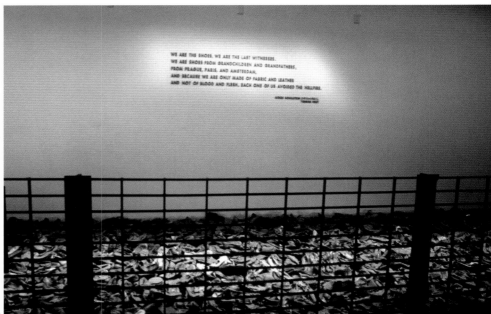

10

1

The British Galleries

Victoria and Albert Museum
London
UK
Casson Mann
2001

3

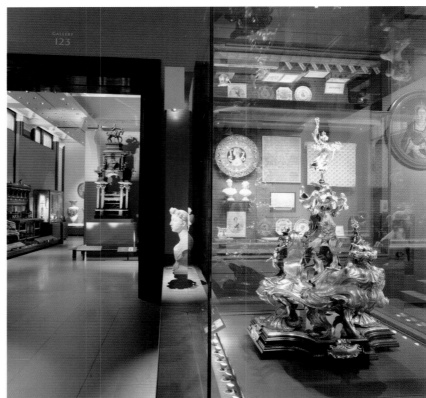

2

4

1. Gallery 120 showing objects from the Regency period. At each of the seven points of entry, the visitor is greeted by a bust of the appropriate monarch – in this case George IV.

2. A bust of the young Queen Victoria sits between a centrepiece designed by Alfred Stevens and a case of memorabilia, including film footage of the Queen's Jubilee.

3. Plan of the upper level showing the scale of the project (1500 square metres/16,000 square feet per level), and the creation of 'bite-size' areas within the large galleries.

4. View through Gallery 120 showing the suspended raft carrying the fibre-optic lighting and security cameras.

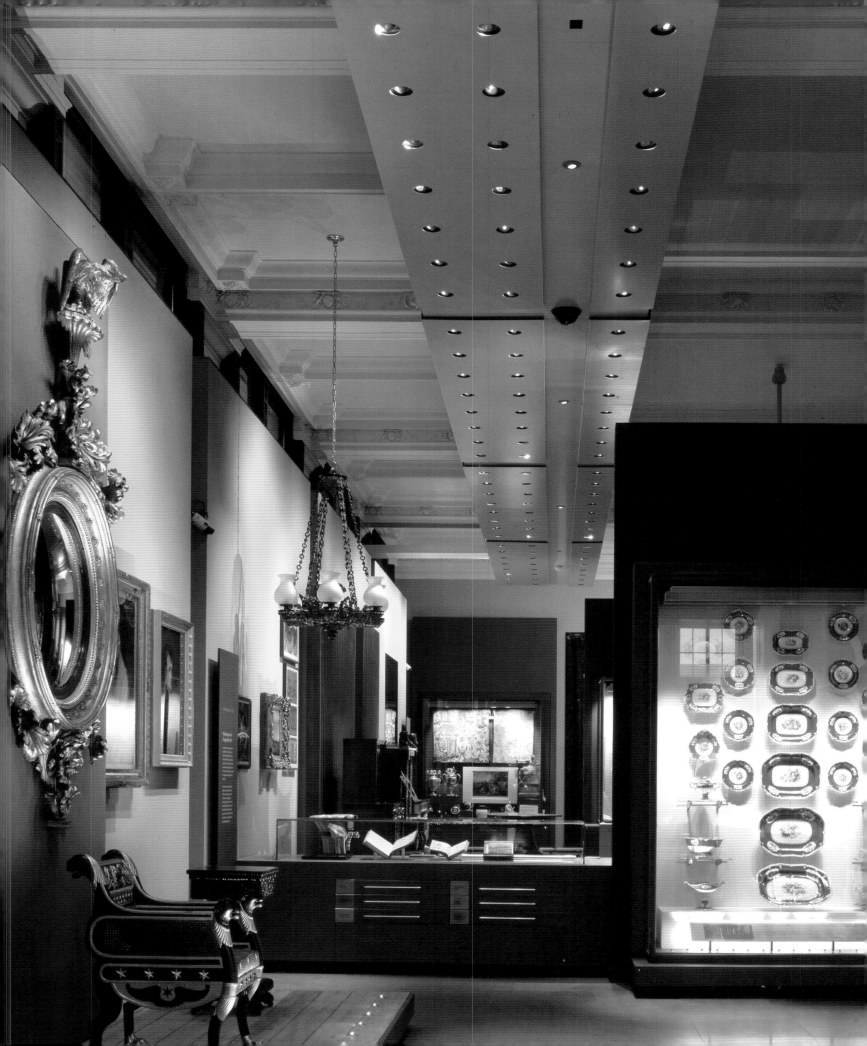

5

The British Galleries at the Victoria and Albert Museum in London herald a remarkable shift in the character of modern museum display. Innovative design by Casson Mann has opened up an extraordinary collection so that it is experienced as an open, active and engaging journey of discovery. Unlike many contemporary museum installations, the innovation is not solely technological – rather, its balanced use of appropriate technology is complemented by other modes of display that engage visitors in movement, play and an altogether demonstrative interaction with the content.

The galleries trace the development of British art and design from 1500 to 1900. The display is object-focused and its principal organization, determined by the museum at an early stage, is chronological. Into this basic narrative the curatorial team wove several pertinent themes concerning style, taste, fashionable living and technological innovation. Acknowledging the diversity of the audience, these themes make the objects more accessible to non-specialist visitors, and alleviate the rigidity of a purely chronological arrangement. Their variety is echoed in the extensive use of colour and

5. The Restoration display dislocates the objects from their rightful place (for example the mirror is set away from the wall on legs) to encourage visitors to read them as illustrations of the style under scrutiny.

6. Visitors are invited to create a plausible narrative to accompany a painting about which little is known. The more successful contributions are displayed alongside.

7. A clear example of how the dislocation of objects can change our perception of them – a section of wallpaper, a picture frame, a wall tile, a cast-iron corbel and a bowl all demonstrate strong stylistic connections through their use of motif.

textiles, and the range of display techniques – there are no big empty walls or single iconic objects. Rather, the journey through the galleries is one of overlapping views, ever-shifting textures, and diverse rhythms and scales.

The sense throughout the collection is composed. A calm passage through the galleries is facilitated in part by the scale of display elements and the views they frame between spaces, and also by the judicious location of Discovery Areas and audio-visual rooms slightly off the main flow. The corner rooms are given over to object-free spaces for relaxation and learning, with reference material and comfortable chairs.

Overall, the experience of the display benefits from a carefully judged relationship between the existing set of galleries and the installation. And, despite the delicate nature of the objects, a memory of the original side-lit galleries is retained. Though now diffused through a series of screens, glimpses of the exterior provide an important sense of orientation. Artificial lighting (and security systems) are carried on a raft at a height of 4 metres (13 feet). This is positioned to allow views of the original gallery ceilings, and

6

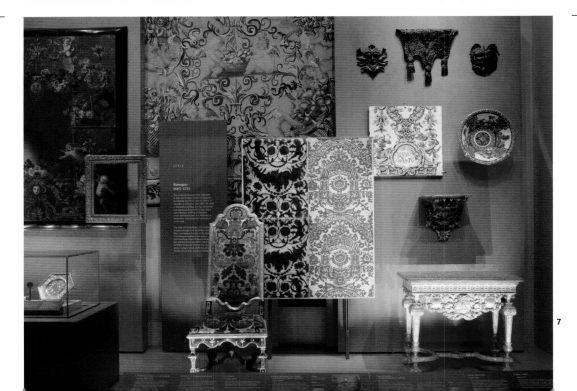

7

8

9

10

the constant presence of these existing elements contributes to the unity of the narrative and its relationship to the rest of the museum. The sense of the whole picture is never lost as key views open up between spaces, and interrelationships are emphasized by dramatic transparencies built into the display elements.

A particular characteristic of the British Galleries is the technique of grouping objects around topics. For the first time, as a result of enhanced environmental conditions, paintings, drawings and prints are displayed alongside costumes, textiles, furniture, glass, ceramics and fine art. Clusters of objects are gathered together to create a rich set of relationships – a collage-like setting – where the sense of a particular event or theme can be explored by visitors. Displays called Taking Tea, Eating and Drinking, Entrepreneurs and Collectors, for example, are built out of various objects (busts, tapestries, clothes, images, household items and other fragments) whose content is enhanced by the play of colours, textures and materials to capture the active imaginations of visitors. Such open dialectics encourage closer inspection, and comparisons undirected by the museum.

The pattern of these displays is interrupted by five period rooms where the picture is completed, as it were, in an actual setting.

At all levels there is an emphasis on precise and accessible scholarly exploration of the objects that embody the historical narrative. At the same time, this scholarship is communicated to individuals through an inventive range of techniques. Unusually for a museum like the Victoria and Albert, the learning experience moves towards more active engagement with the objects. A large number of fragments are available to be touched and others can be found in drawers, while in the Discovery Areas visitors are invited to explore by doing: try on a ruff, a gauntlet or a hooped petticoat; learn to tie a cravat. Touch becomes important and the museum learning experience takes on a fresh character: it becomes more varied, playful and memorable, and, perhaps most importantly, accessible.

8. Breathless by Cornelia Parker hangs in the oculus created by the architects to provide the only place where the two levels can be visually connected. The position of the artwork forces the viewer to look down from above and to look up from below. This commissioned piece is the only contemporary art work in the galleries.

9–10. Many of the objects for touching are positioned immediately adjacent to related cased objects with a programme of texts in braille alongside. The computer programmes enable visitors to design a coat of arms or a silk pattern and then e-mail it home.

11. The three Discovery Areas, positioned within the overall chronology of the galleries, allow visitors to try on period clothing.

11

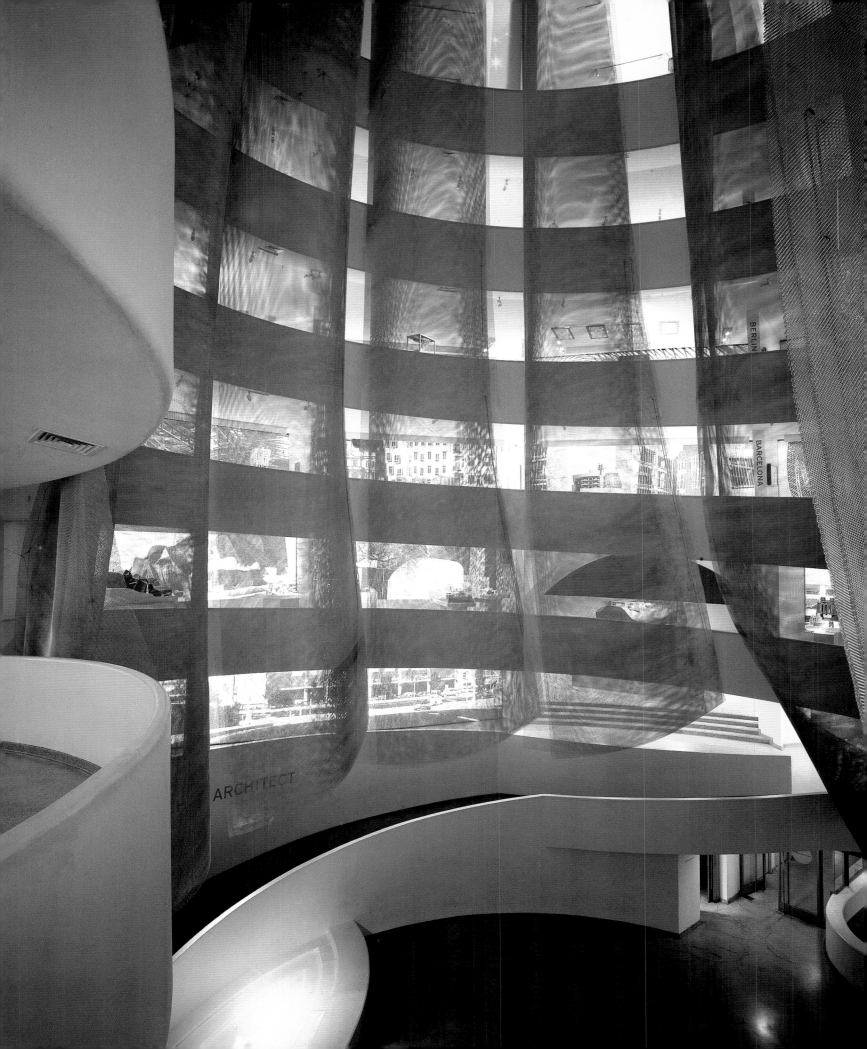

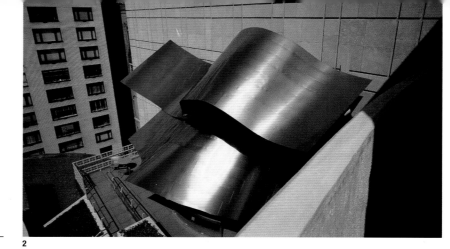

2

Frank Gehry, Architect
Solomon R. Guggenheim Museum
New York
USA
Frank O. Gehry Associates
18 May – 4 September 2001

1. Metal-mesh curtain installation in the lobby.

2. Gehry's specially designed titanium structure on the Sculpture Terrace, Level 5.

3. View down the top of the spiral ramp to the lobby floor.

4. Plan of the exhibition layout on the Level 3 ramp.

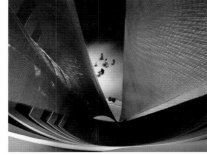

3

The retrospective exhibition *Frank Gehry, Architect* was a significant achievement in terms of the inventive and coherent display-landscape that was fabricated from the wide variety of material available, and in the way it overcame the difficulties normally associated with showing architecture effectively. The installation featured Gehry's major buildings, now of global significance, together with other unbuilt projects and furniture. It incorporated work from all stages of the creative design process. In addition, on the external terrace of the tower galleries, Gehry built a small canopy, which still remains intact. Reminiscent of the curving metal-clad architectural forms of his recent buildings, this completed the picture, offering visitors real experience of actual built work.

The entrance hall to the Guggenheim was treated in characteristic spectacular fashion. It was transformed by an array of metal-mesh curtains that lined the interior of the ramp. They were hung from mechanical devices high in the upper structure of the hall and moved gently, filtering natural light and forming translucent screens across its space. This floating world hovered above the entrance level and, like the

terrace canopy, was cleverly reminiscent of the signature language of Gehry's architecture.

The bays of the ramp held a number of podia of different sizes. The materiality of the models contributed to appreciating the weight and sculptural nature of the architectural proposal and, significantly, most were displayed without covers. Each model was seen against a giant photograph (or montage) of the building in its context, or alternatively of a detail, mounted on the rear wall. These well-lit panels looked like fictive windows along the edge of the ramp and successfully situated the foreground models.

Along the ramp, large-scale graphics of these projects were laid high up on the leading edge of the tapering structural fins. Each stating only the name of the city in which the building is located, they emphasized the global identity of Gehry's architectural production. Closer inspection revealed that further details of each project were located on the base of the model's podium and on the flank walls of the ramp's fins.

In contrast, as though going behind the scenes, the tower galleries were more like workshops. Here the displays were about the process of putting a building or object together,

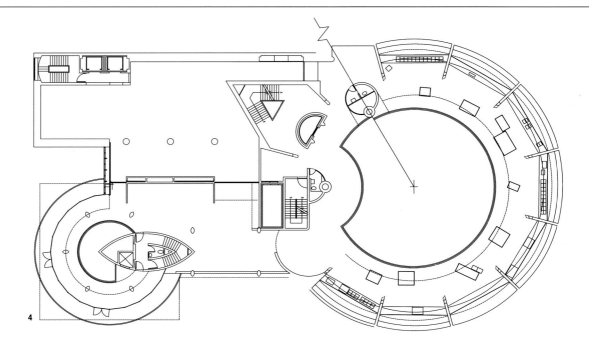

4

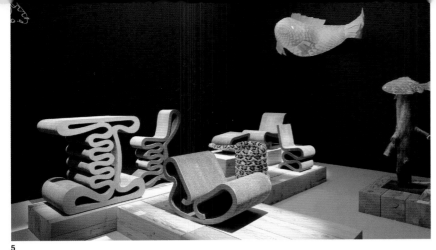

5

6

5. Detail of the display in the annex, Level 5.

6. Display devoted to an architectural project for Massachusetts Institute of Technology in the annex, Level 7.

7. Lighting and furniture design display in the annex, Level 5.

8–9. On the Level 2 ramp, displays devoted to particular projects featured backlit images and models.

about the performance of creative architectural production. As such, these galleries brought together a variety of elements, collage-like, to give the impression of work in progress. In one space, great sketch models were placed on robust wooden trolleys and set against a wall of sketches, drawings and large black-and-white photographs of the construction process. These galleries succeeded in combining different media to contextualize the buildings, projects and objects in relation to sketches, prototypes and constructional phases.

Elsewhere in the tower galleries there was a particularly effective display of Gehry's chairs and other objects. These were set on massive timber sections and individually spotlit against black walls that featured sketches and drawings describing their design. This installation appropriately emphasized the formal complexity and material textures of the objects, and immersed them in a context of creative design output that had an immediate resonance with the buildings illustrated on the ramp.

7

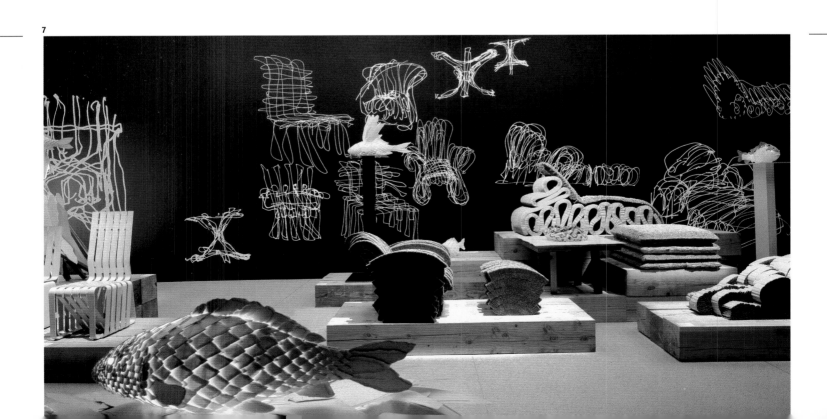

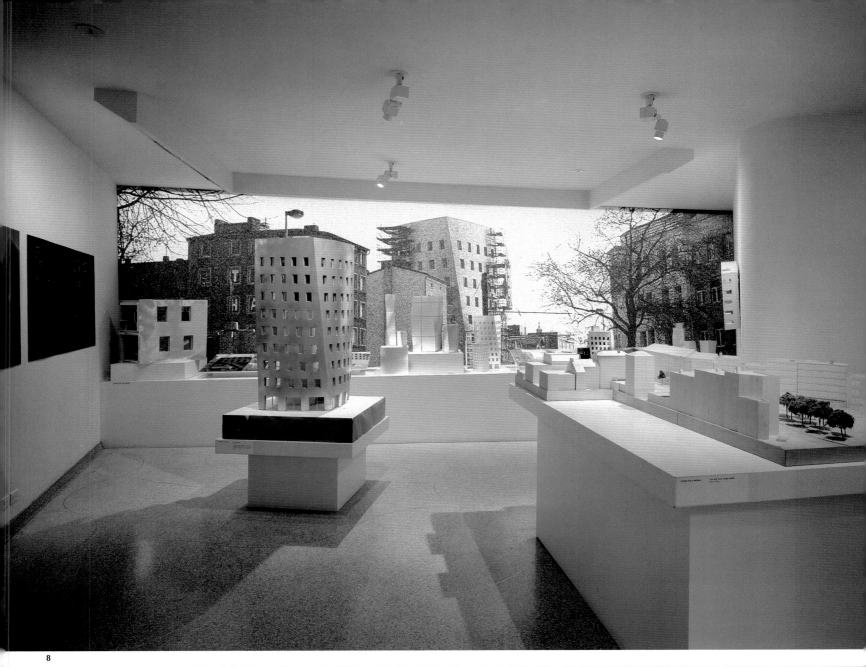

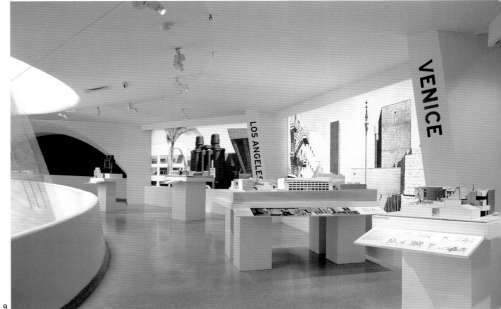

1

Guinness Storehouse

Dublin
Ireland
Imagination and Robinson Keefe Devane
2000

1. Exterior view – the white circular light of the Gravity Bar gives the building the appearance of a pint of Guinness.

2. The original sketch of the Guinness Storehouse clearly shows the 'pint-glass'-shaped atrium.

3. In the Gravity Bar visitors enjoy free pints of Guinness and a panoramic view of Dublin.

4. A hand-drawn sectional rendering.

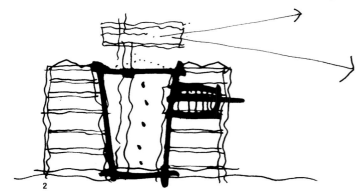

2

The Guinness Storehouse is a remarkable example of how a brand can connect with a community, its employees and its customers. The company has been associated with Dublin for generations: it is a principal local employer and its product is Ireland's most famous export. But concern that the brand was becoming less relevant for contemporary Dubliners led, in 1998, to the invitation to the design company Imagination to create a new visitor attraction to replace the Guinness Hopstore.

Working in conjunction with Dublin-based architects Robinson Keefe Devane, Imagination expanded the idea of a visitor centre: a central hub was to include corporate facilities, conference and training areas for Guinness staff and people involved in the wider drinks industry, public facilities, bars, and gallery and exhibition spaces. The approach was the formulation of a spatial experience that was to be the ultimate expression of the character of Guinness.

A six-storey disused fermentation plant in St James's Gate Brewery was completely restructured. Designed in 1904, it was Ireland's first steel-frame building, and, together with elements of the existing industrial plant and masonry perimeter infill walls, this structure was retained and explicitly exposed as an integral part of the spatial experience. Together, these fragments give the project an important rhythm and measure: they 'ground' the brand in this historic context and communicate a powerful sense of orientation.

A partially glazed atrium (profiled to resemble a pint glass) was carved out of the heart of the building and, in a straightforward manner, this forms the main focus of vertical access. The entrance, on the ground floor, leads directly into this space and at the summit of the atrium there is the spectacular Gravity Bar, where visitors can finally sample the product.

On the ground floor the retail area, set off to one side, is unobtrusive and the emphasis is on greeting visitors personally. Exhibitions tell the story of Arthur Guinness, founder of the brewery, and there is a spectacular account of how Guinness is made. The threshold to the main hall provides an elegant demonstration of projection technology – a suite of high-level projectors is carefully aligned with reflectors (angled at ground level) to back-project onto a curved screen – and opens out to form a gathering

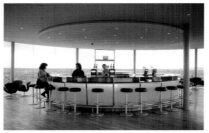

3

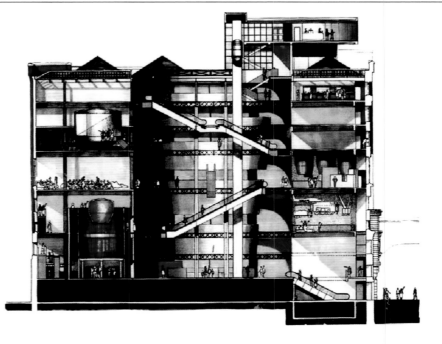

4

5. The Guinness waterfall creates a striking experience, capturing an image of the natural goodness of the brand with its legendary ingredients.

6. Young Dubliners watch the launch of the Storehouse, with acrobats suspended in the glass atrium.

5

6

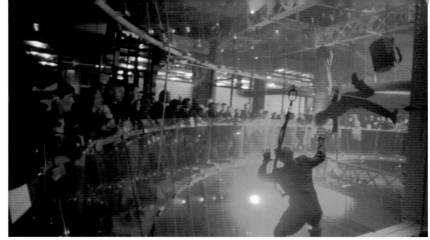

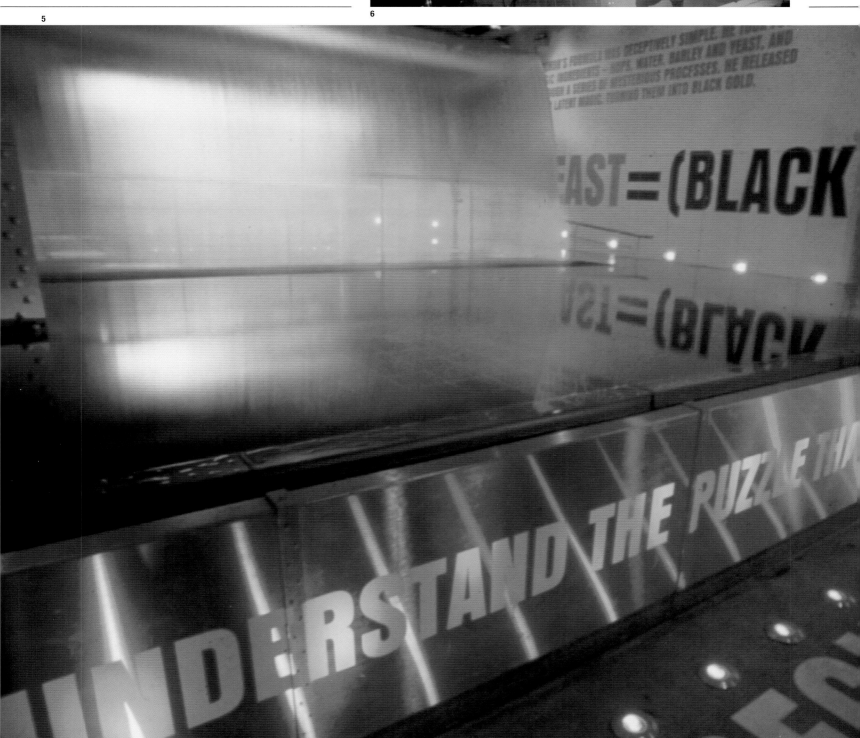

7

space, or foyer, at the entrance to the main hall. Here visitors pause to watch shifting stills that introduce the familiar brand. This display sits, gem-like, in the vast hall, which is otherwise stripped back to the bare masonry of its perimeter walls. In either direction a landscape of set pieces – extraordinary brewing equipment – reinforces the sense of belonging to the community of Dublin.

The exhibition takes visitors through the stages of the brewing process, starting with the ingredients used in Guinness, and then to accounts of the export and consumption of the product around the world. On all levels graphics and lighting combine with particular effect, clearly defining the journey through the darkened spaces. Especially powerful is the use of large-scale graphics, applied directly to the surfaces of existing walls and windows: the building itself is a vehicle for communication, rather than simply a support for informative panels. Perimeter surfaces are used to reflect light back into it, and so become effective orienting tools – the eye is drawn across the space to key words or messages on the luminous periphery.

7. Barrels stacked in the traditional way create a walk-through area where visitors can learn about the skill of coopering.

8. The Transport area illustrates the various ways in which Guinness is distributed globally to consumers.

This scale contrasts with the detail of individual interactive devices, invented to clarify the theme of the exhibition. It is characteristic of Imagination's approach that these are not dominated by technology – which is, instead, dropped in as and when it is appropriate to the content. Visitors are also invited to touch and feel and smell (and finally taste), as the experience is made tangible through actual physical engagement. This is nowhere more evident than in the spectacular waterfall where images of the brand character are interwoven with the natural ingredients of Guinness: the sound of the flow of the legendary water creates a powerful backdrop to the exhibition.

A passage at the mezzanine level in the ground-floor hall takes visitors back over the displays. At its head is a custom-built translucent room. Here, back-projected onto three walls, is Imagination's *Life*, a suite of films that purvey a sense of the *craic* – the spirit of the Irish. In contrast to the tactile world of the brewing process, visitors are, unexpectedly, surrounded by local sounds, conversations, stories, music and sound bites, taken from radio archives and combined with resonant graphic

images. The films powerfully evoke the qualities of 'Irishness', but, unlike many promotional films, they are mainly graphics. As a result, the images they evoke are incomplete, and demand an active and creative engagement. This lack of attempt to sell the product makes this display one of the most effective of its kind.

Other elements in the exhibition include a replica cooperage that combines three-dimensional displays, rare film footage and interactive installations that convey the brand in a wider social context.

In the display of Guinness advertisements visitors can move between interactive screens, and the idea of advertising is explored through graphics. All surfaces are used to house these, and words, arrows and colour become an architecture in themselves – 'graphics' is conceived of as a three-dimensional field that weaves between other display elements.

Some of the screens are placed within industrial equipment that was salvaged for the purpose. Others are built into display structures that integrate information with the history of the brand through the familiar media characters that have represented it. It is a reminder of the

8

9

effective use Guinness has made of the broadcast media in the past, and is built into the new form of brand 'experience design' that Imagination pioneered here.

In a relatively new installation, filmed interviews explore the relationship between Guinness and local life. As elsewhere in the exhibition, visitors choose whether or not to pass through this section, but its dark, reflective surfaces, suggestive of the product itself, invite entry. The interior has almost labyrinthine qualities and visitors are quickly immersed in its intriguing filmic imagery.

The selective use of technology played an important role in the design of the exhibition. For example, in contrast to the artificial setting for the films, there is a low-tech space where visitors can make and display postcards. This risky but effective strategy for public feedback is illustrative of the overall approach to the design: visitors are to make of it what they want. The new medium of brand experience is people, not broadcasting. The success of this approach is proven by the visitor figures: in its first year Guinness Storehouse passed the Book of Kells as Ireland's number one tourist attraction.

9. Old brewing vats have been transformed into interactive areas.

10. Many of the signs and way-finding graphics in the Storehouse are applied directly onto the original steelwork of the brewery.

11. Large-scale graphic treatments give the Storehouse a harmonious balance of organic and industrial.

12. The Guinness Storehouse ticket – actually a glass pebble that holds a bubble of pure Guinness essence.

10

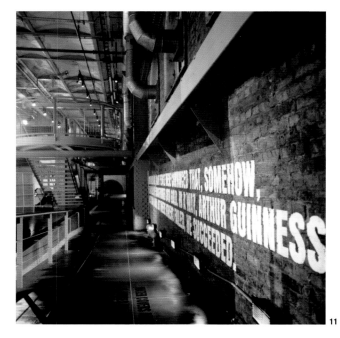

11

12

1

Expedition Titanic

Hamburg
Germany
Atelier Brückner with Götz, Schulz,
Haas – Architekten
1997

The approach to this temporary exhibition, which recounted how the *Titanic* sank on her maiden voyage, focused on the dialogue between the individual visitor and the displayed object as the source of experiencing and interpreting the event. This strategy clearly required careful attention to the display of the artefacts and, indeed, the staging of each sequential space: while there would be a clear thematic structure, the chronology of events would inevitably underscore the experience.

The design avoided the practice – so common in well-known historical accounts and in the emotional interpretations in recent films – of establishing any heroes. Rather, the exhibition used five passengers as narrators without specifying whether or not they survived. The aim was not to comment on the tragedy but to let the staging of the exhibits speak for itself. The emphasis on the intimacy of experience, rather than upon didactic narrative, gave the show a rich material quality and an inventive landscape of display that drew inspiration from theatre and film.

The exhibition was structured around a central passageway lined in raw steel,

40 metres (130 feet) in length. Dipped in dramatic blue light, it was poignantly left empty. To either side were rooms structured around themes such as Welcome on Board, Life on Board, The Drama of the Sinking, and Rescue. Visitors constantly crossed the empty passageway before arriving at two final rooms: the Room of Silence and, like an epilogue, a room entitled Myth.

The entire length of the central hall of the exhibition – located in Hamburg's historical harbour warehouse district and contemporary with the *Titanic* – unfolded as a journey through the experience of the voyage, from the passengers boarding the ship and life on board to the sinking of the *Titanic* and, finally, a reflection on the memory of the event. This overall chronology was overlaid by the strong individual themes in each space and was at times deliberately interrupted.

Visitors entered the passageway from an installation entitled Welcome on Board, where there was a 'sight line' through to the final scene in the Myth room. A central 'ice bell' hung silently in the distance. Its silence was matched by the cold steel walls of the passage that

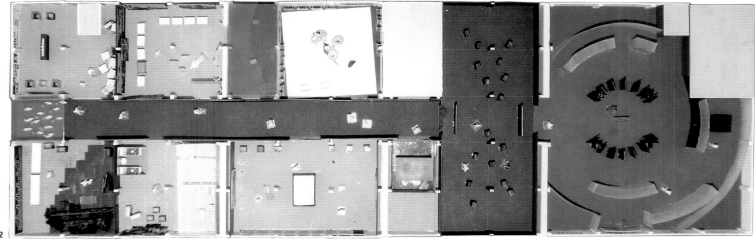

2

3

framed the view. The full significance of the event was powerfully communicated in the first space. Here a dialogue was constructed between a display of suitcases, lashed with ropes, and a wall of photographs of individual passengers. In its midst stood a resplendent model of the *Titanic*. Like the opening act of a drama, the impact of the whole and the anticipation of the voyage's fate was captured in an instant.

Subsequent rooms built up an image of the reality of the ship and life on board her. Fragments of salvaged materials and reconstructed rooms combined with large-scale photography to convey a sequence of interiors that culminated in the Champagne Room. This was a further theatrical experiment in that it deliberately broke the narrative structure of the other spaces: blue light and an almost imperceptible, low-pitched sound combined to create an uncomfortable setting for the awkwardly housed displays. The feeling of unease provoked by this setting was reinforced by the sound of metronomes that lined the central passageway and beat ever faster, heralding the sinking of the ship.

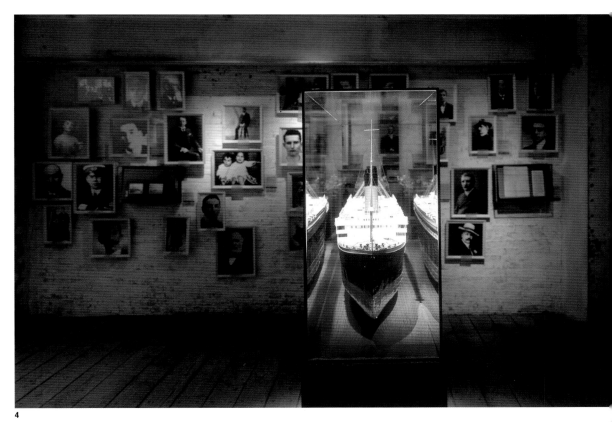

4

3. Display of artefacts recovered from the *Titanic* debris field.

4. A wall of photographs introduced individual passengers.

5. The blue-lit, steel-lined central corridor.

5

6

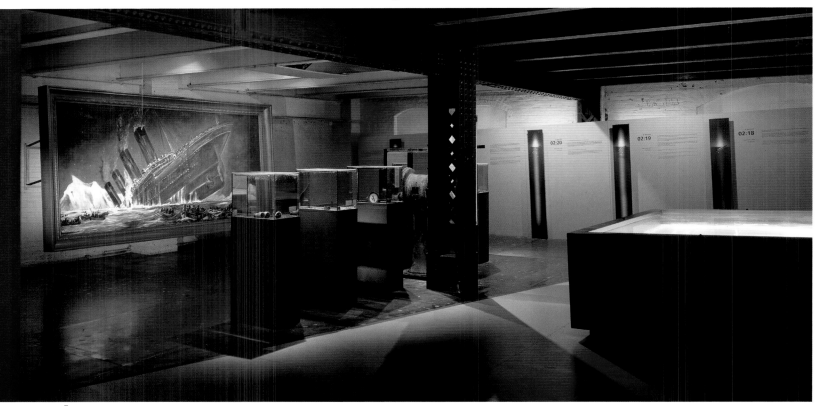

7

8

6, 8. Recreated interiors, lit in a theatrical manner, built up a sense of what life was like on board.

7. The Drama of the Sinking section, with objects displayed in water tanks.

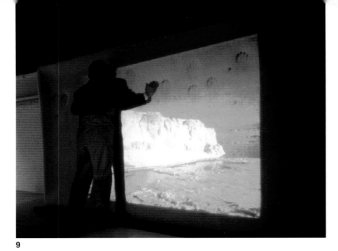

9

The collision with the iceberg was itself powerfully communicated through the use of other theatrical devices, such as a sloping floor, projection of film footage of icebergs onto panels of ice, and the display of artefacts under water. The emphasis here was on making an effective emotional connection with visitors rather than using technology to create an illusion or a realistic reconstruction. There was a deliberate emphasis on the imaginative participation of each individual: simple audio tapes recorded actors reading original accounts and quotes from surviving passengers.

The heightened tension created by the sequence of rooms was effectively countered by the first of the two final spaces: the Room of Silence. Darkened and soundproofed, it appeared to be under water – a still archipelago of cabinets, tailor-made for the individual-yet-anonymous objects intended to pay tribute to those who did not survive.

Beyond was the last room of the journey: Myth. This brightly lit space, framed by wave-like walls, focused on the ice bell at its centre, which may have forewarned of the danger of a collision. Contemporary texts and quotes

9. To communicate the drama of the collision, footage of icebergs was projected onto panels of ice.

10. The concentric Myth Room featured the bell that was probably rung by crewmember Frederick Fleet when he saw the iceberg.

11. The Champagne Room with the dialectic installation of six original champagne bottles and a leather workman's boot.

dealing with the continuing interest in the *Titanic* disaster overlapped with messages in the form of historic newspaper reports and accounts of other shipping disasters, inviting the visitor to reflect upon the broader significance of the *Titanic*'s voyage.

At no stage did the exhibition comment on, or interpret, the material in order to influence how the tragedy was read. The strength of the design was that the fragments that had survived were

allowed to communicate their own message to visitors. The story of the *Titanic* was 'staged', rather than simply narrated, and was portrayed through the objects themselves rather than through curatorial interpretation. Dramatic lighting, tactile and textured displays, changing temperatures and low-tech audio environments were deftly combined to create an emotional engagement between visitors and the event.

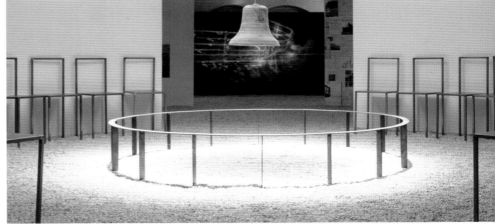

10

11

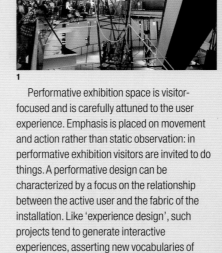

1

2 PERFORMATIVE SPACE

Performativity has been much discussed in recent philosophy of language and interest in this notion has arisen outside of this immediate field. Recently the concept of the performative in architecture has attracted attention as a new approach to spatial organization and interactivity that emphasizes the dialogue between space, body and time: the curatorial programme for the Kunsthaus in Graz, Austria, for example, is particularly sensitive to this agenda within the new gallery space.

In a similar way performativity is one of the most significant developments in contemporary exhibition design since it reaches beyond the semiotics of exhibition display and develops the notion of experience design in the recognition that the body plays a fundamental role in communication and learning. Performative space is an approach to exhibition design that sees the potential of display to explore new ways of interactivity: the body and its movement through the exhibition is a vital exchange between the content of the show and the private associations of the individual visitor. The exhibition experience becomes an encounter with the moving body, a space of events.

1–3. *Sisyphos*, a project by Atelier Brückner intended for the IAA Motor show in Frankfurt, 1999, explored boundaries between theatre, acrobatic performance and installation design.

Performative exhibition space is visitor-focused and is carefully attuned to the user experience. Emphasis is placed on movement and action rather than static observation: in performative exhibition visitors are invited to do things. A performative design can be characterized by a focus on the relationship between the active user and the fabric of the installation. Like 'experience design', such projects tend to generate interactive experiences, asserting new vocabularies of media façades, immersive displays, digital environments and information walls.

It might be argued that this kind of exhibition environment lends itself most immediately to projects for children. In Our Global Garden (at Eureka! The Museum for Children, Halifax, England) the design company Imagination invite children to explore environmental issues through a physical engagement with the display apparatus in varied ways. A similar approach was taken by Casson Mann in their design for The Garden at the Science Museum, London, an arrangement of learning devices that is particularly popular. In part, the success of this approach is that it opens up the important

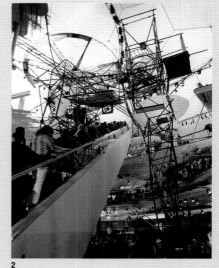

2

relationship between learning and play. As much like sophisticated playgrounds as museum interiors, the display devices ingeniously invite the children to move and interact in fun ways whilst learning important scientific principles. Physical interaction is key: they are spaces full of movement and expressive sounds that accompany the thrill of learning in this way.

3

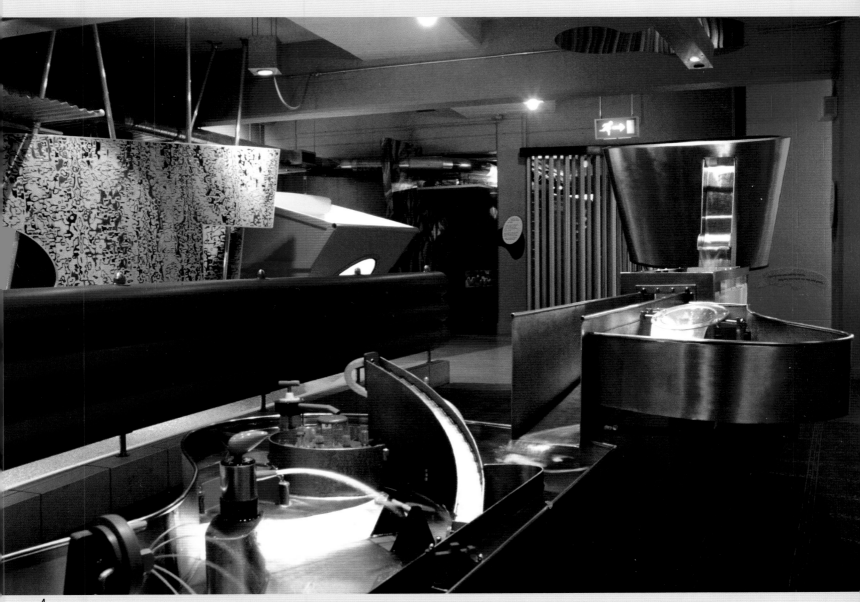

4

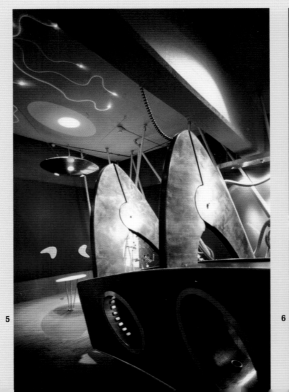

5

6

4. The Garden, Science Museum, London, by Casson Mann. The colourful display was designed as part of a brief to introduce the basic principles of science through hands-on experimentation.

5. The interior in The Garden provides a journey through three different landscapes, with activities, secret dens and sound effects.

6. At The Garden even the youngest visitors are engaged by the colourful, user-friendly interactive equipment.

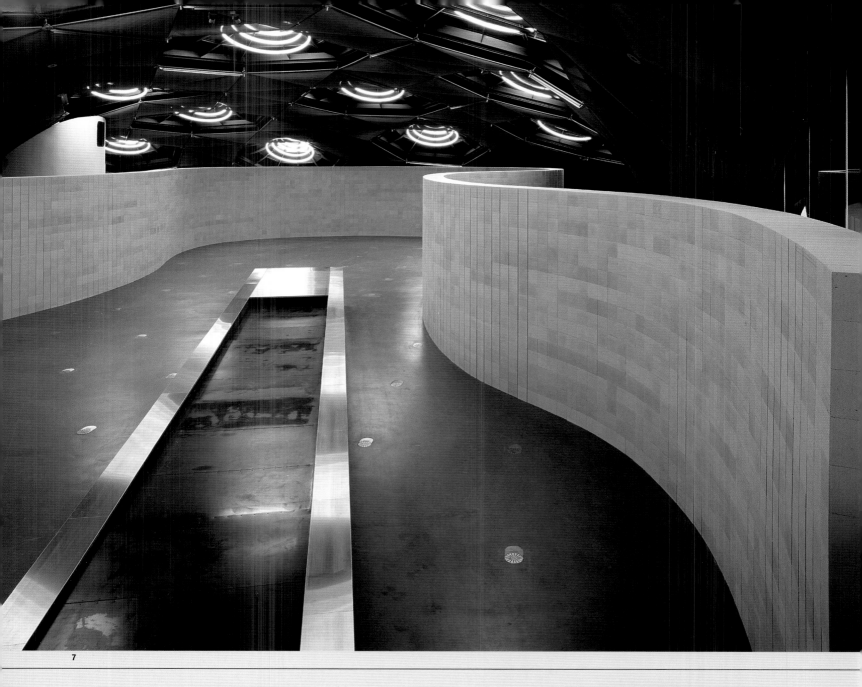

7

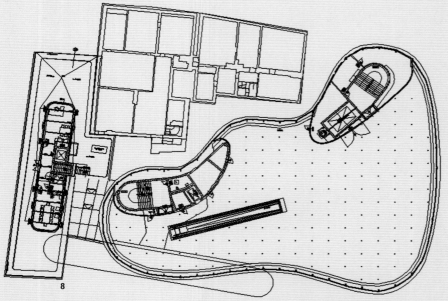

8

7. *Wall*, Sol LeWitt, 2004,
Kunsthaus Graz. The
strong architectural
forms of the gallery
space established a
dialogue with the
sinuous forms of the
masonry installation.

8. Plan of the Kunsthaus
Graz showing its curving
forms.

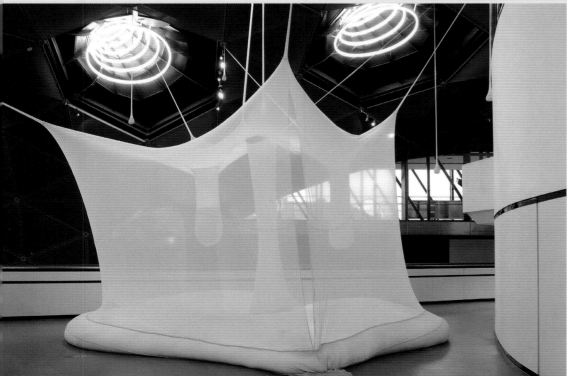

9

Through play the children in these projects find a world between their own interior imagination and the ordered knowledge that the museum has to offer. In a way, and reflecting the well-known ideas of the child psychologist D.W. Winnicott on this subject, the exhibition displays are like 'transitional objects', that mediate inner and outer worlds. In contrast to conventional static screen-based interactives, here movement and play are at the heart of the learning process.

Other expressions of performative space are developed from interactive software. Innovative examples include Imagination's stand for Ericsson for the 2001 CeBIT telecom fair, London. Here, in the Mobility cube for example, icons representing music, sport, travel information and entertainment were clustered together on a large screen to form the outline of visitors as they passed by at the entrance to each stand. The images caught the visitor's imagination and triggered further inquiry – time spent doing so immersed the visitor in the images of leisure, interspersed with the Ericsson story. The Fun cube engaged people in more of a performance. Visitors triggered sounds using

9. The curving architectural membrane of the Kunsthaus Graz encouraged a dynamic experience in the space between the reciprocal forms of Sol LeWitt's installation and the gallery wall.

10. At Graz the performativity of the architecture itself influences curatorial direction and selection of artworks, as shown in this view of _Nave Noira, Blop_ by Ernesto Neto, 1998, from the exhibition _Perceptions in Art_, 2003–2004.

pressure pads on the floor to create their own music, illustrating the way in which mobile Internet technology allows one to enjoy entertainment everywhere.

As we have seen, performative devices are not restricted to any one technology: rather the range of interactive devices, the diversity of engagement and different ways in which the visitor is invited to think through the content of the exhibition, is an important characteristic of performative design. Devices may vary from the simple provision of appropriate seating or non-stepped access to sophisticated, immersive environments that respond to movements and sounds.

Performative space grows out of an understanding of the spatiality of display in terms of human experience. The transition mapped in the course of this survey, from narrative space through experience design to performative space, is a change in emphasis from story-telling to interactive theatre. Just as contemporary theatre explores new ways of engaging with the audience, so performative space is about inviting people to interact with the exhibited artefacts or the fabric of the space

in novel ways. Performative design can challenge the hushed interiors of conventional exhibition spaces: a particularly interesting experiment by Atelier Brückner (whose exhibition designs are characterized by strong links with theatre) outside the IAA Motor Show in Frankfurt appeared to be a spatial collage of fragments inhabited by acrobats. Had the show not been stopped by the client, the project was to include a meticulously detailed performance by the acrobats, juxtaposing the drama of the circus ring with the formal setting of the Festhalle. The visitors were to progress through a theatre of extraordinary movements full of excitement and surprise.

Despite the long-standing inclusion of interactive devices in exhibition spaces, such creative shaping of performative space is a relatively new tendency. The approach may not fall within the traditional boundaries of exhibition design as established by modern professional criteria, but the variety of experience, movement and activity that it invites will be fundamental to creative and inclusive exhibition experiences of the future.

10

1

Ericsson
CeBIT
London
UK
Imagination
2001

1–3. The theme of this cube was Work. To show the ease of Ericsson's Chatpen visitors were asked to draw on a glass panel with their fingers. Their drawings were traced in light onto a layered series of glass panes which, over time, created a three-dimensional drawing.

4. Imagination created the Ericsson CeBIT stand to inform, inspire and intrigue visitors. Four interactive installation 'cubes' were created which covered four key areas of human experience that make up our daily lives – Home, Work, Fun and Mobility.

CeBIT is the largest annual trade show for information and telecommunications technology, with events taking place around the world, and at the 2001 fair there was a particular impetus to communicate the mobile Internet to a wide variety of customers.

The high-profile Ericsson brand is well known for its high level of design and historically this has been reflected in its trade stands, which have also tended to be innovative materially. For the 2001 CeBIT there was the need for a different emphasis: to express wireless technology as part of the everyday world.

Imagination designed two stands for the show: one for consumers and an applications pavilion. The latter, traditionally attractive to the more technologically minded, was designed as an immersive experience to enable customers to think about how they could create their own mobile Internet worlds. Emphasizing the connection between Ericsson's technology and everyday life, the core experience of the pavilion focused on four key areas of day-to-day living: Mobility, Fun, Home and Work. Each of these was the theme for an 'experiential cube', where multimedia displays, music and animation

2

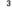

3

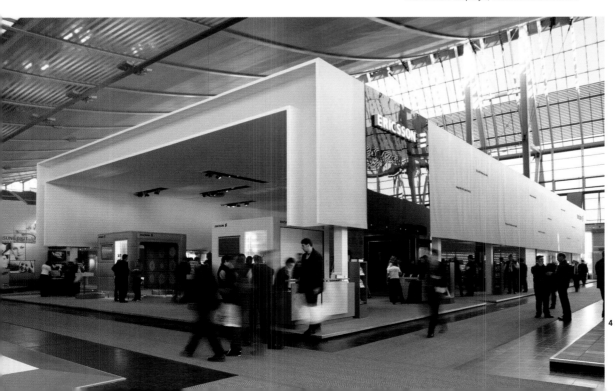

4

5–7. The Mobility cube showed how Ericsson brings technology to the customer. To demonstrate this a camera measured and recorded the shape created by anyone who happened to pass the screen. Millions of technology icons on screen mimicked the same shape, creating a fun mirror effect with clusters of icons.

5

6

7

8

combined to bring to life the possibilities presented by the mobile Internet.

In the Mobility cube, icons representing music, sport, travel information and entertainment clustered together on a large screen to form the outlines of people as they went past the entrance to each stand. These attracted the attention of passers-by and triggered them to enquire further – which immersed them in the images of leisure, interspersed with the Ericcson story. The Fun cube engaged visitors in more of a performance: they used pressure pads on the floor to create their own music, illustrating how mobile-Internet technology allows people to enjoy entertainment everywhere. In the Home cube they viewed films depicting mobile-Internet scenarios, projected onto everyday, household objects. Compelling images send a straightforward message.

Together the cubes created an eventful and varied set of experiences that were visually engaging and drew visitors into a performance of a kind. They were also there to be watched. Audience and performers came together in the theatre of a display environment, enjoying, exploring, discovering – and, above all,

9

10

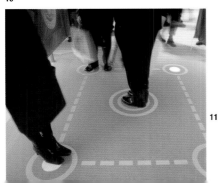

11

8. The use of projection onto ordinary objects (in this case a lamp) created fun and eye-catching displays.

9. Once visitors had been lured away from the experiential cubes, they were presented with the Ericsson story, delivered in an accessible way.

10–11. In the green, quilted Fun cube, visitors experienced an interactive soundscape as they stepped on different areas of the spongy rubber floor. The technology used was taken from Ericsson's digital radio systems.

12. As well as the interactive cubes, the rest of the exhibition stand was supported by high-level video and a dramatic lighting scheme.

12

13

remaining immersed in the brand environment long enough to take in the simple message that the Ericsson brand touches every aspect of their everyday lives.

The consumer stand explicitly underlined this message with the entire product range displayed on a Product Portfolio Wall. This looked like a shop window, with each product shrink-wrapped with commonplace objects that reflected its personality and that of the person who might use it.

What is important here is that the detail of the design, both in its material character and in its conceptual inventiveness, was the key to communicating the special character of the Ericsson brand and gaining attention for it over other companies with similar product ranges.

14

15

16

13, 16. In the Home cube, Ericsson's 'hidden home technologies' were translated into a glass-topped table with frosted cups, bowls and plates on top. On closer inspection the crockery revealed tiny detailed animations of home life.

14. The exterior of the Home cube. Each cube had its own colour and texture, creating individual atmospheres for each space.

15. Boxing gloves made eye-catching displays to hold the telephone handsets in place.

1

Eureka Our Global Garden

Eureka! The Museum for Children
Halifax
UK
Imagination
2002

2

3

In Our Global Garden, a permanent installation for an environmental gallery, Imagination explored the role of play in the learning environment of Eureka! The Museum for Children, in Halifax. The exhibition aims at developing awareness of the natural environment, and is designed as an imaginative journey through the world's major cultural, geographical and climatic phenomena. The content is carefully linked to the educational curriculum, and addresses key issues of interdependence, citizenship, stewardship, needs and rights, diversity, sustainable change and uncertainty.

The environmental theme is articulated in a language that is readily accessible and visually compelling for the visitor age-group. The exhibition comprises a sequence of elements that can be interpreted as transitional objects, vehicles that enable children to explore a world beyond themselves.

Six themed gardens are structured over two floors of a triangular hall. First, on the ground floor, a Town Garden offers a familiar image that facilitates awareness of the natural environment. Imitation garden-walls house an

array of opening devices, things to do and see, in surroundings that recall a traditional backyard. The Jungle Garden and Ocean Garden are also on the ground floor and provide contrasting, more unfamiliar settings. In engaging with these less commonplace topographies the children are furnished with an image of the sheer diversity and extent of the natural environment.

In a similar manner, on the first floor visitors enter a familiar place: a Countryside Garden. As on the ground floor, this is followed by contrasting settings: the Ice Garden and Desert Garden. The structure of the installation works successfully, as visitors move between everyday images and contrasting ones that provoke response because of their diversity. It is a technique that is likely to hold concentration.

A seventh garden, the Ideas Garden, provides children with the opportunity to contribute their own ideas at the end of the experience.

The installation technique is particularly instructive in the way it draws from literature, book design and illustrations for children to develop a language that is accessible and facilitates communication to the target age-group. The design for each garden is developed

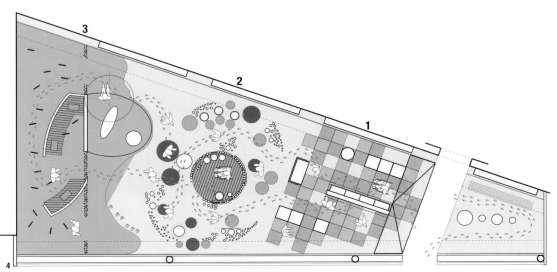

4

5

6

around a cluster of key images, colours and forms that are clearly representative of a particular environment. The Desert Garden, for example, works with oasis-like circular forms and undulating dunes in warm oranges, and has a backdrop depicting sun and sand. The Country Garden has similar apparatus, but here a very different palette is used to depict rolling fields, in flattened perspective.

Other forms are more complex. The imaginary world of the Ice Garden, for example, is articulated with images of ice creams and penguins. Colours shift to white and light blue, and materials become transparent and

5. The Country Garden is made up of styled wooden hedgerows that incorporate various hands-on experiences for children to discover.

6. The Ice Garden includes an Igloo building set where children can learn to create one for themselves.

7. In the Ice Garden children are encouraged to take rubbings of snowflake shapes. Individual podiums have been built with creative areas and snowflake effects on each.

8. Second-floor plan. 1. Country Garden, 2. Ice Garden, 3. Desert Garden.

reflective. Screens take on the form of icicles and great blocks of ice can be put together to make an igloo.

Throughout the exhibition each setting is skilfully augmented with an individual soundscape and the use of projections: wave patterns shift across the floor of the Ocean Garden, the forms of the Ice Garden are overlaid with images of snowflakes. These images instigate other forms of engagement: graphics on the floor of the Ice Garden, for example, remind children that each snowflake is different, and they are encouraged to pick their favourite from a nearby set and make a rubbing of it.

In this way, each garden integrates a variety of interactive activities in order to develop awareness of the natural environment. Movement is key to the experience as children, by lifting flaps, taking rubbings or opening drawers, discover new things to learn. For light respite, there are carefully considered pockets of space (like the igloo) for chatting and hiding.

The overall experience of this robust installation is indeed characterized by a set of delightful engagements with colours, textures, moving parts and sounds (including the voice

of an invisible gnome called Gordon), so that learning about the natural environment is interwoven with the enjoyment of play and discovery. Characteristic of Imagination's approach to 'experience design', the theme of the exhibition is communicated in a non-judgemental fashion; there are no severe messages, just an intriguing array of questions and suggestions designed to enable an individual and creative learning experience.

7

8

1

Orange Imaginarium
Explore At-Bristol
Bristol
UK
Imagination
2002

1. CAD designs show the space covered with a forest of fibre-optic cables.

2. In the interactive game Say Your Name visitors are invited to use the latest Orange voice technology.

3, 7 (overleaf). Chase the Rainbow has a pressure pad on the floor – once it is triggered, fibre-optics turn from white to orange in a wave.

4–5. Computer renderings were produced to show the client how the fibre-optics would work.

6. The walls and floor of the Imaginarium are covered with a reflective black material to give maximum impact to the fibre-optic lights.

Explore At-Bristol is a hands-on science centre, consisting of three main areas: an IMAX cinema, Explore and Wildwalk. The telecommunications company Orange (At-Bristol's major sponsor and a key local employer) invited Imagination to develop an area within the centre as a permanent installation. In collaboration with a team of researchers, programmers and futurologists from Orange, the designers set out to explore ways of communicating the ideas behind wire-free technology to four- to 16-year-olds in 'simple, fun, surprising and stimulating ways – aimed at engaging the imagination of a child on a multi-sensory level'.

Imagination installed a forest of lights in a conventional exhibition space. The dense array of fibre-optic cables is housed in plastic sleeves and held on a steel structure. The cables stretch from floor to ceiling and invite engagement. They are inevitably grabbed, pulled and otherwise moved by visitors, and the resulting lighting effect is enhanced as it is seen in a black environment with a mirrored ceiling and polished floor. The project successfully creates a fully immersive experience, where the senses and the environment connect and interact.

The first stage of a visit to the Imaginarium is the Orange Story, a series of animated stories that illustrates the link between everyday needs and the three technologies that visitors discover as they explore the extraordinary installation. These are three pieces of interactivity embedded in the environment. Say Your Name demonstrates that machines will respond. Children interact with directional speakers that

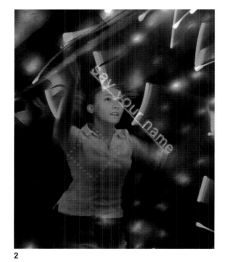

2

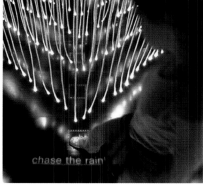

chase the rain

3

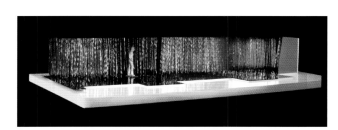

4

5

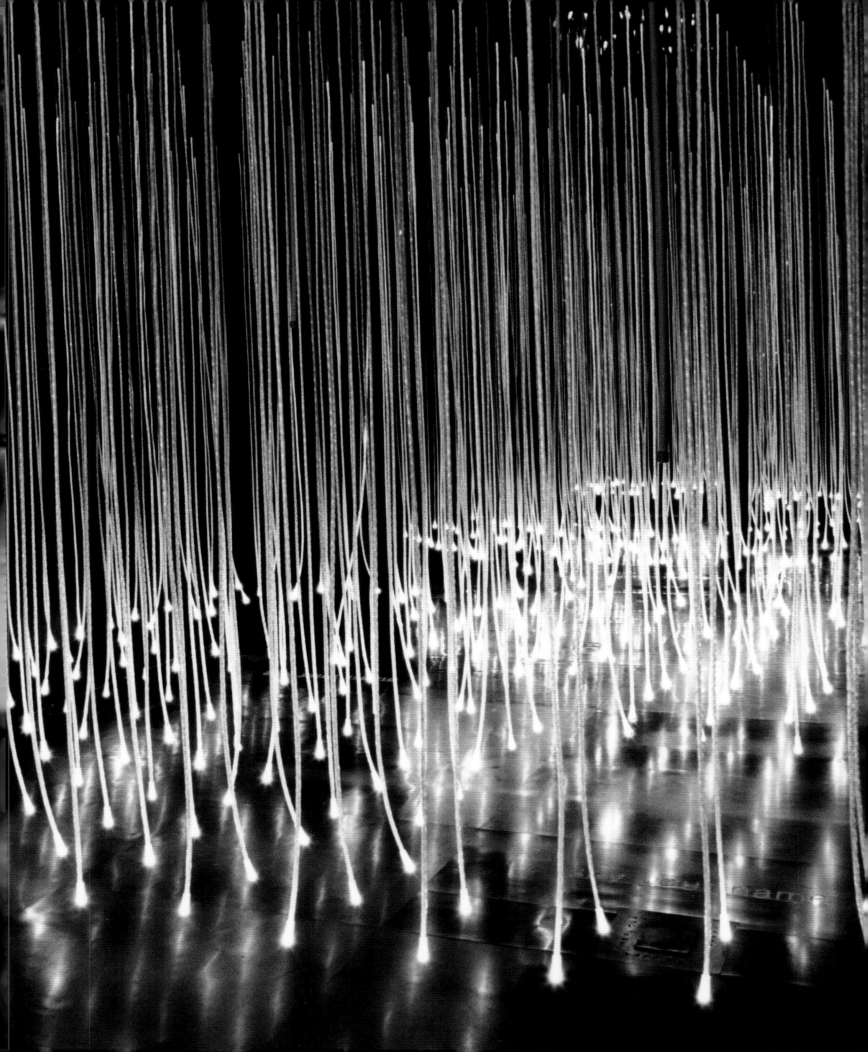

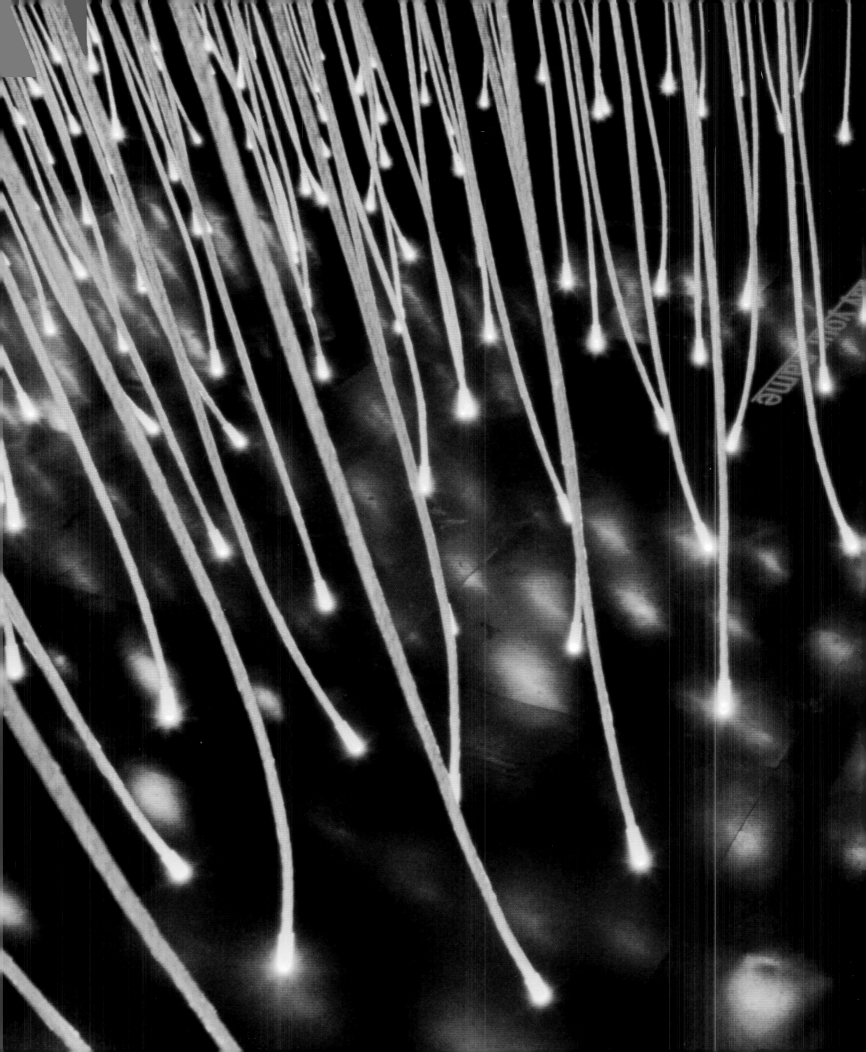

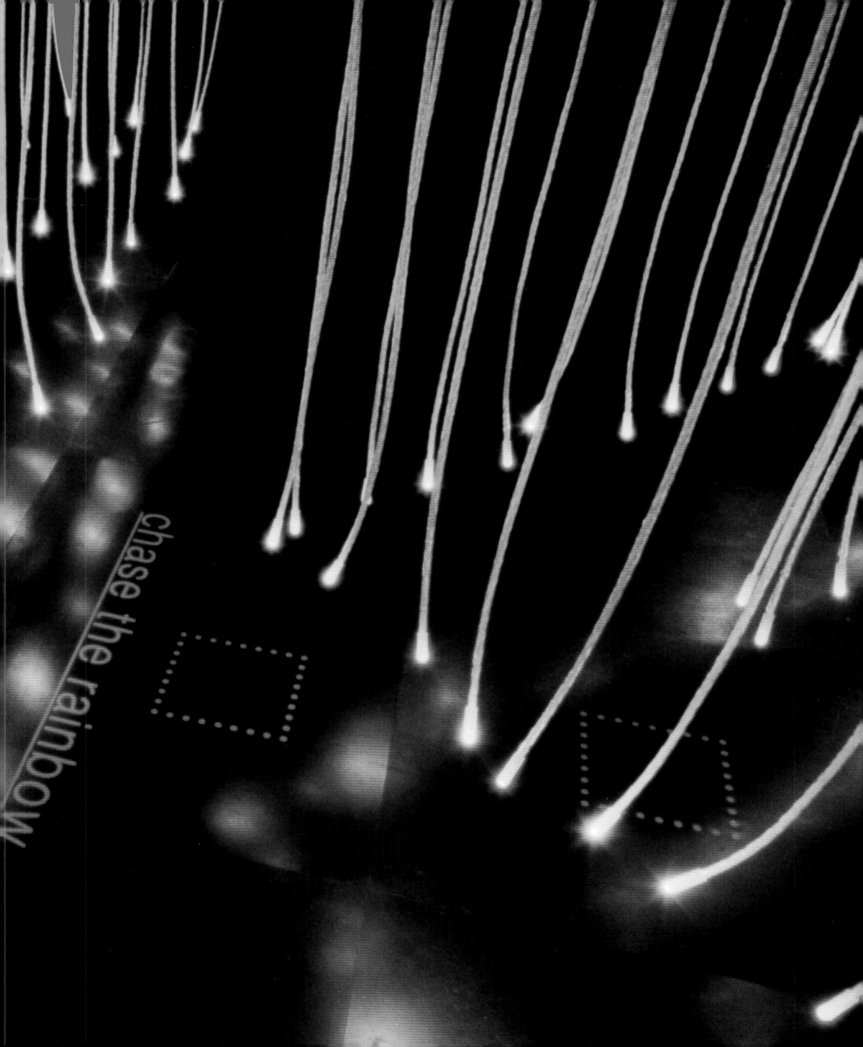

chase the rainbow

8

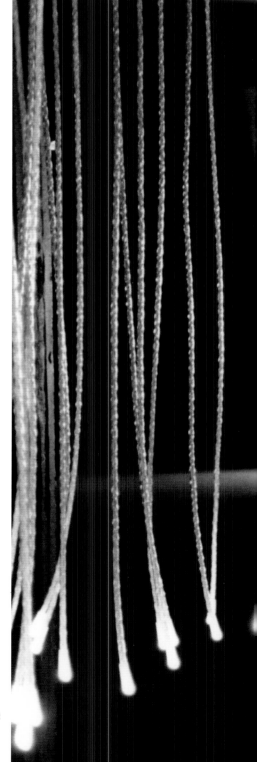

12

8–11. Young visitors are able to run, jump, climb and totally immerse themselves within the fibre optics while at the same time using ground-breaking technology that is normally only produced for mobile phones.

12. The Orange Imaginarium has been a great hit with visitors to the museum, as well as with the design industry, and has gone on to win several interior and design awards.

play their voices back at different pitches, and humour is used to engage them and retain their attention. The second interactive, Chase the Rainbow, involves different movements: children move through a series of touch-sensitive fibre-optics, turning them from white to orange: 'In a representation of how technology can personalize their space, children learn how they can be the trigger to their environment, making it respond to their commands.' Finally (although the sequence is non-linear) Tell Me a Joke uses voice-activation technology to recognize children's individual voices. The programme interacts, telling jokes on request.

The installation is playful, and enormous fun for the whole range of the target age-group. It translates complicated technology into an attractive field of discovery, transforming complex content into an intriguing field of movement and play. Here the physical movements of the visitors, and their engagement with the space of the installation, are key to a new departure for 'experience design', towards performative space.

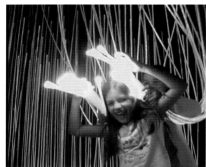

9

10

11

1

Hall of the Universe; Hall of Planet Earth

Rose Center for Earth and Space,
American Museum of Natural History
New York
USA
Ralph Appelbaum Associates
2000

1. Exhibits are characterized by stainless-steel housings, and laser-cut and etched graphics.

2. View of the main exhibit area, containing interactives exploring the frontiers of human knowledge.

3. Glass floor mosaics delineate the four major systems: planets, stars, galaxies and the universe (shown here).

4. Visitors descend the ramp of the Time Line of Cosmic History and emerge in the Hall of the Universe.

5. View under the sphere towards the 15-tonne Willamette meteorite.

6. Hall of the Universe plan. The coloured areas indicate planets (green), stars (yellow), galaxies (blue) and the universe (purple).

The Rose Center for Earth and Space revitalized the Hayden Planetarium in New York's Museum of Natural History by expanding it from a traditional sky-based projection theatre into a new type of public learning environment. The Hall of the Universe is linked in sequence with the Hall of Planet Earth, the Hall of Biodiversity (see page 94) and the Halls of Vertebrate Evolution (see page 156), all designed by Ralph Appelbaum Associates. Careful co-ordination of information displays and architectural elements creates a seamless narrative experience.

Architects James Stewart Polshek and Todd H. Schliemann clad the Hall of the Universe in a colourless glass (Pilkington water white) on a steel structure. Inside a sphere, which appears to be hanging in the space, a Zeiss supercomputer projector re-creates complex virtual realities.

Scholarly curation, multimedia, real-time feeds, images, kinetic models and advanced computer graphics illustrate astrophysics, astronomy and earth science for a diverse audience. The goal is to extend the voice of the scientist by utilizing the broadest available range of new technologies and learning strategies.

The hall focuses on the evolution of the universe, galaxies, stars and planets. The ground floor is awash with activity, and is remarkable for the diverse ways in which visitors are able to engage with the innovative learning environment. Ralph Appelbaum aptly describes the space as 'park-like'. Organized into four parts – planets, stars, galaxies and the universe – an array of touch-screen multimedia, artwork, kinetic models, mini-theatres and interactive media is set against acoustic backgrounds of narration and audio effects to provide intimate engagement with up-to-date scientific data.

Sixty separate multimedia productions range from the planetarium's Space Theater to the AstroBulletin wall of video modules, and to floor exhibits that require visitors to orbit around the information while peering into the media screens that crater the floor. Of particular interest are four large, floor-mounted 'lenses'. These receive digital projections from underfloor platforms (and so are easily updatable). One shows a supernova, and another activity on the surface of the sun – a rear-projection video. On a third lens there is a quasi-holographic projection of two galaxies.

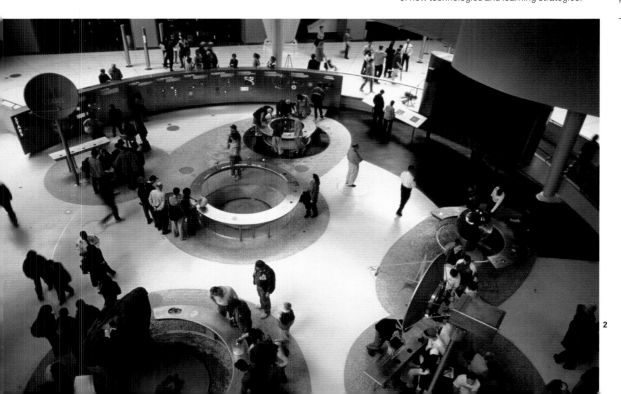

2

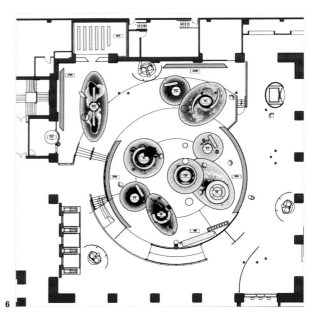

3

The Scales of the Universe provides visitors with a 120-metre (400-foot) spiral walkway around the sphere's 27-metre (90-foot) diameter. This is used as a scaling reference for rail-mounted and suspended models that explain the shift in size from galaxies to stars to planets to microscopic and, finally, subatomic particles. These prepare visitors for the scale of activity about to be seen in the Big Bang Theater. Rings, situated between the sphere and the glass balustrade of the walkway, are calibrated to represent time since the big bang: every step is 75 million years and the length of a human life is a strip the width of a human hair.

In the Hall of Planet Earth a collection of massive rocks, documented on video, lends context to the story of the earth as constantly in the process of renewal and regeneration. Of particular importance is a sulphide chimney, the first of its kind, that was cut from a black smoker on the Pacific mid-ocean ridge and raised to the surface. Video interviews with earth scientists and the latest in computer modelling, supported by a high-definition Geo Bulletin screen, give the hall a sense of immediacy. Sounds of the earth, recorded on geophones placed in glaciers, volcanoes and desert sands, add to the feeling of the earth as a living planet.

In the centre of the hall there is a cut-stone amphitheatre, where visitors can see the earth as it is seen from space. This first-of-its-kind hemispheric projection system uses the latest satellite images and computer models to slowly peel away clouds, vegetation and water to reveal the slowly turning earth.

The Willamette meteorite is one of the few astronomical 'specimens' in the hall. It has been remounted, and is poised to hit the 'media crater' that catalogues meteorite hits on the earth. It commands one of six 'constellations of information', around which visitors engage with 'view windows' that reveal computer animations and interactive interpretative elements.

The range of movement patterns, display techniques and interactive devices reflects the complexity of this fascinating sequence of installations. The overall landscape appears to be ever-moving, with ever-changing perspectives. Rich in metaphors, the design vocabulary supports the feeling that visitors are in a great, modern scientific instrument.

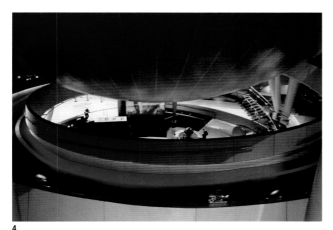

4

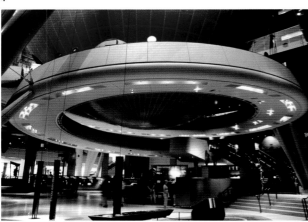

5

6

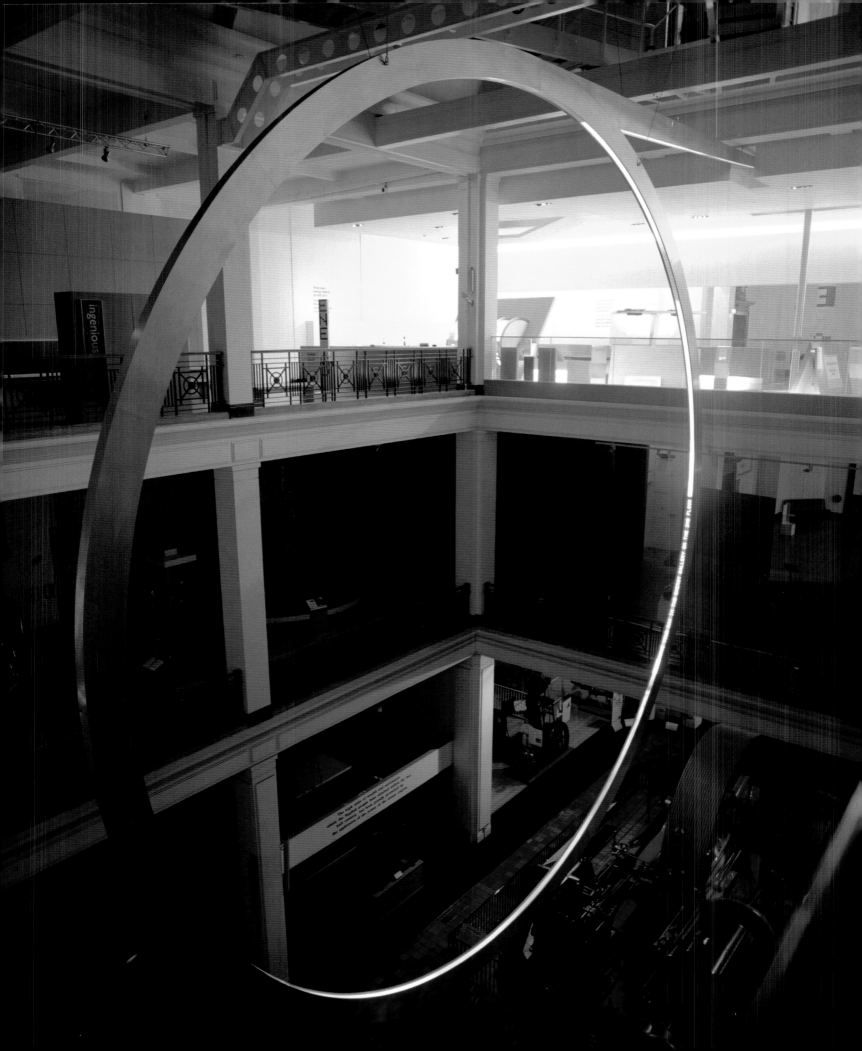

2

Energy Gallery

Science Museum
London
UK
Casson Mann
2004

1. The Energy Ring is both an iconic beacon for the gallery and a platform for visitor feedback.

2. The gallery is a static architectonic box containing a dynamic folded landscape.

3. Gallery graphics are a seamless extension of the folded landscape.

4. The entrance totem randomly emits a split-second flash of brilliant light that ricochets back down the approach stairwell.

The Energy Gallery in the Science Museum, London, aims to engage visitors in the crucial energy issues that face society today and in the near future. With key facts written on its walls to provide a framework for debate, this permanent installation skilfully combines perturbing information with inventive, entertaining and interactive displays to capture the imagination and attention, and to engender critical thinking by visitors of all ages.

The exhibition consists of a colourful landscape of 11 individual works by selected artists: Casson Mann were engaged to draw these together into a coherent whole. They achieved this by first establishing a clear distinction between the two existing wings of the museum and the Energy Gallery itself. The space overlooks the East Hall, through which visitors pass to enter other parts of the building, and is visible from all its levels. It reads as the culmination of a journey through the existing galleries that work around the central void.

The gallery was clearly disengaged from the existing fabric of the museum by raising its floor and lowering its ceiling. Parts of the painted ceiling were then cut into, to house lighting

devices. A similar language of layered surfaces was developed for the floor and display structures. Colourful folded, veneered surfaces made from rubber-faced plywood move between the floor as well as all exhibit supports, projection booths, showcases, tables and chairs. The space is almost like a stage set: colourful and luminous, the coherence of its

3

4

5

detailing draws the diverse artworks together as a whole. At the same time it is robust, and is designed to allow for change over time.

The theme of the gallery is dramatically announced to the rest of the museum by the Energy Ring, the central installation in the hall. Suspended in a three-storey void, it is 13 metres (43 feet) high and comprises a LED screen, 40 metres (131 feet) long, that forms a ring of moving white light. Its image heralds energy as being central to future scientific endeavour.

At a practical level, it acts as an interactive device to gain feedback from visitors. An 'augmented reality' view of the ring on four touch-screen terminals that overlook it from the exhibition area enables them to zap it, causing a small explosion of light to flash around it. The screens also allow visitors to change the patterns of the light and to respond to energy-themed questions. An individual's response may then be displayed on the ring for all to see.

The exhibition is immediately impressive for the way in which artists were engaged to produce installations. Partly as a consequence, the experience of the gallery is one of remarkable variety, clarity and enjoyment.

5. The Do Not Touch installation acts as the central point in the landscape, with all the other pieces placed at a tangent to it.

6–8. The folded landscape incorporates all the individual installations and draws them together to create an integrated space.

Each work engenders a different kind of interaction: movement and play become an integral part of learning.

Making Energy Useful, for example, asks which sources of energy should be used in the future. It consists of four screens with pressure-sensitive floor areas in front of them. Symbols representing different energy sources fall down the screens, and visitors 'catch' the appropriate one by moving their feet. Technologies are matched to the sources by means of a playful interaction, and at the end of an energetic game the performance of each visitor is scored. Movement, rhythm and almost dance-like motion accompany the learning process.

Energy Everywhere conveys the complex nature of energy cycles in the natural environment. Like Making Energy Useful, it draws on the performative, calling for a variety of movements to trigger the projected display. Visitors stand on a pressure-sensitive pad (called an energy square) and clap to make thunder and lightning, wave their arms to create a wind and so release the energy trapped in clouds, or make digging motions to discover the energy trapped below the earth's surface.

Up-to-date graphics, clear accessible language and the theatre of the 'dance' immerse individuals in the theme of the display and also capture the attention of other visitors.

Energy is experienced physically through Do Not Touch. The title of the work incites the opposite reaction, and as visitors touch a steel pole they experience a small electric shock and there is an accompanying sound.

As well as these and other artist-designed installations there are more conventional case-displays, video works and interactive screens.

6

7

8

1

Olympic Rendezvous @ Samsung Electronics

Salt Lake City
USA
Imagination (USA), Inc.
2002

1. Brightly coloured interactive pods created personal phone booth areas in which visitors could use Samsung phone products.

2. Displays were used to house games, products and brand images.

3–4. In each area the main point was for consumers and athletes to enjoy the space and use it as a relaxing and fun space to visit.

5–7. Visitors were invited to use the latest Samsung products to upload pictures, messages and texts, which were then transferred onto the huge LED screens on the exterior. The screens changed constantly and showed results, scores and news headlines.

Samsung electronics, a worldwide partner of the Salt Lake City 2002 Winter Olympic Games, challenged Imagination to bring the brand adage 'Digitall: Everyone's invited' to life. In a sense, what was wanted was a type of consumer pavilion, or brand destination, an immersive environment designed to make an emotive connection with visitors through sounds and visuals. It would be about demonstration, as much as display, and through the experience of the pavilion the brand would be differentiated from its competitors.

The destination for the brand, then, was to be iconic in the field of tented structures in which it would be seen: it was to attract the public and media attention, and at the same time showcase Samsung's innovative technology. Imagination's approach was to make visitors, and what they had to say about the Olympics, the central part of the brand experience.

Olympic Rendezvous @ Samsung was a two-storey, 1160 square metre (12,500 square foot) structure that broadcast, in words and images, stories of people's experiences at the games and what they were experiencing in the pavilion at any given moment. A key feature was the

media screens that formed the entrance façade. There was a ramp underneath these and visitors entered a double-height atrium, the upper part of which was reserved for athletes.

Roving squads with Samsung phones and digital cameras encouraged spectators to share their experiences of the games – what they said, and photographs, were broadcast on the façade. This was structured as an array of curving screens. Their lines echoed the style of the product range, and they showed graphics, images and incorporated the broadcasts.

2

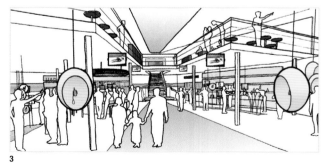

3

4

5

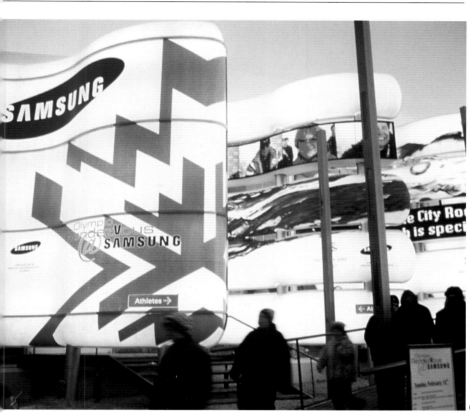

6

7

8

9

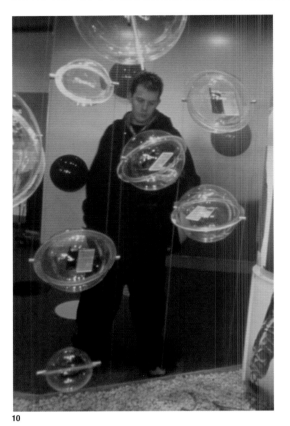

10

8. Visitors played a
virtual snowball game
using the latest
Samsung hand-held
PDA phones.

9. Large graphic
treatments worked with
smaller product displays
to create interactive play
areas.

10. Each transparent
bubble, which appeared
to be floating in mid-air,
held a Samsung product
within it.

11. Coloured bubbles for
children to play with.

11

12

12. Display language reflects other interactive design throughout the space.

13. Organic-looking displays held the latest Samsung products, which visitors could pick up and use.

14. A huge light screen was created so that each visitor could manipulate it and make their mark.

13

The pavilion, its design inspired by the image of a down-filled jacket, was in constant flux, and became a popular centre for athletes and spectators alike – a vehicle for visitors to express their excitement about the games and communicate it to others.

Samsung phones were suspended on cables from the ceiling and visitors could place a phone call to anyone in the world. Elsewhere, they could have virtual snowball fights using Samsung's hand-held PDA phones or use the company's products in casual seating areas or the Internet cafe. Such areas were lined with screens that showed the sporting events.

Where appropriate, displays hung from an oversailing structure, provoking an image of colourful precipitation, or even snowflakes, against the mountainous landscape visible through the pavilion's fabric. Other products meandered across the floor on slender structures. Like an imaginative garden, the falling droplets were transparent, printed or rendered in bright warm colours (and often highlighted). Splashes of orange, yellow and red formed a rich field of display elements. Each element held a jewel-like product, inviting visitors to hold and explore it. These floating displays contrasted with the cooler blues and neutral tones of the background areas and were interwoven with pillars covered with fragments of sports images.

In this inhabited, artificial landscape the Samsung brand, a sense of belonging to place and the spirit of international sport were brought together with impressive coherence as a spatial experience. Moreover, at the core of the pavilion was the active participation of the visitors, who used the product range not just as in a demonstration, but also, almost inadvertently, to express their personal experience of the games. The product and the pavilion effortlessly demonstrated how the Samsung brand facilitates communication and, because images of this communication were displayed on the façade of the pavilion and its interior was awash with both athletes and spectators, how inclusive this is. This was an experience that primarily demonstrated 'belonging', but also showed how the brand's innovation and openness can contribute to the lives of all kinds of people.

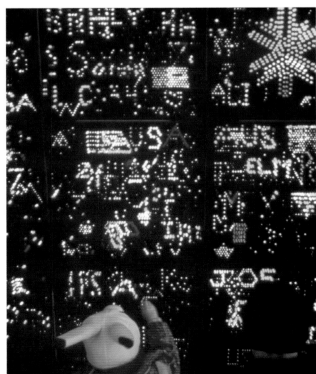

14

1

Les Immatériaux

Pompidou Centre
Paris
France
Jean-François Lyotard and Thierry Chaput
1985

1–2. A wide range of subject matter – from painting to interactive installations – was used to explore the diverse inquiry into new materials, simulated experience and virtual reality.

In 1985 the French philosopher Jean-François Lyotard, with Thierry Chaput, director of the Centre de Création Industrielle, curated a temporary exhibition for the Pompidou Centre, Paris, that would have lasting significance: *Les Immatériaux*, or *Immaterials*, was philosophically driven, an orchestration of ephemeral experiences, rather than a traditional display of objects. The intention was to provoke questions around a specific philosophical investigation concerning the nature of post-Modern culture.

Les Immatériaux concerned the relationship between human beings and the material world. Lyotard saw this as being fixed by a post-Enlightenment view that looked to overcome nature: 'A free will imposes its own aims on given elements by diverting them from their natural course. These aims are determined by means of the language which enables the will to articulate what is possibly [a project] and to impose it on what is real [matter].' Lyotard stated that the aim of the exhibition was to provoke a questioning of the shift in this relationship as a result of the prevalence of new materials.[1]

Implicit in his approach to materials is the assumption that technology in contemporary society, and in particular the way in which it is embodied in new materials, is a means of gaining total control over nature. With such control, Lyotard argues, there also comes a loss of identity for human beings – implied in the very substance of these new materials, which he terms 'immaterials'. Immaterials reveal within themselves a dissolution which is comparable to man's. In this vein, the exhibition attempted to represent a philosophical position in relation to contemporary life in the context of technological advancement.

Lyotard described the aim of the exhibition as being 'to arouse the visitor's reflection and his anxiety about the post-Modern condition' and, accordingly, he proposed that in its scenography *Les Immatériaux* should distantly echo a 'wise melancholy'.

The exhibition occupied the fifth floor of the Pompidou Centre, with its entrance foyer on the fourth-floor mezzanine. The display apparatus included a large number of radio transmitters, each covering a carefully limited zone and each broadcasting a particular soundtrack. Visitors

2

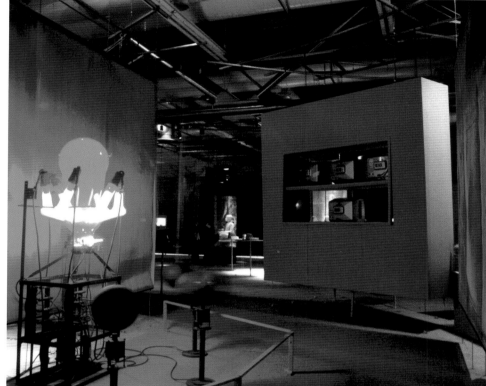

wore headphones: musical messages, poems, prose, exclamations and quotations were transmitted as 'arts of the time' and the most immaterial forms of communication.

A broad range of topics was selected to form specific domains within the structure of the exhibition, from foodstuffs and painting to astrophysics and industry. These domains were grouped together according to the themes they illustrated. For example, one of them looked at literary networks, and a computer-writing experiment was designed to question the way in which computers dematerialize the handmade mark and potentially subvert the identity of authorship. Other early performative space experiments included *Sound=Space* by Rolf Gehlhaar, in which interactive physical space was subverted and sound was manipulated with nothing in the room being touched.

Between such installations were less defined areas, or 'desert' in Lyotard's terms, where the visitor became an investigator: 'An individual itinerary might be recorded,' Lyotard stated, 'on a magnetic memory card, and given him in the form of a printout when he leaves.'[2]

3–4. General views showing the relationship between the exhibition installation and Pompidou interior. The 'desert areas' between individual displays were places where visitors could record individual journeys.

5. The darkened environment and headset acoustics heightened private experience and engagement with 'immaterial environments'.

3 SIMULATED EXPERIENCE

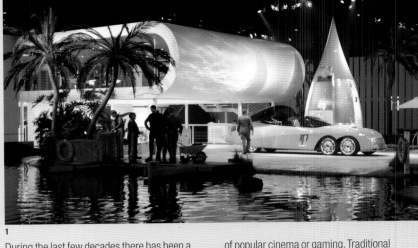

1

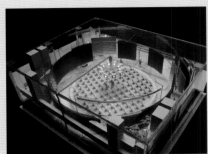

2

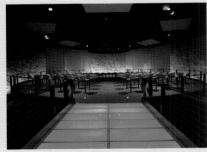

3

1. For Thunderbirds Powered by Ford, at the Ford Motor Company stand at the 2004 Birmingham (UK) Motorshow, Imagination recreated Tracy Island – the Thunderbirds International Rescue base – complete with a deep blue lagoon and a beach made from five tonnes of sand.

2–4. Environment Theatre, National Museum of Natural Science, Taipei, Taiwan, by MET Studio Design. The theatre illustrates the way in which museums are reaching new audiences by creating an emotional event.

During the last few decades there has been a proliferation of computers for public use in museums and galleries. Sometimes these provide user-friendly online catalogues, educational facilities that supplement the information on show, and indeed that extend the exhibition to a vast audience via the Internet. More recently, however, there has been an emphasis on using digital technology to enhance the learning experience and to complement the display of real objects. Simulated environments, reconstructions, and experiences of virtual reality are ever-more part of contemporary exhibitions that look for fresh ways to communicate.

In some ways illusionistic displays in a museum are nothing new, merely a natural progression of a long tradition that includes the nineteenth-century diorama and *camera obscura*. These entertaining and popular optical experiments presented a substitute reality to the audience with nothing more than paint, lens and light. In contrast today's museum experience demands increasingly sophisticated equipment to create immersive, multi-media experiences that can bring museum learning into the realm of popular cinema or gaming. Traditional museum experience is progressively transformed into an emotional event, as the museums reach out to a new audience through the familiar language of music events and film.

The recently completed Environment Theatre designed by MET Studio Design for the National Museum of Natural Science in Taiwan illustrates the ways in which contemporary museums explore cross-over technologies of this kind. Visitors enter the darkened space via a narrow glass bridge, before taking their seats in a circular 150-seat revolving platform. Surrounded by a complex array of a 5-metre (16½-foot) high cyclorama, they experience one of three dynamic multi-media shows on the rhythms of the natural world. Mechanical screens circulate and are dropped down to create multi-layered images, which simulate the real experience of a journey through the museum, as one memory builds over the next. More than 3000 images are displayed using 88 slide projectors, 12 video projects, a laser graphics system and more than 100 theatre lights. The audience is bathed in anything from the colours of sunset to giant-size leopard print.

4

5

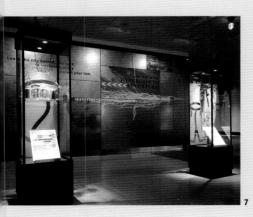

7

5–7. An Underground
Adventure, The Field
Museum, Chicago, by
MET Studio Design.
Visitors are 'shrunk' in
an Ames Room and then
taken into a simulated
underground
environment.

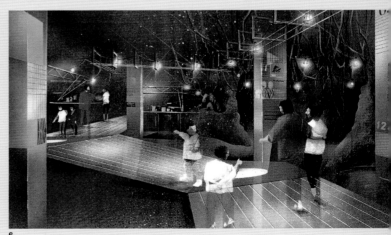

6

8

9

8. *Beyond Pages*,
installation by Masaki
Fujihata at ZKM Centre
for Art and Media
Technology, Karlsruhe,
Germany, 1995. The
installation featured a
table, lamp and chair in
an interactive, semi-
darkened room.

9–10. *Interactive Plant
Growing*, installation by
Laurent Mignonneau
and Christa Sommerer
at ZKM Centre,
Karlsruhe, 1993. Plants
were placed on
pedestals in front of a
large projection screen.
When touched, the
plants sent an impulse
to a computer that
generated simulated
growth patterns on the
projected image.

11–13. *Memory Theatre
VR*, by Agnes Hegedus,
ZKM Centre, Karlsruhe,
1997. Virtual and real
environments were
combined with historical
references in a rotunda
space.

10

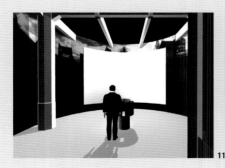

11

12

13

14

Here, the simulated environment takes advantage of the effects of film and the imagery of popular culture, blurring the interface between the museum interior and the language of the leisure industry.

Today's museum experience is benefitting from experimentation in the field of computer simulation. There are two relevant and interrelated fields, Virtual Reality (VR) and Augmented Reality (AR). VR attempts to give the user a sense of a spatial experience (visual, auditory and tactile) in computer-generated environments. In order to experience these the user must wear a headset (although lately these cumbersome devices are being replaced by projection-based displays). Though they adopt the familiar character of games, these VR experiences have the advantage that the user can explore a topic actively, and take an individual set of decisions to make a unique experience. There is increasing interest in adopting real-time game codes in such simulations to make use of familiar and tested software that is accessible via the Internet.

Augmented Reality, on the other hand, superimposes computer-generated graphics

14. In *Legible City*, **by Jeffrey Shaw at ZKM Centre, Karlsruhe, 1988–91, a bicycle was mounted in front of a projection of simulated urban environments.**

15 Environment, Landscape, Climate Themepark, Expo 2000, Hanover, Germany. For this exhibition Atelier Brückner created several simulated 'landscapes'. The Forest Zone, shown here, incorporates innovative woodwork 'trees' and video screens.

onto the user's view of the real world. It is a complex technique that allows real and virtual objects to appear in the same visual field. Like VR, one of the methods of viewing AR is through head-mounted devices, although recent research has led to the development of a 'virtual showcase'. This is a display element designed to be able to substitute a conventional cabinet. It is a half-mirrored, conical chamber fitted with digital projectors and lighting into which the real objects are placed. Standing outside of the showcase, and wearing special glasses, the visitor's perception of real and projected information fuses into a layered, three-dimensional illusion. The technique has been recently developed to enhance experience of architectural ruins, and in the field of palaeontology. Here, fossils, for example, are first scanned in three-dimensions and reconstructed in the conventional manner. The computer then combines this various information, real, hypothetical and simulated, to produce a collage-like three-dimensional image of striking 'realism'. Using a technique called live video-mixing, a similar AR technique can be used to study processes of movement.

These techniques are increasingly part of exhibition experience and, despite resistance from traditional museum culture, they offer a real opportunity to engage with a new audience and communicate in a way that is inclusive and far-reaching. The future use of simulated realities will not be determined by technical limitations, rather it will depend on their creative distribution among real artefacts and the exhibition as a whole. Only with a thorough integration will this new audience understand the interdependence of the simulated and real worlds, and the worth of actual experience in an increasingly artificial lifestyle.

In a sense, this creative integration of artefact with virtual reality and interactive software has already been achieved in the groundbreaking series of projects for Samsung by the design company Imagination. Their latest project in particular – the Samsung Experience, New York (see page 90) – brings together real experience and web interaction, via a specially developed site, the Cyber Brand Showcase. The brand centre expresses this contemporary experience as an essential ingredient in both New York lifestyle and the Samsung brand character.

15

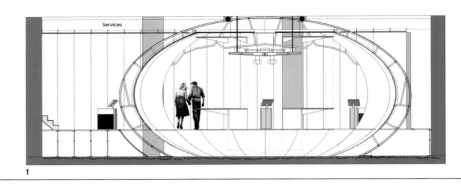

1

Theatre for Lucent Centre of Excellence

Nuremberg
Germany
MET Studio Design
2001

A permanent installation for the international telecommunications company Lucent Technologies, this theatre is the focal point of its Centre of Excellence in Nuremberg. The immersive environment, created by MET Studio Design, crosses boundaries between exhibition design, brand experience, product design and theatre: although the intention of the venture was to sell Lucent's business-to-business

1. Section showing the double-skin structure of the theatre within the Machine Domain.

2–3. Exterior of the theatre space with the various plasma screens set into the skin.

4. Overall model view of the Machine Domain from above.

'briefing' expertise and vision to a global client base, the dramatic setting is without obvious parallels in either retail or brand environments.

One of the reasons for the radical nature of the project is MET Studio's approach to its design from the outset. They stressed that Lucent's message should be about communication rather than products – and that the focus should be to create an experience that stimulates imaginative enquiry into this theme as much as to explain the company's complex technologies. It was a notable departure from conventional approaches to the display and communication of a brand portfolio.

Visitors are met at the main entrance to the building and taken through a secondary foyer, along a glass corridor, to an elevator, where their journey – physical and metaphorical – begins. As the elevator door closes ambient lighting fades and a pulsating lighting effect is set against a soundtrack of a cacophony of communication noises, ranging from television and radio soundbytes to digital information being transmitted. A discreet LED indicator in the elevator suggests an arrival point at level minus 50 – as though the descent had been to

the deepest of basements, to the very core of the machine world.

When visitors leave the elevator the hum of the soundtrack merges with a white-noise ambient sound in the theatre area (which also masks the sound made by cooling fans and other services). They then enter the Machine Domain, an animated, dark and dynamic space full of whirring lights and racks of equipment, designed to communicate the high-integrity, high-capacity, high-speed networks that are the company's hallmark. A number of interactive consoles are placed around the space to facilitate individual enquiry.

At the heart of the space sits the theatre – a white, oblate sphere, 9 metres (29 ½ feet) in diameter and lit in red from below by a glazed apron surrounding the base. On its exterior, plasma screens are set into a structural web in the depth of its skin. In the low light it looks as though they are linked by strings of blue lights. This translucent screen-wall is a brand image for Lucent's optical networks.

The experience of entering the blue-lit interior of the theatre is orchestrated with lights and projected images: visitors walk over a glass floor

2

3

4

onto one covered with projections of a star field. The character of the sequence is decidedly space age. Mirrored projections are carefully adjusted so that the stars seem to continue beyond the boundaries of the enclosure (which, as a result, appears to float).

Inside the theatre 20 high-backed seats, on a dark carpeted floor with a glass outer ring (initially also dark), face back towards the entrance. The interior is in the form of a hemispherical 'spitz' projection screen. Before the show begins the door to the theatre closes to complete the sphere. Simultaneously, the lighting changes with the blue wash fading out and concealed lights below the floor fading in to illuminate the inner face of the sphere.

The floor revolves, and as it nears the end of its 180-degree rotation the prologue show fades out and two large movable segments of the sphere part and slide back into open positions. Simultaneously, three projection screens drop from the ceiling space and, clicking into position as the sliding sections come to rest, signal the beginning of the main display.

5–8. Internal and external transformations occur, as lighting and projections alter perceptions of space and experience.

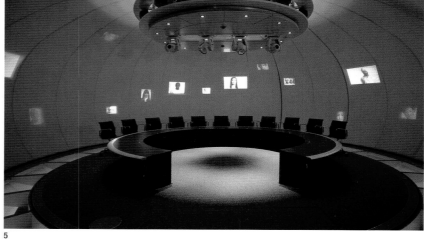

5

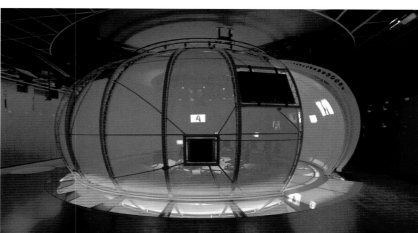

6

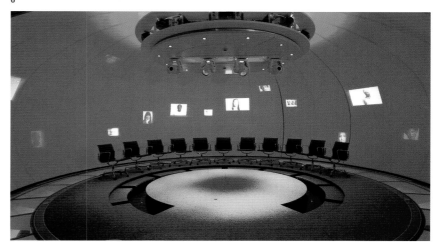

7

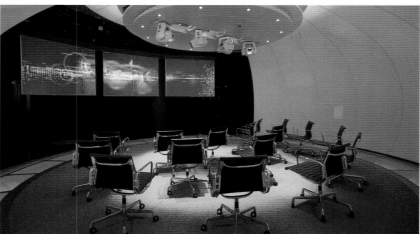

8

1

Wired Worlds

National Museum of Photography,
Film and Television
Bradford
UK
MET Studio Design
2000

1. Display panel detail.

2. Plan showing the placement of installations, which interrupt the exhibition space and create an ambiguously defined spatial sequence.

3 *Another Time, Another Space* **by Japanese digital artist Toshi Iwai.**

Wired Worlds is the first gallery in the United Kingdom to be dedicated to digital media. It was designed by MET Studio Design in close collaboration with the design team at the National Museum of Photography, Film and Television in Bradford.

The content of this permanent exhibition concerns digital technology and its impact on all aspects of everyday life. It is not about hardware, and it was important that the designers avoided an elaborate display of this. Rather, the message was to be more socially based, within an entertaining and immersive environment that would engage visitors in questions about the ongoing impact of rapidly changing technologies on social perceptions, behaviour and communication. It was to appeal to all ages, to those who are informed as well as to people who feel anxious about today's digital technology.

The display environment has been kept dark, and illuminated exhibits seem to float off indefinite boundaries. Where possible panels are transparent, and the exhibits themselves are reduced to reveal structure, wiring and circuitry, demystifying how they work. The whole

environment plays down its structures in order to reflect the intangibility of digital concepts.

The exhibition is particularly interesting in the way it integrates artworks into its didactic structure. All exhibits, including these, are interactive by their nature, but the creative contributions of media artists give a dimension of engagement that goes beyond the usual collective gaming approach. Here there is a real sense of physical interaction with the creativity that is facilitated by digital technology. In this way, the spirit of the exhibition opens up the field of technology to audiences in a positive, refreshing way.

One artwork, *Another Time, Another Space* by the Japanese digital artist Toshi Iwai, illustrates how computers process information. It takes the form of an angled steel framework with eight monitors, and cameras spaced between the monitors. The cameras capture images of visitors milling around in the space, and process them instantly, by different means, so that distorted images are replayed on all eight screens simultaneously. A serious didactic message is thereby conveyed, with all the joy and laughter of a Victorian hall of mirrors.

2

3

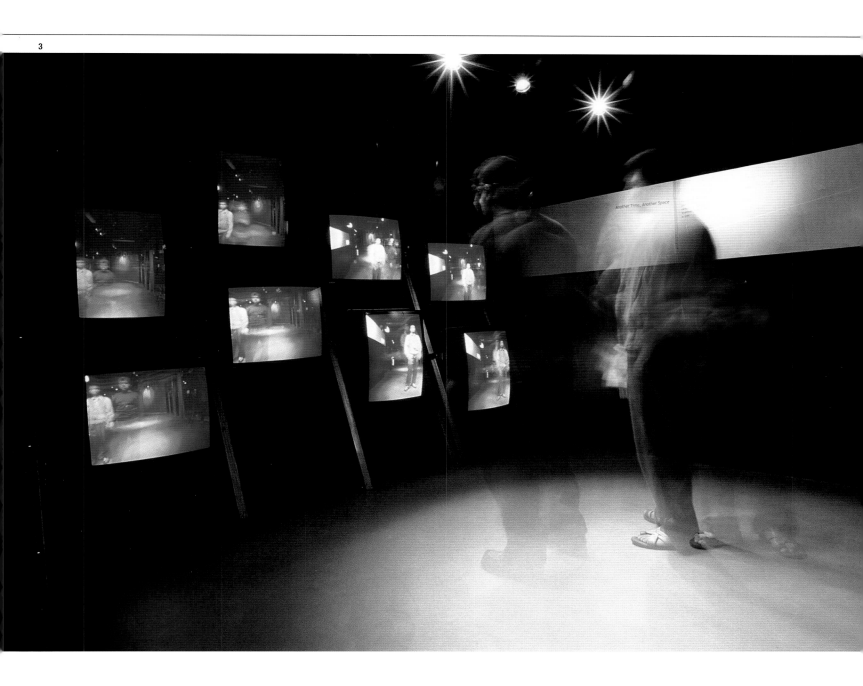

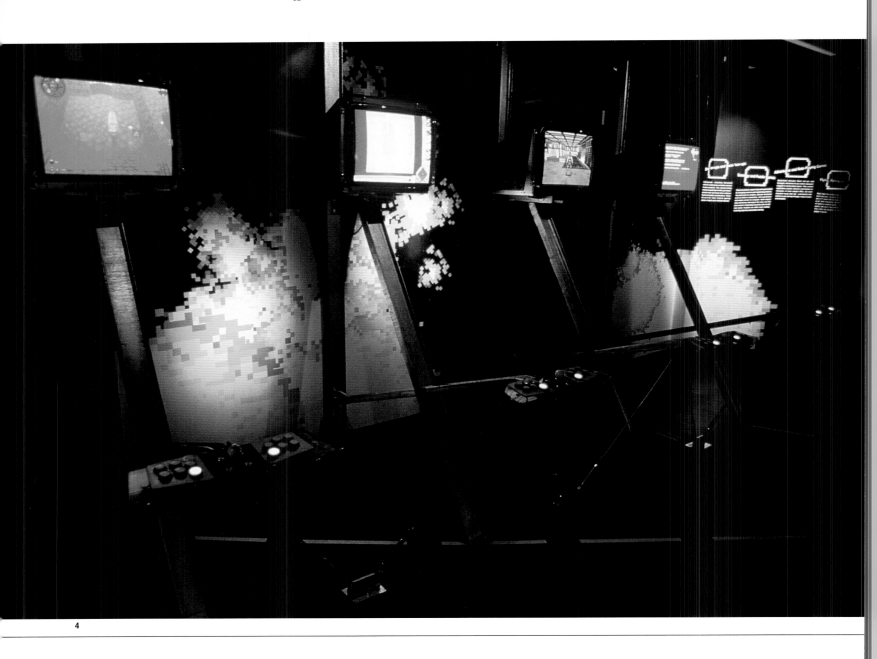

4

5

6

Another popular artwork is *Telematic Dreaming* by the Berlin-based British artist Paul Sermon. It examines bodily presence and absence in today's video-conferencing techniques. Two beds are connected by a live, two-way digital link. The images of real people on one bed appear on the second, separated by space and screens. Pre-recorded information is mixed into the imagery to add to the dream-like quality of the piece.

These and other exhibits absorb and entertain visitors, drawing them into the deeper implications of digital technologies and enabling them to learn through personal, playful engagement. Many are integrally entertaining and the gallery cannot be entered without hearing laughter at the distorted images made possible by the interactive pieces.

There is a fluidity to this intriguing, transparent space as the technologies are constantly referred back to the realities and experiences of people's lives. It is an archipelago of dramatic, light-filled exhibits that invites enquiry into the extraordinary world of digital media.

4. Robust interactive display design can withstand heavy use.

5. A sketch exploring the scale and placement of installation elements.

6. Exposing wiring and circuitry demystifies the digital imagery.

7–8. *Telematic Dreaming,* by Berlin-based British artist Paul Sermon, is one of the gallery's most popular interactive experiences.

7

8

1

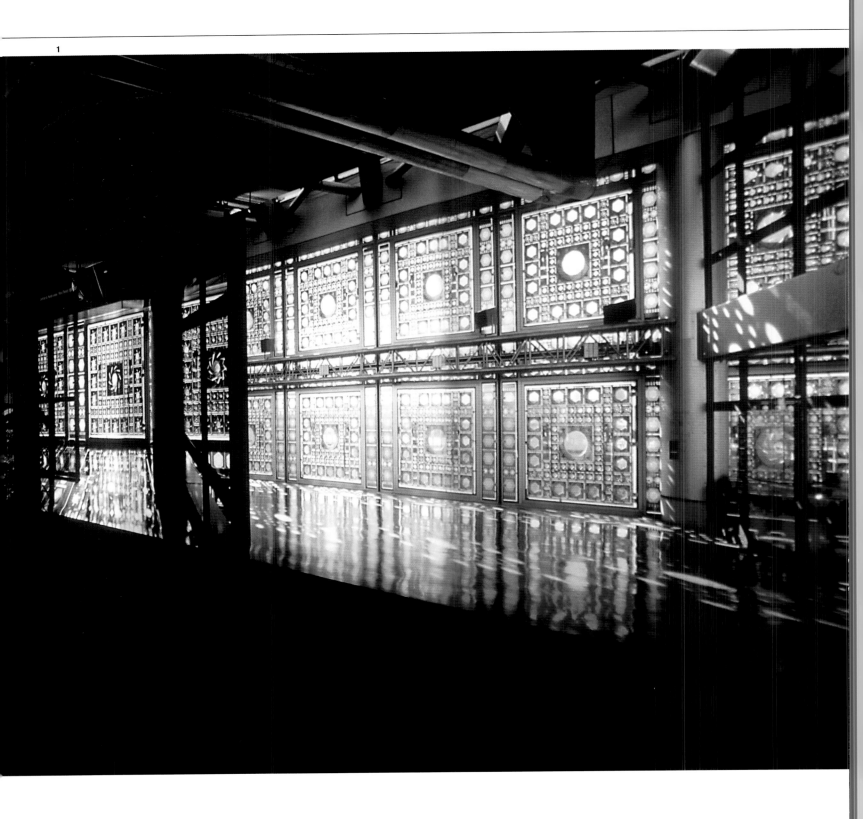

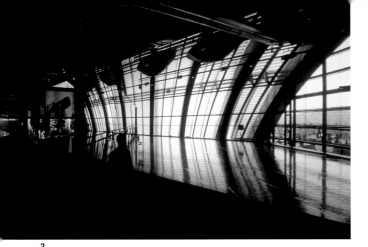

Jean Nouvel
Pompidou Centre
Paris
France
Jean Nouvel
6 December 2001 – 4 March 2002

1. The museum interior was transformed into a vast image of Nouvel's Institut du Monde Arabe.

2. The scale of the projected architecture challenges the exposed structure of the Pompidou interior.

3. The scale of the projection blurs boundaries between real and projected images.

This major retrospective of Jean Nouvel's architectural output followed a remarkable year during which he won the Royal Institute of British Architect's gold medal, the Praemium Imperiale, awarded in Tokyo, and the Borromini Prize, awarded in Rome. Installed on Level +6 of the Pompidou Centre, and designed by Nouvel himself, it was heralded internationally for its innovative approach to the display of contemporary architecture.

The exhibition was essentially created around an image system in place of any didactic narrative. Rather than displaying conventional combinations of architectural drawings, models and photographic or projected images, it was an immersive experience made up solely of still and moving images at a variety of scales. It translated the tendency towards transparency and dematerialization of surface that pervades Nouvel's architecture into a landscape of projected and light-filled imagery, quite different to the tactility that accompanies traditional architectural exhibitions.

Visitors were immersed in a darkened environment (an initial move that has certain advantages for display in the context of the Pompidou) and engaged in a journey through rooms of images that were divided into a number of broad thematic sequences. The first room, for example, with a blackened floor and walls, was, interestingly, entitled The Essence of Materiality and was made out of huge banks of small, slide projections with larger ones at the higher level.

A sequence of rooms was devoted to displays of computer imagery – Nouvel's work has been entirely designed on computer since his project for the Cultural and Conference Centre in Lucerne, Switzerland (1990–2001). A further sequence offered a virtual visit, via photographic reportage by Georges Fessy, to 11 emblematic buildings, from the Institut du Monde Arabe, Paris (1981–87) to the conversion of a gasometer in Vienna, Austria (1994–2001), and from the Nemausis housing project in Nîmes, France (1985–87) to the Cultural and Conference Centre in Lucerne. The reportage recorded the current state of the buildings; these were projected almost life-size and visitors confronted constructed space.

The exhibition was divided into two, and urban projects – certain phases of the Seine-

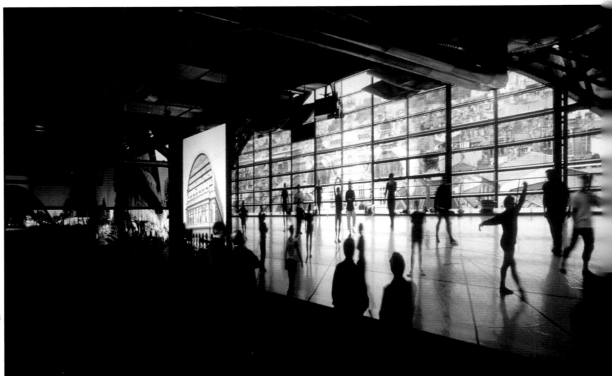

4, 5 & 7. Wall projections combined a variety of documentary information, images of inhabited space and text.

6. The juxtaposition of the position, scale and format of the images generated a variety of interactions with viewers, encouraging them to move around the space.

Rive Gauche in the Austerlitz-Salpêtrière district of Paris (1993), and the Stade de France in Saint-Denis (1994) – were animated by Alain Fleisher in a narrow, spine-like passage that linked the two halves. Architectural Office, a reconstruction of Nouvel's studio, was the only illuminated room in the exhibition. Here 18 monitors, arranged on three tables, allowed visitors to consult the archives, dossiers and databanks of the office.

4

5

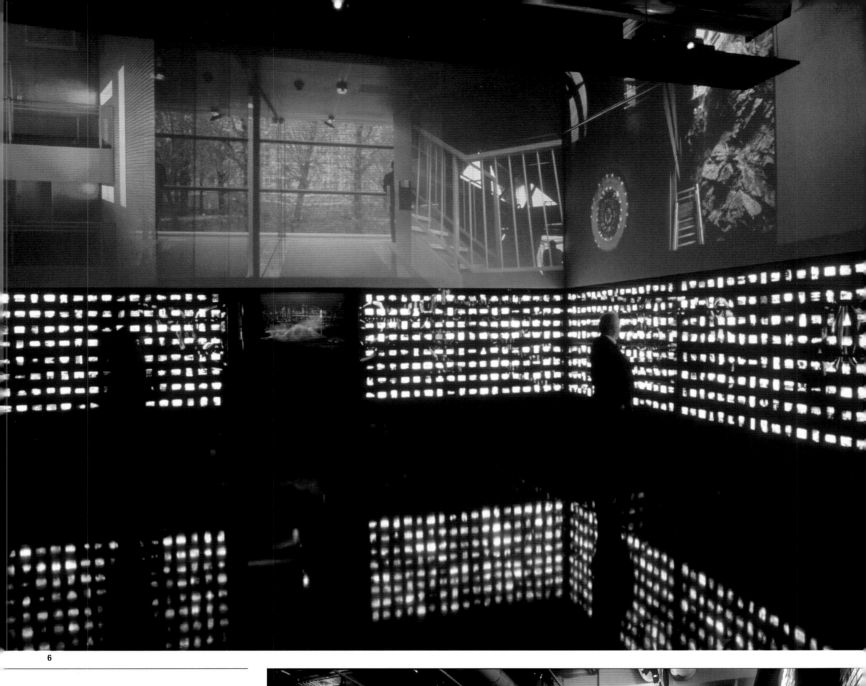

6

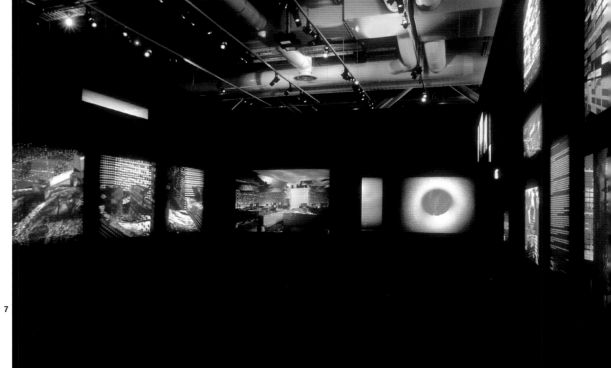

7

1

The Weather Project

Tate Modern
London
UK
Olafur Eliasson
16 October – 21 March 2004

1. Overall view of the Turbine Hall from the entrance ramp.

2, 5. The installation viewed from the ground level of the Turbine Hall.

3–4. Views up to the reflective ceiling. The performative effect of the installation was to generate a new piazza-like public space where people engaged in a variety of activities. Some gathered in groups and looked for their reflections in the mirrored soffit, others sought solitude.

Gallery or museum space is increasingly treated as a virtual extension of the artist's studio, the traditional locus of creative activity. The physical conditions of a given space provide the impetus for contemporary artistic enquiry – none more provocatively so, perhaps, than the Turbine Hall at Tate Modern, the scale and sheer emptiness of which holds a certain latent meaning, situated as it is at the heart of Britain's leading museum of contemporary art.

The Weather Project by Olafur Eliasson was not exhibition design in a traditional sense. Rather, the artist's role was extended into the realm of curator and designer to become the sole generator of the experience of the show. The displayed and its environment were no longer distinct, but merged seamlessly into a kind of live-in artwork.

Of the many examples of artists' installations, this one is particularly intriguing, not simply because of the extraordinary optical illusion that formed it, but rather because of the effect this visual impression had on visitors. It transformed the Turbine Hall into a piazza-like public space, where a whole range of sounds, movements, gestures and playful activity contrasted with

the usual restrained behaviour in the typical London streetscape.

The Weather Project was the fourth in the Unilever series of commissions for the hall. Eliasson's stated intention was to take the subject of the weather as the basis for exploring ideas about 'experience, mediation and representation'. At one end of the hall he fixed a vast, semicircular disc made up of hundreds of monofrequency lamps – yellow and black were the only colours visible. This form was reflected upwards in hundreds of small mirrors that were hung from the ceiling to give the impression of an entire sphere of extraordinary luminosity. Each mirror was offset fractionally so that the upper edges of the form appeared blurred, tricking the eye into thinking that the effect was related to the light or to heat but, either way, reinforcing the illusion of the elemental sphere that was the experience of the installation.

The boundary between real and fictive space was further eroded by means of a fine mist that permeated the space – it seemed to be seeping in from the nearby River Thames. As visitors paused in this dream-like landscape relaxed conversations began, people wandered through

2

the space, sat or lay down on the floor, with friends or alone. In part these movements were a playful response to the mirrored ceiling: individuals searched for their own reflections, groups co-ordinated movements for effect.

The simulation transformed the empty hall into a busy space full of people, performative in the sense that through movement visitors were able to find out more about the work in a way that recalls the wonder and charm that accompanied traditional magic and trickery – for which the mirror was also the touchstone.

3

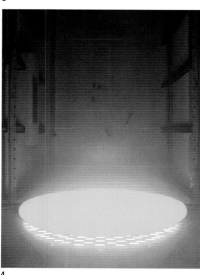

4

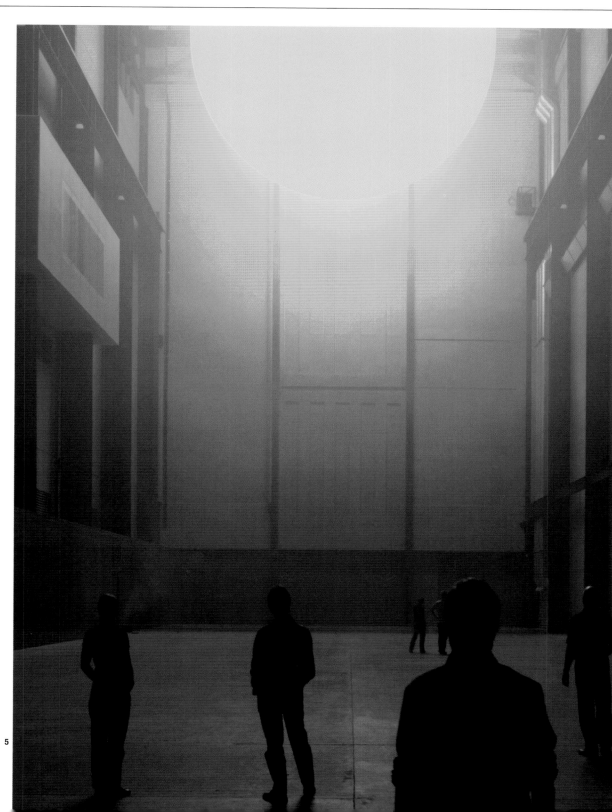

5

1

The Samsung Experience
Time Warner Center
New York
USA
Imagination (USA), Inc.
2004

1. Cross-section through the Samsung Experience.

2. The Welcome Experience is a semi-permanent interactive installation made up of rotating LCD screens. The exhibit will change regularly to reflect themes relevant to Samsung's consumers and showcase rising creative talent.

3–4. Imagination drew rough renderings to explore the ways in which to set out the product viewing areas as well as the Welcome Experience.

The Samsung Experience is a permanent venue on the third floor of the Time Warner Center, New York. Designed by Imagination to communicate how the Samsung brand is integral to a new urban, digital lifestyle, it is a so-called 'unstore' – an environment where customers are 'engaged with' rather than 'sold to'. They are invited to relax and learn how the latest devices can enrich their lives without being pressurized in a sales environment.

The extent to which the company is embedded in New York is first communicated through the Orientation Table, an interactive map in the public foyer outside the main space. Visitors can use this map to find places and activities that typify New York's boroughs, and to view film clips that introduce them to digital living in the city.

The Samsung Experience is straightforwardly planned: interactive devices and displays are arranged orthogonally as a sequence of elements from the front to the back of the 930-square-metre (10,000-square-foot) space. The first of these is the Welcome Experience, an interactive installation made up of rotating LCD screens. This changes every three months to reflect New York-related themes and showcase topical personalities. On either side of it, the city's 'digital' lifestyle is further reinforced in Access Bars. Here visitors have the opportunity to create personalized postcards of New York City and are greeted by Samsung staff.

Further towards the rear there are enticing displays of Samsung products, arranged in the contexts of work, home and play. These interactive areas provide a number of options for visitors who want to try out the devices. They can work out for themselves how to use them, get help from a Samsung expert or follow a series of Scenario cards that tell them what to do.

The Cyber Brand Showcase adds a unique 'virtual realm' to the Samsung Experience. This participatory website allows real-time visitor information to be exchanged between physical space and online space via cyber conduits – lights that change colour depending on online activity.

A further innovation will allow visitors to use a hard-disk-based camcorder to shoot videos around New York City. They will then be able to edit the footage in kiosks inside the Samsung

2

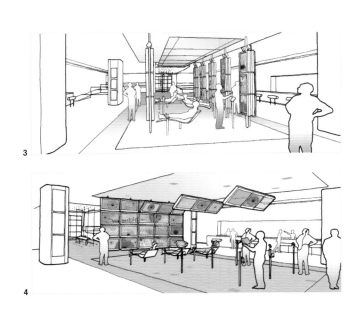

3

4

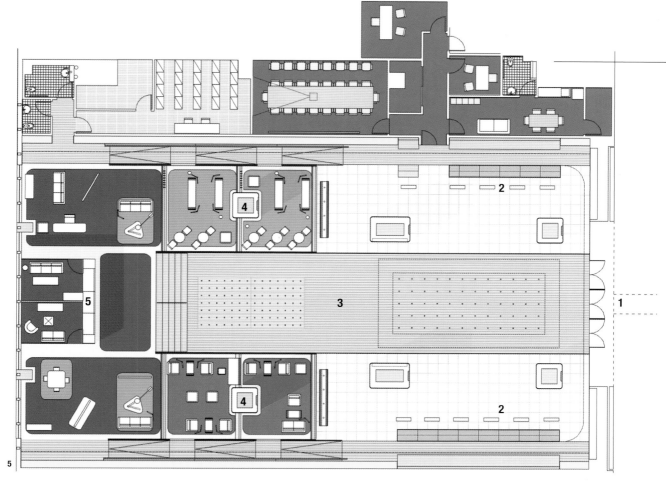

5. Floor plan.
1. Entrance, 2. Access
Bar, 3. Welcome
Experience,
4. Interactive Stations,
5. Main Stage

6.
The Access Bar allows
visitors to record
memories of their New
York 'digital living
experience', creating
personalized postcards
using artwork
showcased on the
Orientation Table.

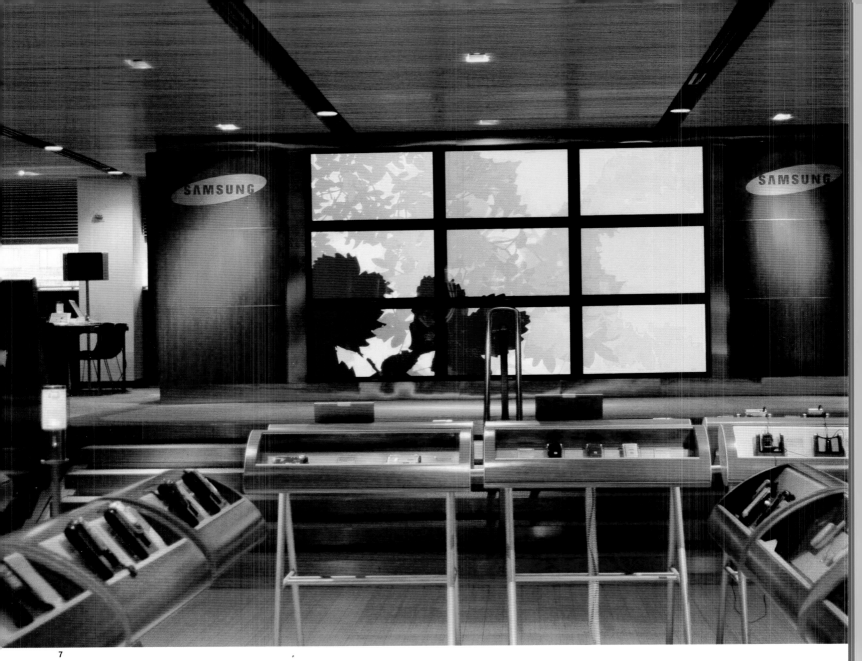

7

8

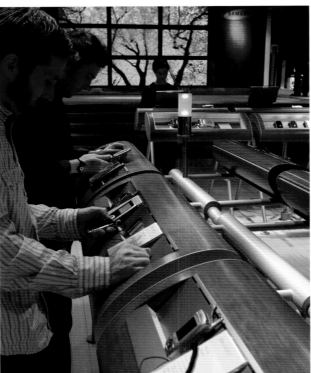

9

7. Large video walls
displaying emotive,
high-definition motion
graphics bring an
element of nature
into the Samsung
Experience.

8. The Orientation Table
houses a map of New
York, allowing visitors to
explore the city digitally.
Using hand movements
visitors can move
around the map and see
how people live digitally
in New York in three
original films.

9. Visitors are
encouraged to try out
Samsung products at
the interactive stations.

Experience, burn their films onto DVDs and return home with a digital souvenir. Visitors will also be able to use Samsung Napster MP3 players to download songs from Napster to compact discs, and ring-tones to their mobile phones.

10–11. The main stage places products in various interconnective, real-life scenarios. Visitors can engage in hands-on product encounters, experiencing digital living as a seamless immersion encompassing 'work, home and play'.

10

11

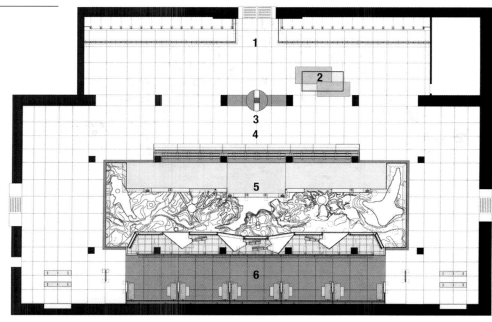

1

Hall of Biodiversity

American Museum of Natural History
New York
USA
Ralph Appelbaum Associates
1998

The Hall of Biodiversity in New York's Museum of Natural History communicates the richness of biodiversity and also tells the story of extinction. It provides a 'call to action' to prevent further loss of species and increased habitat degradation, and its target visitors vary from the general public to students and scientists.

In the limited space available for the hall, off the museum's Roosevelt Rotunda, Ralph Appelbaum Associates compressed its complex theme into two ambitious display elements: the Rainforest, a replica Central African Republic environment in the centre of the hall; and, to one side, the Spectrum of Life, an extraordinary glass wall of light, 30 metres (100 feet) long, that shows plant and animal species. Other sections are the Habitats Wall; and the Resource Center, an interactive area where visitors can learn about ecological efforts.

1. To create the leafy rainforest environment, the museum enlisted a large group of volunteers and museum preparators.

2. Floor plan of the 1,022 square metre (11,000 square foot) exhibition space. 1. Spectrum of Life, 2. Endangered Species, 3. Crisis Zone, 4. Habitats Wall, 5. Rainforest, 6. Resource Center

3. The Spectrum of Life (right) displays more than 1,000 individual specimens. Opposite this is the Endangered Species case.

The Rainforest develops the museum's tradition of dioramas. It is a remarkably painstaking and detailed creation, with latex moulds of intricate leaves made from real flora, a wildlife soundtrack and replicas of nearly two dozen species of trees. Hidden projectors cast high-resolution images onto screens behind the trees, and sounds, smells and videos combine to create an enveloping illusion of real depth and fictive space, where animals appear to move.

The challenge in lighting the Rainforest was to recreate accurately a 'dawn' light filtering through tree canopies, while simultaneously ensuring that specimens are visible. Light-pipes were used to achieve a diffuse daylight effect, and custom pipe-fittings with silica lenses, fibre optics and focusable mirrors converted a single light-source to multiple endpoints. These were interwoven with branches to aim light at specimens. An air-handling system transmits the smells of flora and fauna.

The Habitats Wall — with a video and graphic display 18 metres (60 feet) long — surveys the earth's nine major habitats and underscores what is threatening them. Visitors experience the transformation of the Rainforest from a pristine state, to one altered by natural forces, to one degraded by human intervention.

In contrast, the Spectrum of Life is full of light and explicit display. The glass wall displays more than 1,000 specimens that vary in visual texture from glass models to examples of taxidermy. Innovative light-pipes, 30 metres (100 feet) long, provide a back-lit illuminated field against which all life is viewed and, by disbursing any unwanted spills, allow for the dynamic front-lighting of specimens. These are mounted like rare jewels on projecting armatures, and are generally unshielded by glass to give a sense of 'access'. Ten interactive computer stations enable visitors to learn about the ecological services the specimens displayed on the Spectrum of Life provide for humanity.

The Resource Center, located off the main traffic flow, provides a place for visitors to study the causes of mass extinction. Brightly lit text, photographic images and diagrams can be directly examined. On either side of this a Transformation Wall documents the threats to life's diversity; and a Solutions Wall explains how individuals and organizations are working together to stop species and habitat loss.

2

3

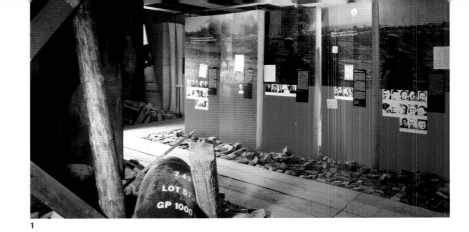

1

Stuttgart in the Second World War

Stuttgart
Germany
hg merz architekten
1988–1989

1. Recreation of the aftermath of an air raid.

2. Map of concentration camps.

3. Reconstructions evoked the chaotic wartime landscape.

4. Recreation of a demolished room after an air raid.

5. Display on civil air defense.

Stuttgart in the Second World War was a temporary exhibition that told the story of the city before and after it was destroyed in the war. It was installed in two adjacent buildings connected by a temporary 'tunnel' designed to look like an air-raid shelter. The strength of the exhibition's structure lay in the clarity of the dialogue between the buildings, which was set up by a distinct time frame that contrasted the structured life of the city before the war with the chaotic landscape that followed its destruction.

The relative lack of historical artefacts meant that a great deal of information was in the form of texts and photographic images. These were complemented by objects, films, interviews with contemporary witnesses and other audio material. Similar dialogues were explored further in the detailed design of the display environment. For example, the historical events were portrayed by juxtaposing images that reflected the everyday lives of individual inhabitants of Stuttgart with ones that depicted how the city as a whole was transformed: artefacts that belonged to the scale of the individual were complemented by audio tracks featuring the voices of Hitler or Goebbels, or by

air-raid sirens that echoed the context that underpinned the exhibited objects.

Given that there were few actual artefacts, the exhibition was particularly skilful in using partial reconstructions to simulate fragmentary settings. Real artefacts were combined with texts, photographs, material surface, colour and texture to create an environment that provoked imaginative engagement with the themes in play. This use of a more abstract language of reference was illustrated by the simple wooden boxes that structured the exhibition, and which served, in the architect's interpretation, as metaphors for transport and death. Almost empty, their bare wooden walls were intended as spaces of the imagination – still areas, away from the flow of images and objects.

Although the aim of the exhibition was to engage visitors' emotions, the approach was not to reproduce wartime Stuttgart in simulated space. Rather, the strength of the design lay in the distance from the actual experience, the abstraction of the representation and the way in which, as a result, the display was open to imaginative interpretation.

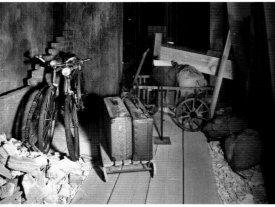

2

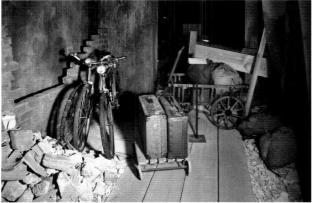

3

4

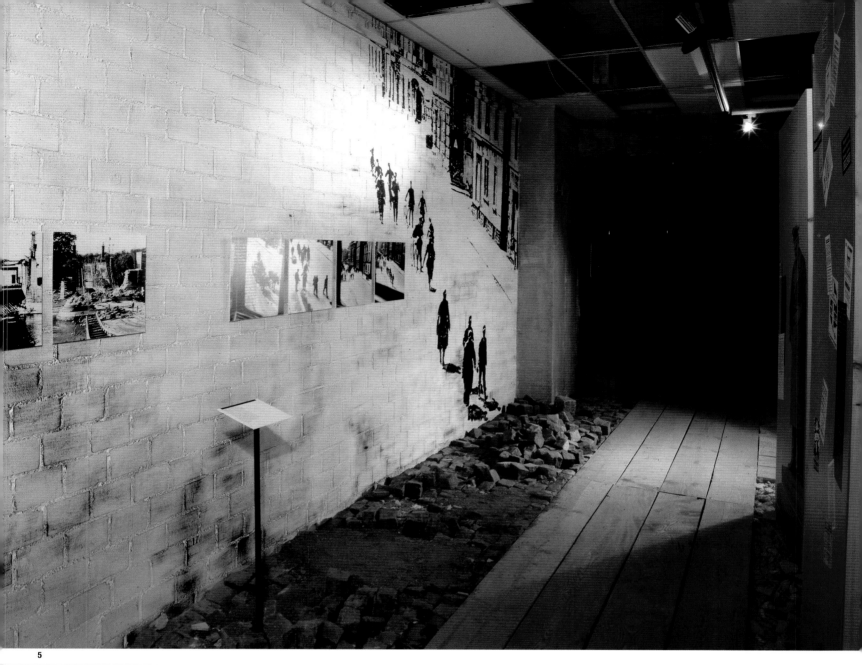

6. Plans of the adjoining buildings. 1. Entrance
2. Advertising column
3. From Polish to French campaigns
4. Mobilization
5. Forum: Life under a Dictatorship
6. National Community (*Volksgemeinschaft*)
7. Exclusion
8. Life and pictures of Kathe Loewenthal
9. Racial warfare
10. Civil air defense
11. Aerial warfare above Stuttgart
12. Children in war
13. Home front
14. A soldier's life

15. Connecting 'air-raid shelter' tunnel
16. Air raid 1944
17. Forum: Dancing with Death
18. Video of the destruction
19. Industry
20. Injured in an air raid
21. Last victims
22. End of the war
23. Ruin scenery
24. Door of Hotel Silver
25. Exit

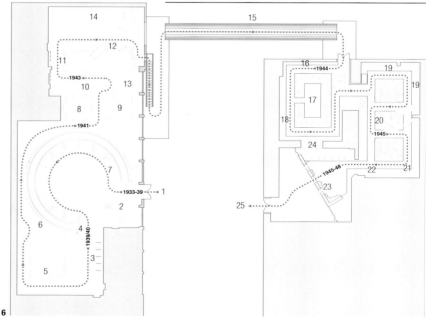

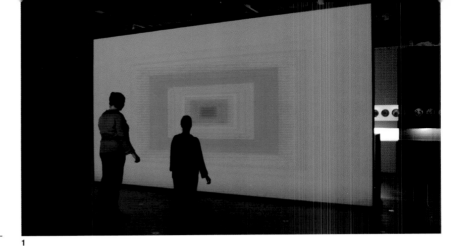

1

Eyes, Lies and Illusions

Hayward Gallery
London
UK
Christophe Gérrard, Critical Space
7 October 2004 – 2 January 2005

Centred on Werner Nekes' remarkable collection of pre-cinematic optical inventions and illusions, *Eyes, Lies and Illusions* was installed in all five of the Hayward's galleries, arranged on two floors. The strength of these spaces is their flexibility, and the way in which the strong sculptural and material presence of the architecture can be selectively revealed and so contribute to the display environment. In this exhibition the scale and variety of the spaces were explored in a sequence of thematically structured displays that used light and dark to create a rich landscape of optical wonder.

Eyes, Lies and Illusions was an extraordinary exploration of the art of visual perception from the Renaissance to the present day, and included more than 1000 instruments, images and artefacts in a sequence of diverse and interactive displays. Covering a broad subject

1. *Scrub Colour II*, Ann Veronica Jenssens, 2002, Gallery 5. This video artwork projected a hypnotic rhythm of endlessly shifting rectangles.

2. Display of nineteenth-century lithographic picture disks in Gallery 5. A layering of space was achieved using colour and floating planes.

3. The video installation *Blue Dilemma* by Tony Ourssler, 1999–2001, in Gallery 4.

4. Gallery 1 included a display of various optical instruments and a back-lit wall of panoramas.

5. The Ames room installed in Gallery 3.

matter, from high art to popular entertainment, philosophical enquiry to scientific discovery, the displays varied from shadow projections and *camera obscura* to academic treatises and optical tricks for children.

The first of the themes, Shadowplay, was appropriately housed in the entrance gallery. Visitors were immersed in the dark side of optics, in a space of flickering lights where silhouette animations combined with floating shadows and displays of working magic-lanterns. The haunting shadows by Christian Boltanski, first encountered here, revealed themselves intermittently elsewhere and underscored movement between galleries.

Another contemporary work, by Ann Veronica Jenssens, confirmed the curatorial ambition to communicate how this 'art of deception' still inspires artists, and articulated the adjacent ramp. This led to Tricks of the Light. The large gallery was painted with simple panels of black or white, and visitors were entertained by convex mirrors, nineteenth-century distorting and multiplying 'witch' mirrors, and other 'riddles of perspective', including anamorphous drawings and an elaborate reconstruction of a

walk-in Ames room. Visitors entering this space could be seen to shrink and enlarge as a result of the illusions created by its perspectival construction.

Beyond this gallery, World Revealed was a lighter environment suitable for the exquisite panoramas that exploited the scale of the space. A vertical, double-sided light box illuminated transparencies on one side, and on the other it incorporated alternate light sources that revealed transforming pictures made on paper and porcelain. On the upper level the exhibition continued with Enhancing the Eye, a combination of installations, projections and cabinets, a highlight of which was the giant lens from Britain's first public *camera obscura*. A wall of peep shows led to Deceiving the Mind, which included hidden images, visual puzzles and other optical riddles. The exhibition ended with Moving in Time, a display that explored ingenious devices like the mutoscopes and flip books that were employed to capture motion in images. These were suitably adjacent to a cinema-like space that housed Anthony McCall's Line *Describing a Cone*, where a seemingly 'solid' beam of light was created from

2

3

a projected white spot that grew slowly into a complete circle filled with smoke. Visitors were lost in the fictive world of artifice, light and dark, and the journey from the animated shadows of the entrance gallery was completed.

The exhibition was remarkable for the clarity of its curatorial direction, and for the creative interpretation of the installation and lighting design. At the same time, its theme served to reveal the background to the simulated realities of contemporary exhibition environments. The 'deceptive art' portrayed in *Eyes, Lies and Illusions* explored the boundary between real and fictive that continues to captivate – through its ability to create wonderment, through humour or through the way in which it provokes movement and interaction. In exploring the limits of illusion made possible through today's technology, it would be pertinent to recall the simple delights of tricking the eye that were so effectively communicated in this exhibition.

4

5

TECHNIQUES

4 DISPLAYS

This chapter explores ways of displaying exhibits. The selection of projects focuses on the contemporary museum and gallery environment and covers a range of objects and artefacts – in both temporary and permenant installations – that effectively portray the emerging tendencies in contemporary display design.

In any exhibition presentation matters: museums, galleries and other commercial bodies are increasingly aware of the important role display, both real and virtual, has in communicating the nature of an institution, the content of an exhibition or a brand character. While we perhaps reluctantly acknowledge the nature of this image-driven marketplace, we must also reflect on how the making of displays happens at so many levels in contemporary life, from market stalls and shop windows to our home interiors. There is something inate and instinctive about making displays.

In acknowledgement of this, contemporary exhibition design draws increasingly on display techniques that have emerged outside the confines of the gallery. Retail design is an obvious territory, and was explored by OMA in the exhibition *Cities on the Move* at the

1. *Cities on the Move*, OMA, Hayward Gallery, London, 1999. A detail exploring the informality of the urban setting and the boundary between retail and fine-art display.

2. Interior of the Palais de Tokyo, Paris, showing the street-like effect of the information booth inside a trailer (right) and the book shop surrounded by chain-link fence (left).

3 The Jaguar stand at the 2004 Detroit Motor Show, by Imagination, juxtaposed traditional wood panelling with high-tech display fittings and motion graphics.

Hayward Gallery, London. Here displays were influenced by the nature of temporary occupation and the colourful vitality of the market stall display. More recently the Parisian streetscape inspired the design of the interior of the Palais de Tokyo, Paris. Here the informality of the displays, the ad hoc material qualities of its finishes and the organization of the entrance sequence communicate a sense of

contemporary street life that is far from that of a conventional museum. At the Palais de Tokyo boundaries are blurred, appropriately echoing the unconventional nature of the exhibitions that take place there.

This kind of off-beat approach to the design of a museum interior is characteristic of a new diversity and experimentation in contemporary display. The shift is probably in no small part due

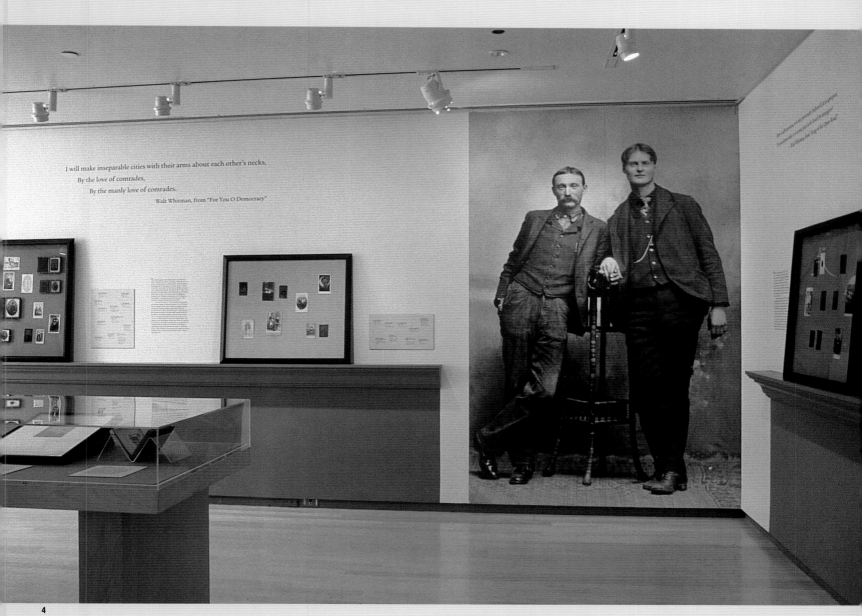

I will make inseparable cities with their arms about each other's necks,
By the love of comrades,
By the manly love of comrades.

Walt Whitman, from "For You O Democracy"

4

4. *Dear Friends: American Photographs of Men Together, 1840–1918*, International Center of Photography, New York, 2001, by Julie Ault and Martin Beck. Original photographs were displayed in intimate cases, while selected images were also enlarged to wall size.

5. Elegant acoustic lobbies reflect the surrounding architectural language at the Guggenheim, Bilbao, seen here in the exhibition *Moving Pictures: Contemporary Photography and Video from the Guggenheim Collections*, 18 October 2003–16 May 2004.

6. Casual groupings of video monitors in *Moving Pictures*, Guggenheim, Bilbao.

5

6

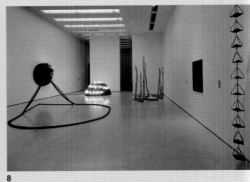

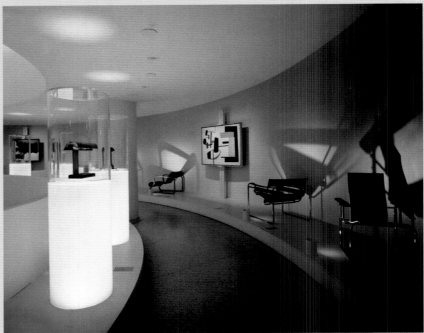

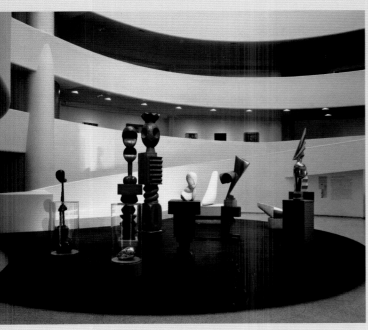

7. *Rendezvous: Masterpieces from the Centre Georges Pompidou and the Guggenheim Museums*, Guggenheim, New York, designed by Andrée Putman, 1998–99. This display of postwar furniture in an annex gallery uses large blocks of colour to set off the objects.

8. *Rendezvous*, Guggenheim, New York. Arte Povera installations in the annex gallery are displayed against the more conventional white background. From left: Gilberto Zorio's *Per Purificare le Parole* (1969), and untitled pieces by Jannis Kounellis (1969), and Eva Hesse (1970).

9. *Rendezvous*, Guggenheim, New York. Sketch by Andrée Putman for the design display in the Thannhauser Gallery.

10. *Rendezvous*, Guggenheim, New York. Design display in the Thannhauser Gallery.

11. *Rendezvous*, Guggenheim, New York. Display of Brancusi sculptures in the rotunda lobby.

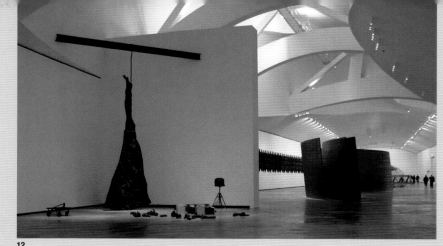

12

to the participation of curators and artists in the process of exhibition design: as we have seen, the artist will now tend to specify the way in which a work should be displayed and indeed, using the museum as an extension to the studio, design site-specific works. Increasingly, however, an exhibition is supported by a wide range of printed and virtual material, gadgets and downloads, so that the question of display extends beyond traditional boundaries and now necessarily involves the coordination of a broader range of materials and media. The best way to communicate a particular brand may not necessarily be through objects at all, it may be through performance or broadcast, for example. There is a strong argument, on the basis of access, that supports the further development of the web-based exhibition experience. Technologies are now emerging that offer the possibility of real-time experience of museums and also, as a kind of portable, digitized museum guide, headgear that allows a virtual inhabitation of historical environments.

In this chapter the focus is primarily on the creation of real experience and for this purpose it is important to recognize that the means of

12. A large-scale installation in the Fish Gallery, Guggenheim, Bilbao (2002–2003), featuring works from the permanent collection: in the foreground is Joseph Beuys's *Lightning with Stag in its Glare* (1958–85), with Richard Serra's *Snake* (1994–7) in the background.

13. The installation for *Andy Warhol: A Factory* at Guggenheim, Bilbao, 19 October 1999–16 January 2000, combined graphic form and structure.

14–15. *Malcolm Morley in Full Colour*, Gallery 4, Hayward Gallery, London, 2001. Two views showing the contrasting scale of works and enclosure.

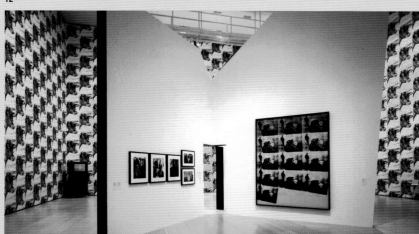

13

display will play a vital role in the way in which the visitor engages with the object and the way in which the exhibition communicates as a whole. The question of display is fundamental to the creation of exhibition scenography.

The core areas of display design remain remarkably consistent with those of early museums and can be broadly grouped into either wall-hung work or objects that occupy floor space, either exposed (but distant from the visitor's touch) or encased in a vitrine of some kind. A recent, distinct aspect of display design is concerned with interactive displays and screens or terminals of various kinds.

In conventional wall hanging work tends to be placed with its centre of gravity just below eye level, and invariably each work is given a neutral background (often off-white). In contrast

14

15

16

to Herbert Bayer's experiments in the 1930s to orchestrate wall displays according to a systematic understanding of viewing angles, in modern galleries the tendency is to take into account the actual presence of each work in the space. This approach does not predetermine an arrangement and gives priority to the works themselves, dialogues between individual works, and the subtleties of human perception.

Despite the conventions of the contemporary gallery interior, it is now generally acknowledged that the context of a work has an important effect on how it communicates: there is a renewed interest in the relationship between the architecture of the museum and its exhibits. Traditionally cabinets, elaborate frames or furniture would mediate between the scale of the exhibition space and that of the objects on display. This important role has in some way been diminished, as the intriguing, if dusty, landscapes of cabinets are replaced by increasingly transparent, but perhaps more anonymous, cases. At the same time, when these necessary, protective surfaces disappear visually, the objects themselves can appear to be almost freestanding in the space, as in the

16. *Nicolas de Staël 1914–1955*, Pompidou Centre, Paris, 2003. Related pairs of paintings were effectively displayed in vitrines, which were extended into an architecture of freestanding piers that structured movement through and experience of the work.

17. *Nicolas de Staël 1914–1955*. A well-judged dialogue between scale and colour created a visual movement between two paintings that complements the corner space of the installation.

dramatic staging for a range of musical instruments and other artefacts by Ralph Appelbaum Associates in the Historical Instruments and Manuscripts Collection at the Royal Academy of Music, London.

The same designers explored this inherent reciprocity between architecture and display in the American Folk Art Museum in New York (see page 118). The interior is characterized by a rich sequence of spaces. The architectural qualities of each space are sensitively complemented by the displays: on the stairs, for instance, objects appear as fictive windows set in dark frames. Labels are located at the top of the flight so as not to clutter the arrangement, nor obfuscate its figurative associations. Elsewhere crafts are set against a stone-faced spine wall and are individually spotlit to offset the cladding. The cladding's surface acts like a shadow theatre and the objects themselves are animated by the raking illumination.

In contrast, most exhibition spaces need to be flexible and lack the spatial diversity of the Folk Art Museum. In these circumstances the designer effectively takes a darkened volume as a context and in this way display design

inevitably becomes closely intergrated with lighting design, the subject of the next chapter.

The powerful world of material objects that careful display design can emphasize contrasts with the ever-popular virtual display. These contrasting media work best when woven together into the overall design of an exhibition. Only when the real and the virtual are explored together does the visitor understand the relationships and differences between the two.

17

18. Historical Instruments and Manuscripts Collection, Royal College of Music, London, by Ralph Appelbaum Associates. Luminous glass cases give a rhythm and range of scales to movement through the space and interaction with the displayed objects.

19. Historical Instruments and Manuscripts Collection, Royal College of Music, London. A musical score is brought to life as the display arrangement implicitly creates the presence of the conductor.

19

18

1

Art of the Motorcycle
Frank O. Gehry Associates

Solomon R. Guggenheim Museum
New York
USA
26 June – 20 September 1998

Guggenheim Museum
Bilbao
Spain
24 November 1999 – 3 September 2000

Guggenheim Museum
Las Vegas
USA
20 October 2001 – 17 January 2003

1. Display on Ramp 3, Guggenheim, New York.

2. View of the ramps at the Guggenheim, New York.

3. The rotunda lobby at the Guggenheim, New York. The curvilinear metal display structures echoed the curved form of the building.

Art of the Motorcycle originated in the Guggenheim Museum, New York, travelled to Bilbao in Spain and was then the inaugural installation at the Guggenheim, Las Vegas. Frank Gehry's design for this extraordinary exhibition, which featured some 114 of the most significant motorcycles in history, drew on the aesthetics of these machines – forms that evoked speed, freedom and movement, reflective materials and arresting colour patterns.

At each of the venues, shiny, chrome-like metallic sheet was key to the formation of the display environments. In New York, the potential of this material was first explored in the rotunda lobby. The balustrades of the ramp were clad in faceted panels of polished stainless steel to create an experience on entry that was full of metallic light, with glimpses of the machines caught in multiple reflections. The movement and mirroring of this installation captured an essential ingredient of the exhibition.

In the entrance the metallic cladding peeled away, and looked like a racetrack winding down to ground level. Here the 1868 Michaux-Perreaux and the 1998 MV Agusta F4 were juxtaposed, representing the chronological scope of the exhibition's structure – eight historical periods, from Inventing the Motorcycle to the Consumer Years – in a captivating image.

In contrast, the rear walls of the ramp were washed in a warm light. Specially developed hidden brackets meant the motorcycles seemed to balance effortlessly on simple podia of various heights and orientations. These were made of two elements: a base and a cantilevered upper surface on which single machines were fixed. The design emphasized the surface of contact, as the base of the podium was thrown into shadow: the motorcycles appeared to have been captured, in mid flight, on fragments of road. There was a real sense of movement: the podia meandered up the ramp at different angles.

The spectacular world of spiralling steel that characterized the ramp levels contrasted with the character of the tower annexe galleries. Here the motorcycles were set on a white surface whose plane, supported on a simple, exposed timber structure, curved and bent upwards like an artificial racetrack. Set off against a dark background, this road-like surface seemed to float and elevated the machines as if they were artworks – as the title of the exhibition implies.

2

3

4

4–5. Annex Level 7,
Guggenheim, New York:
the curved 'Ribbon
Road' display structure.

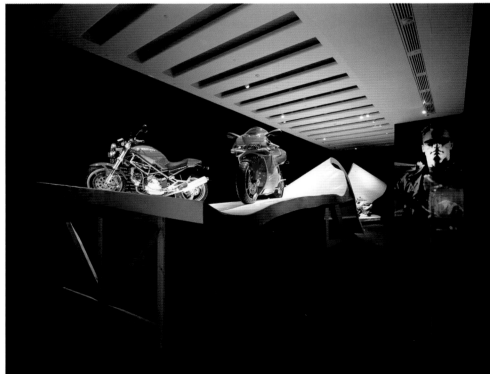

5

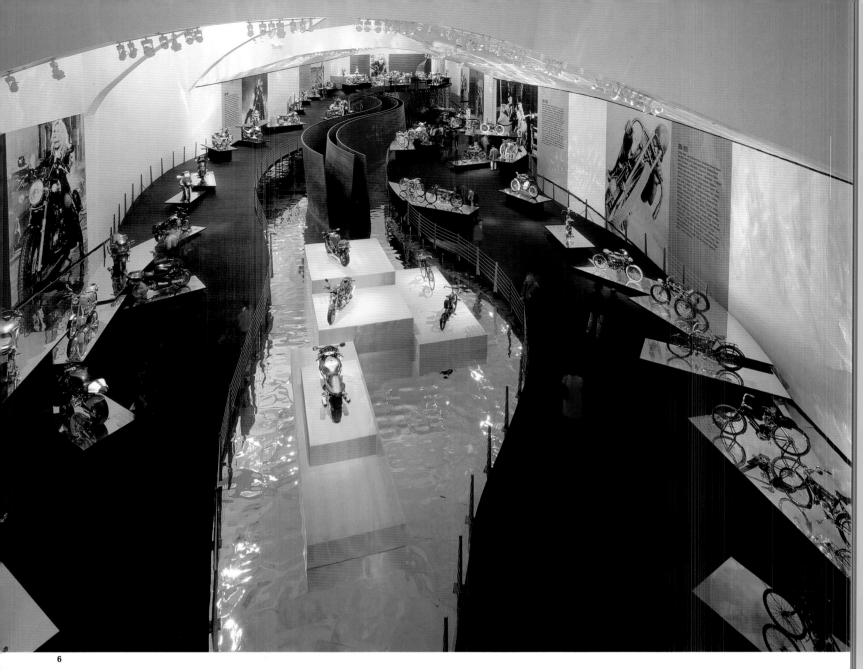

6. Overall view of the
display in the Fish
Gallery, Guggenheim,
Bilbao. Serra's *Snake*
can be seen at the back.

7. The installation
materials, along with the
lighting and colour,
combined to convey the
speed and character of
the motorcycles at the
Guggenheim, Bilbao.

8

The lighting of the ramp allowed projected captions to be read adjacent to the motorcycles. Others, appropriately understated, were discreetly applied to the floor adjacent to each podium; three different font sizes clearly defined the title, subtitle and further information. Reading text on a floor normally poses problems of legibility. Here, however, it could be assumed that enthusiasts, for whom the small text was important, might well be crouching low to see the machine in detail.

At the Guggenheim, Bilbao, the extraordinary forms of the so-called Fish Gallery, which permanently houses Richard Serra's *Snake* sculpture, provided an ideal setting for the exhibition. The installation was as ambitious as it was in New York, and several ideas that had already been developed were adapted for the building's distinctive architectural setting.

The motorcycles were on a pair of one-way, ramped walkways that worked through the gallery and crossed at the rear of the hall after passing the Serra sculpture. In dialogue with the forms of the enclosure and the sculpture, and of the machines themselves, the walkways travelled through the space of the hall and

8–9. Drawings for the specially designed display structures.

10. Objects, images and graphics were combined using different scales and colours at the Guggenheim, Bilbao.

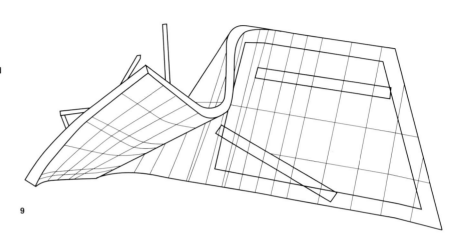

9

created a ground-level island of rippling metal. Motorcycles on this central location were set onto large wooden blocks and were strongly spotlit, making for spectacular lighting effects throughout the hall.

The Fish Gallery's walls were lined with giant posters and panels of graphics, and its length was broken up by panels of colour, interspersed with large images of motorcycles in well-known films (Brando's *The Wild One*, for example, or the Japanese anime film *Bomber Bikers of Shonan*), and emphasized the chronological divisions between groups of machines.

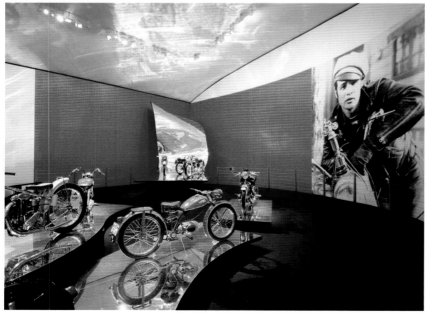

10

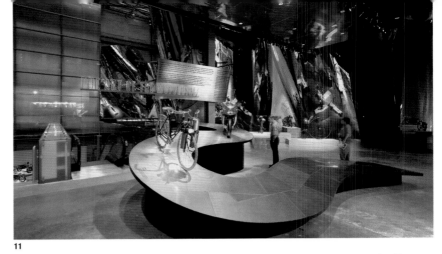

A considerably altered installation was needed for the tall, industrial halls of the Guggenheim, Las Vegas (designed by Rem Koolhaas). The exhibition was announced in the foyer with two translucent bollards. In the background further elements – a blue, neon title over the stairs to the lower level and a winding, path-like plinth for two motorcycles – announced the full extent of the exhibition. On one side, the stair was flanked by a metallic wall that reflected the colours of the lower ground area. On the other, a translucent wall carried introductory text. The drama of entrance was caught in extraordinary backdrops of billowing metallic sheet that reflected and revealed other parts of the exhibition.

The display was on two levels, with a central void between them flanked by two translucent forms. The first was a tall, glazed pavilion, coated with an iridescent film, that acted like a bridge at ground-floor level. From certain viewpoints it appeared to be opaque and moving images of motorcycles were projected onto its surface. From other angles the glazing was transparent and revealed the machines within it. They were on an expressive, stainless-steel

11. Exhibition entrance at the Guggenheim, Las Vegas.

12. Exhibition plan, Guggenheim, Las Vegas. The ribbon-like steel display structure can be seen running through the central lower level.

plane that curved from high in the hall, through the bridge pavilion to the lower ground floor. The ribbon-like surface was a flowing podium for motorcycle displays at various levels.

The second translucent form, at the other end of the void, was edged in billowing, steel mesh. To either side at its upper level, the exhibition was structured with large, undulating forms. These were clad in a reflective metallic surface on the outside; internally they were white.

The arrangement of podia within each of these forms directed the journey between exhibits. Some were housed within the enclosure of the curving walls. These served a dual purpose: in addition to framing more closed settings, their outer surfaces folded, opened and reflected spaces and exhibits beyond the one in the immediate vicinity. In doing so they distorted the images and created a sense of movement and vitality in the static objects. They were boundaries that both enclosed and, more importantly, opened up a dialogue between spaces and exhibits.

On the lower level motorcycles were set onto a curving, metallic, ribbon-like podium whose surface reflected them and transformed them

into images that seemed to be moving. The podium was set against a colourful, stripy background that recalled a slow-exposure photograph of movement.

Overall, the Las Vegas exhibition was less restrained than the one in New York, particularly in terms of lighting, and the metallic theme was explored more freely in extraordinary wave forms. On the one hand, the scale of the display structures and the giant graphic images that lined the periphery walls dwarfed the scale of the motorcycles. But, at the same time, the forms of these structures were broken by endless reflections so that to some extent their surfaces, activated in this way, mediated between the scale of the hall, the display apparatus and the motorcycles themselves. At Las Vegas the exhibition became a more immersive world of reflections, colour and light – an effective merging of the architecture of the enclosure, graphics and the displayed objects.

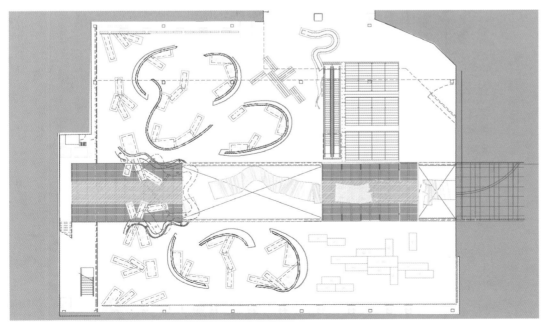

13

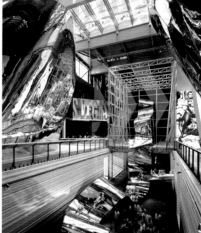

14

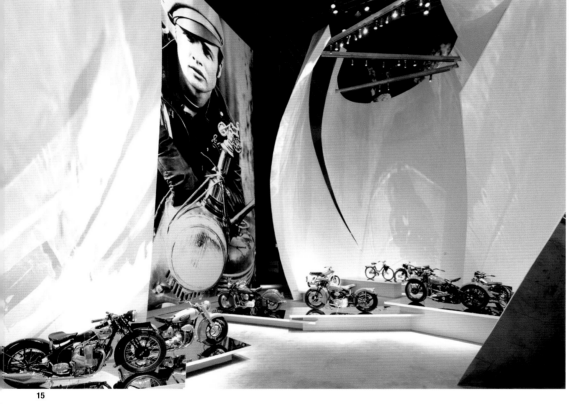

15

16

13–14. Overall views down to the lower level from above, Guggenheim, Las Vegas.

15. Images of famous figures on motorcycles were reproduced at an architectural scale, Guggenheim, Las Vegas.

16. Motion was represented by using dynamic reflective materials and wall treatments made to resemble long-exposure photography, Guggenheim, Las Vegas.

1

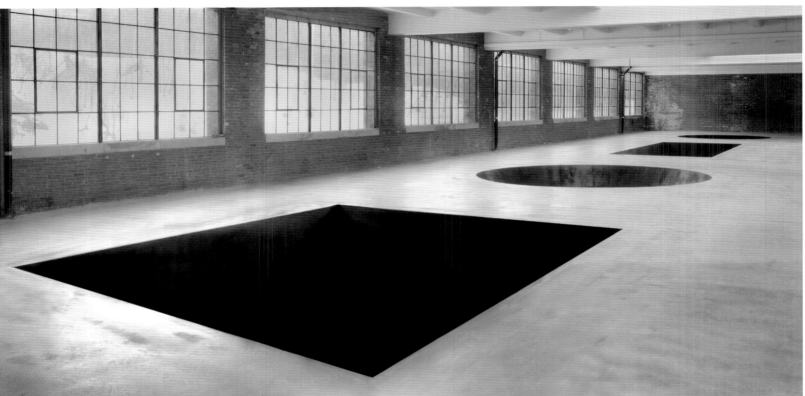

2

1. The windows, glazed mostly with translucent glass, maintain the continuity of the wall surface, while central transparent panes allow a dialogue between the artworks and the outside landscape.

2. Michael Heizer, *North, East, South, West*, 1967/2002.

3. Dan Flavin, *untitled*, 1970.

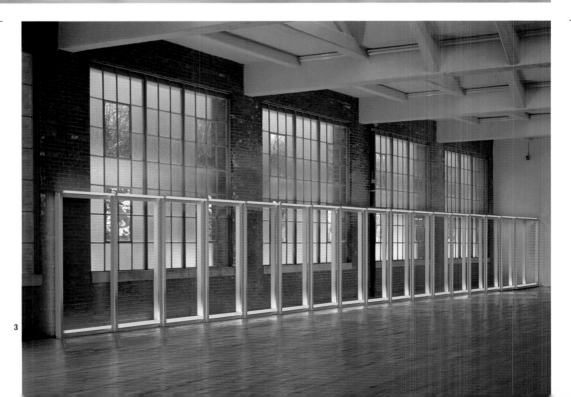

3

4

Dia:Beacon, Riggio Galleries

Dia Art Foundation
Beacon
USA
Dia Art Foundation, Robert Irwin and Open Office
2003

4. Andy Warhol, *Shadows*, 1978–79.

5. Plan.
1. vestibule and forecourt, Robert Irwin and Open Office, 2. offices, café, bookshop, 3. Lawrence Weiner, 4. Andy Warhol, 5. Walter De Maria, 6. Hanne Darboven, 7. Dan Flavin, 8. Sol LeWitt, 9. Michael Heizer, 10. Fred Sandback, 11. Gerhard Richter, 12. Donald Judd, 13. Imi Knoebel, 14. Bernd & Hilla Becher, 15. Robert Smithson, 16. Joseph Beuys, 17. Richard Serra, 18. Louise Bourgeois (upstairs), Bruce Nauman (downstairs), 19. On Kawara, 20. Robert Ryman, 21. John Chamberlain, 22. Robert Irwin and Open Office, west garden, 23. Agnes Martin, 24. Bruce Nauman (downstairs), 25. Blinky Palermo

The Dia Art Foundation, founded by Heiner Friedrich and Philippa de Menil in 1974, focuses on art of the 1960s and 1970s, arguably one of the most radical periods in art history. It supports a select group of artists, and acquisitions have tended to focus on large-scale artworks in order to establish an in-depth collection of the work of a few artists, rather than an extensive anthology of this particular historical period.

The Dia:Beacon, Riggio Galleries were opened in 2003 in Beacon, north of New York City on the Hudson river. The space is a refurbishment and partial restructuring of an old Nabisco box-printing facility, an agglomerate masonry structure dating from 1929.

The programme for the refurbishment was based on principles similar to those held by some of Dia's founding artists, including Dan Flavin, Donald Judd and Walter De Maria. Such artists were intensely involved in the design of the physical context for their works. Dissatisfied with conventional museum environments, they had a particular predilection to reuse existing buildings of all kinds and engage creatively with the limits and boundaries imposed by a given structure.

The artist Robert Irwin was invited to collaborate with the architectural team Open Office in planning the interior and exterior renovations. His interest in light and 'conditional art' (art determined by context rather than personal expression) engaged the dynamic between the given conditions and installations, between intervention and renovation.

Externally, visitors perceive a gentle manipulation of an existing environment, an overlapping spatial sequence. The modest entrance (which is also the exit) is situated in line with a spine wall that divides the building to the north. The mirrored entrance pavilion has two doors, each giving onto different sides of the wall and different experiences of the collection.

Internally, light and movement patterns are combined with considered attention to straightforward issues like access and fire egress. The work of each artist occupies the space it requires, and the works of several artists are never mixed in one space; where possible, artists have chosen or designed their own space. Placement is conditioned by the needs of a work, rather than any overriding chronology or other narrative structure.

5

6

'Consequently,' explains Lynne Cooke, author and curator, 'paintings are sited in the two front buildings, where north-facing skylights produce a limpid diffuse light. Sculpture is mostly located in the back building, where the east–west-oriented clerestory windows filter shifting light that casts shadows over the course of the day, and the heavier concrete floor provides a more substantial-seeming ground plan than do the maple floors in the pavilions containing paintings and wall drawings. Works that, for reasons of medium or materials require low light levels, such as the Bechers' photographs and Beuys's *Arena* are hung in more sombre and more intimately scaled spaces. Necessitating a clear, open area roughly square in configuration, Judd's series of plywood boxes has occasioned the one substantial architectural intervention in the project, the raising of the roof in the centre of the third building.'[1]

So pragmatic a description understates the richness of the installation. At a strategic level, it is first distinctive in its use of the different spatial topographies that were available in the existing structure. Movement – for example, between the western light and the colourful metallic

6. Fred Sandback,
Untitled **(from** *Ten Vertical Constructions),* **1977: a two-part vertical construction, the red variation is shown here.**

7. Richard Serra,
Torqued Ellipse II, **1996 and** *Double Torqued Ellipse,* **1997.**

world of the ground-floor John Chamberlain rooms, and between the melancholic twilight, bare masonry walls and rooflights of Louise Bourgeois' attic installation – is a brilliant exposition of the potential for creative dialogue between artworks and their environment.

Similar shifts of light conditions, scale and placement characterize the arrangements of works by Joseph Beuys, Richard Serra and Bernd and Hilla Becher, among others, whose installations successfully question accepted norms of museum display: distinct from the homogeneity of the museum experience, the emphasis is on structured difference, where the space between becomes an active ground for reflection and dialogue, enabling visitors to make personal connections between works.

A striking intervention into the existing structure is Michael Heizer's *North South West East* – four monumental forms that were let into the basement and cast in situ. Their edges are emphasized and a disturbing equilibrium is set up between the room space and the shadowy voids created by the work. There is a tense dialogue between the elementary presence of the forms and the delicate rhythm of industrial

glazing, and between their indefinite interiors and the framed views to the landscape. This implicitly geographical work points emphatically to a realm beyond the horizons of the room itself.

The journey through the galleries is guided by a notional axis set up by emergency exits that run across the building, east–west, and by the building's perimeter walls. Natural light and views to the exterior also act as orienting devices. The large windows are partially glazed with translucent glass, while central sections are transparent and allow a continued dialogue between exterior landscape and artworks, a pertinent theme for many of the artists.

The lasting impression of the Riggio Galleries is twofold. First, rich and varied reciprocal relationships are set up between the artworks and the spaces of the building – the diverse display environments that contribute to the reading of the works. Second, interrelationships between works are individually choreographed as visitors move freely through spacious display environments. Informal dialogues emerge between the works and out of this experience comes a sense of the collection as a whole, a sense that is dependent on the building.

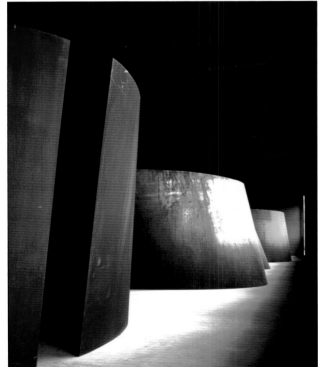

7

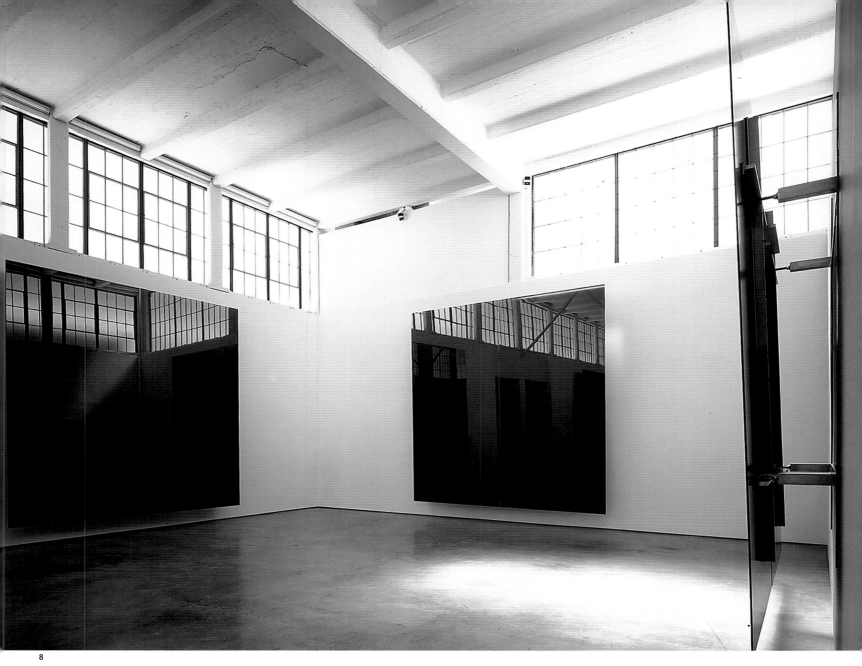

8. Gerhard Richter,
Six Grey Mirrors, 2003.

9. Donald Judd, *untitled*,
1976.

9

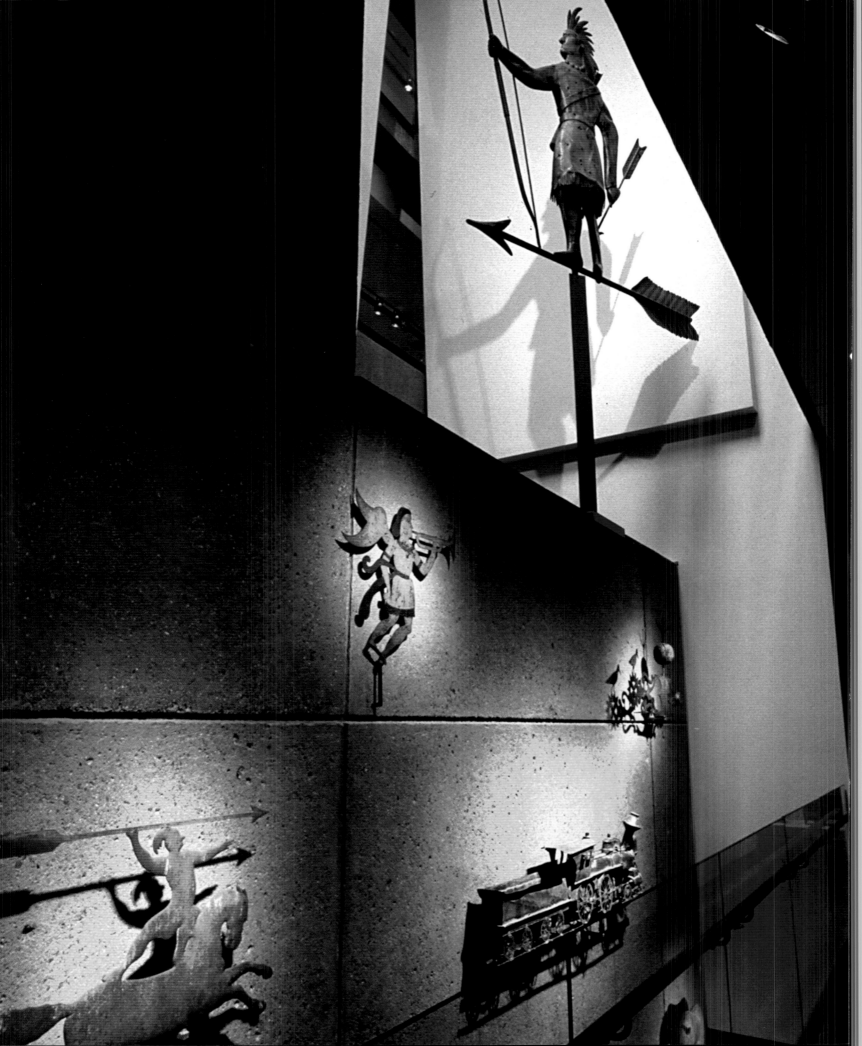

2

American Folk Art Museum

New York
USA
Ralph Appelbaum Associates
2001

1. The Weathervanes Wall rises through several floors of the building. The 2.7 metre (9 foot) high Tammany weathervane is placed at the top and can be seen from many vantage points.

2. The cruciform steel structure was designed to display the Henry Darger Collection to dramatic and symbolic effect. It allows for viewing of the double-sided paintings, and creates a focused environment for viewing the detailed artworks.

3. On the Decorative Stair artworks in embedded display cases float against soft, coloured background lighting. The cases lend a rhythm to the staircase, providing engaging encounters as visitors ascend or descend.

The building for the American Folk Art Museum (designed by Tod Williams Billie Tsien Associates) is recognized for the quality of its crafted details and the spatial richness achieved in its compressed site. It is arranged on eight levels (of which two are underground) and comprises galleries, offices, a shop and an auditorium behind a folded façade of panels cast in tombasil (a white-bronze alloy). The highly articulated environment provided Ralph Appelbaum Associates with a particularly challenging landscape for intervention and display.

Appelbaum's design strategy for the museum's permanent collection was to integrate the artworks into the fabric and structure of the building: exhibits seem to 'inhabit' the space. Display cases or 'niches' are embedded in the interior walls, and iconic works are strategically located throughout the museum. Their location, lighting (a mixture of fibre optics) and scale are subtly tuned to the character and scale of each setting within the internal topography. The multiple perspectives that underpin the experience of the interior become an integral part of the display strategy as there are numerous views, near and far, for each set of objects.

In designing the exhibits and graphics for the museum's two inaugural exhibitions – American Radiance: The Ralph Esmerian Gift to the American Folk Art Museum and Darger: The Henry Darger Collection at the American Folk Art Museum – Appelbaum took two different approaches. The challenge with American Radiance was to create a clear and cohesive display that included a high density of artworks located on three floors in unconventional settings. For the Henry Darger Collection double-sided, mural-sized paintings had to be displayed in a manner that allowed the context of the artist's work to be shown. A cruciform, steel structure, 15.3 metres (50 feet) long and 3.3 metres (11 feet) high, was created for these, so that visitors are able to wander into it and focus more intimately on each artwork.

3

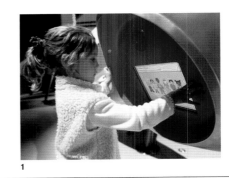

1

Wellcome Wing

Science Museum
London
UK
Casson Mann
2000

1. The Bloids (aluminium display objects) invite interaction.

2. A row of 'traditional' display cases is juxtaposed with the anthropomorphic Bloids, exploiting visitors' initial reactions to both the familiar and the unfamiliar.

3. The Bloids are a family of structures comprising different combinations of a set of four aluminium forms, each derived from the human physique.

Casson Mann's work on three floors of the Wellcome Wing in the Science Museum, London, explores three interrelated themes. On the first floor, Who Am I? looks at the make-up of individuals; on the second, Digitopolis explores the future of digital technology; and on the third, In Future looks at future technologies. All three are remarkable in that the design approach to each is both different and appropriate: an overriding concern was the clarity of the organizational layout for these individual, but connected, galleries.

The installation was constrained by the building layout in several ways: the blue wall installation facing the street set a tonal context for all the galleries; the progressive setback of each floor in section determined aspects of lighting; and the bridge-like character of the floors meant that in effect each gallery had to act as a primary circulation route across the building. The third floor, in particular, had to be capable of absorbing waves of up to 400 people coming out of the IMAX cinema. All the galleries overlook the Visitor Feedback installation, a network of 27,000 LEDs that displays messages left by visitors.

On each floor the design was developed primarily as an expression of the theme of the gallery and not of the individual topics within it. The first and second levels were designed as landscapes within which the content could develop freely: the nature of the galleries on both floors meant this was undecided until late in the design process.

On these two levels the formal arrangement of display elements contributes to communicating the subjects of the exhibitions. In What Am I? the play of apparent symmetry (like the human body), the biological forms of display pods and the shifts of organization between the highly organized and the highly individual all have obvious references to the gallery's theme. The aluminium display objects (known as Bloids) are unusual forms, and are, according to the designers: 'A fusion of the forms of the human body and the technological vocabulary of the typical science museum object.' The Bloids contrast with more familiar display cabinets and cases. These intriguing objects invite further investigation, and engagement with the interactive displays embedded in their surfaces.

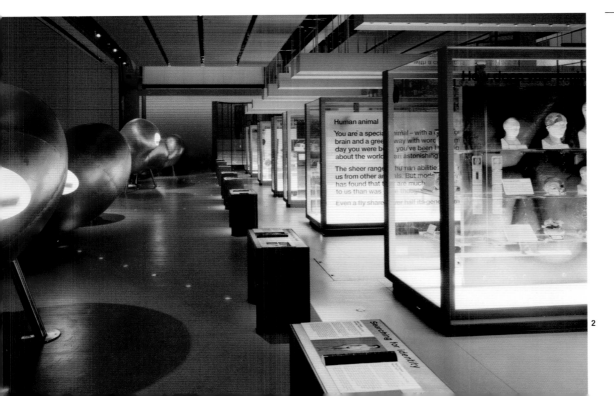

2

Human animal

You are a special animal – with a ... brain and a great way with words ... day you were b... you've been ... about the world ... an astonishing

The sheer range... human abilities us from other an... als. But mod... has found that ... are much ... to us than was ... thought

Even a fly share... ver half its gen...

Searching for identity

3

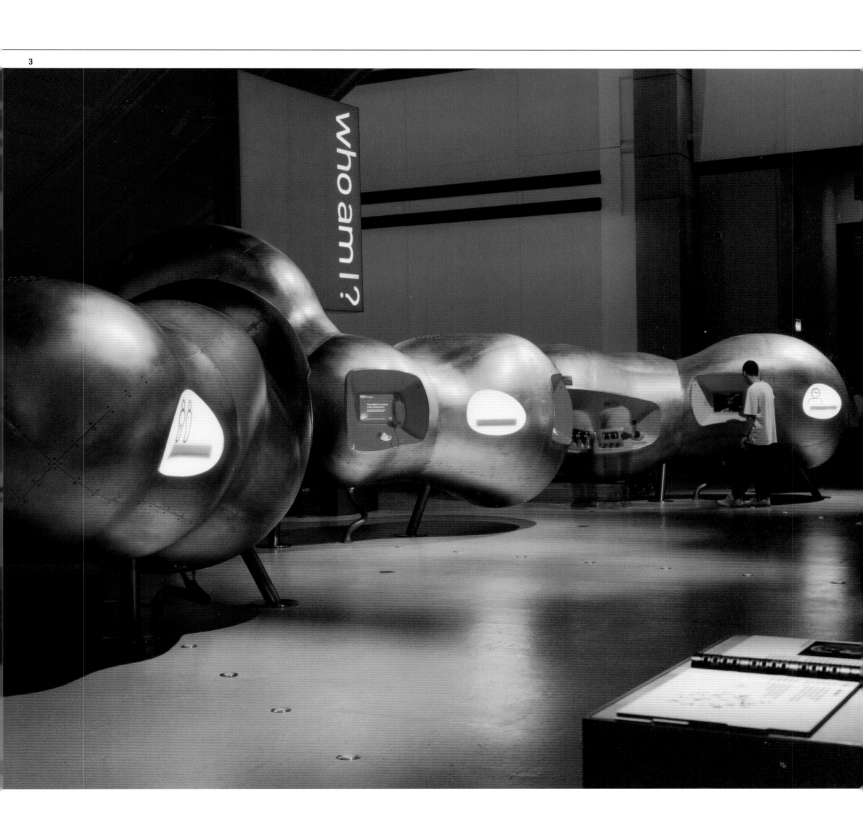

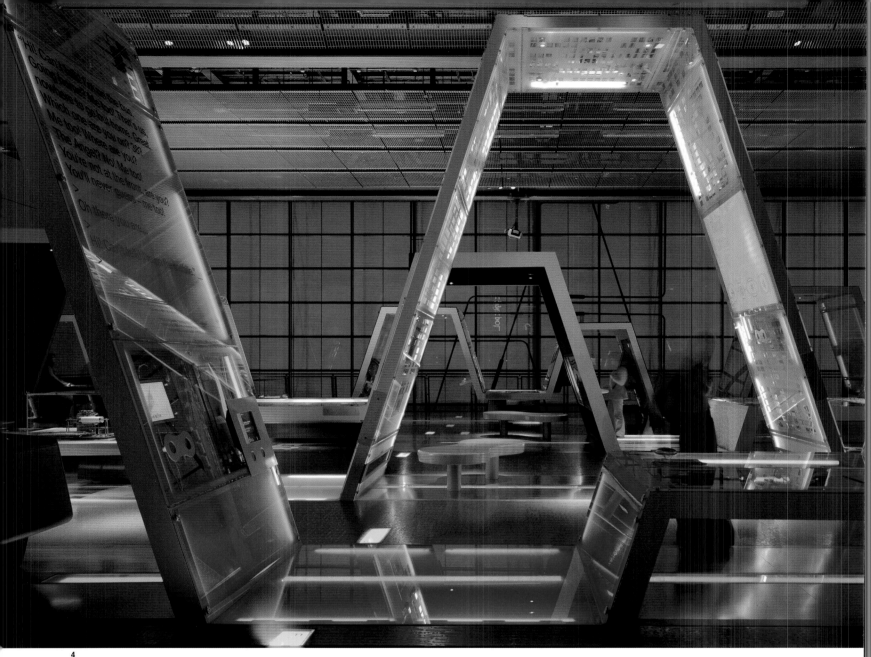

4

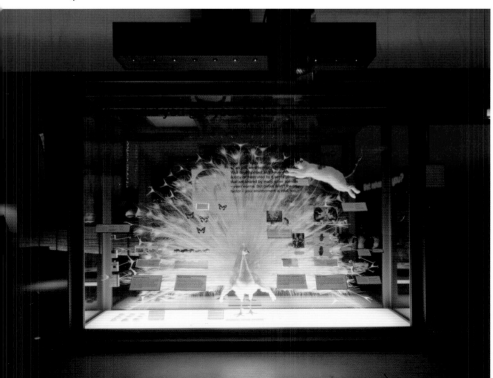

4. The five Warp structures in Digitopolis each provide a variety of display possibilities using an economy of form that relates to the underlying theme of the gallery: that all aspects of our world can now be represented in simple digital code.

5. Each display case in Who Am I? tells a different story: 'Where Did You Get Your Looks From?' explores human genetic development using examples from the wider natural world.

5

In Digitopolis the display system consists of long, ribbon-like structures called Warps; the floor beneath them pulses with streams of digitized information.

On the third floor, In Future is designed as a landscape of tilted circular tables that receive a sequence of games projections. These multi-user interactives deal with some of the difficult questions raised by the technologies of the future. The gallery's casino-like arrangement is a popular means of involving visitors. Players take turns to spin a wheel in the 'game' to prompt questions. An audience gathers and strangers compete by chance.

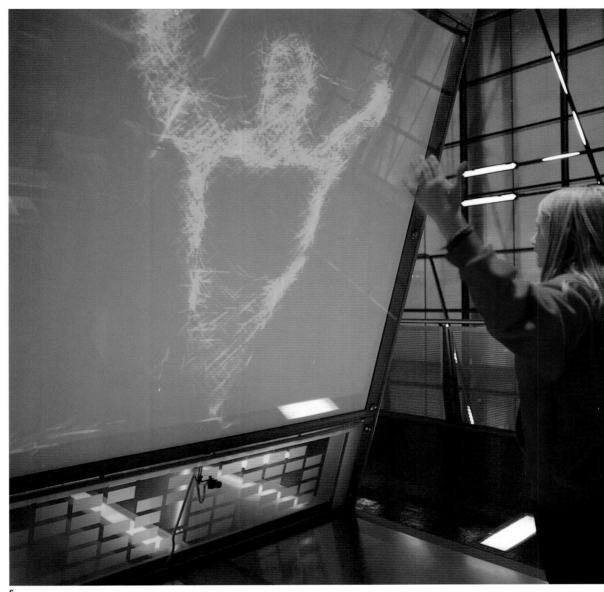

6

6. A series of specially commissioned interactive digital media artworks are integrated into the Warp structures.

7. The In Future gaming tables allow eight players to interact.

7

Crimes against humanity
An exploration of genocide and ethnic violence
Genocide and ethnic conflict have occurred many times in the last hundred years – often under the cover of war. This presentation looks at these events and at the challenges the world faces in trying to prevent them.

1

Crimes Against Humanity

Imperial War Museum
London
UK
Casson Mann
2002

1–2. The design allows the visitor to choose the degree to which they feel able to engage with the harrowing content: a narrow slot in the front offers an initial glimpse (above), while the open sides allow the act of sitting down and fully engaging to be an active decision (below).

Crimes Against Humanity, a permanent exhibition on the upper levels of the Imperial War Museum, London, explores the harrowing themes of genocide and ethnic violence. It looks to document their occurrence over the last 100 years, and the challenges the world faces in trying to prevent them.

The length of the gallery is divided into three sections, linked visually through table-height horizontal gaps in dividing screens. These screens fold into planes that form a dropped soffit, and a table and supports, and their simple language is reflected in the design of the bench seating.

The first screen is encountered in the entrance lobby where graphics announce the contents of the gallery. The vinyl text is wall-mounted and is above a slot in the screen that offers a glimpse through the entire length of the gallery to a projected film – the focus of the installation. The lobby is thus set up as a space in which to pause, or hesitate, before entry.

The next space, designed for research, houses a simple table fitted with flush-mounted interactive screens. Low-level illumination is augmented by a hidden light source in the plane of the soffit, which throws light off a second screen that divides this space from the film area.

A specially commissioned 30-minute film is projected in the final space. The screen is set against a black background whose arched form is slightly let off the perimeter walls to allow a shaft of light to come through its edges, like a door left ajar. This simple move brings a subtle quality of unease to the area and challenges the familiar hermetic qualities of film space. It also has the visual effect, by virtue of the contrasting light levels, of focusing the eye on the film.

As a response to the shocking nature of the film, Casson Mann set out to design a neutral space that 'spoke softly and trod carefully'. The box-shaped benches vary in length, and are arranged in broken rows. They leave two aisles so that the film can be watched alone, in a group or from the sidelines. The viewing is deliberately left open to observation by other visitors, so that any associations with the comfort and anonymity of a cinema are avoided.

Crimes against humanity
An exploration of genocide and ethnic violence
Genocide and ethnic conflict have occurred many times in the last hundred years – often under the cover of war. This presentation looks at these events and at the challenges the world faces in trying to prevent them.

2

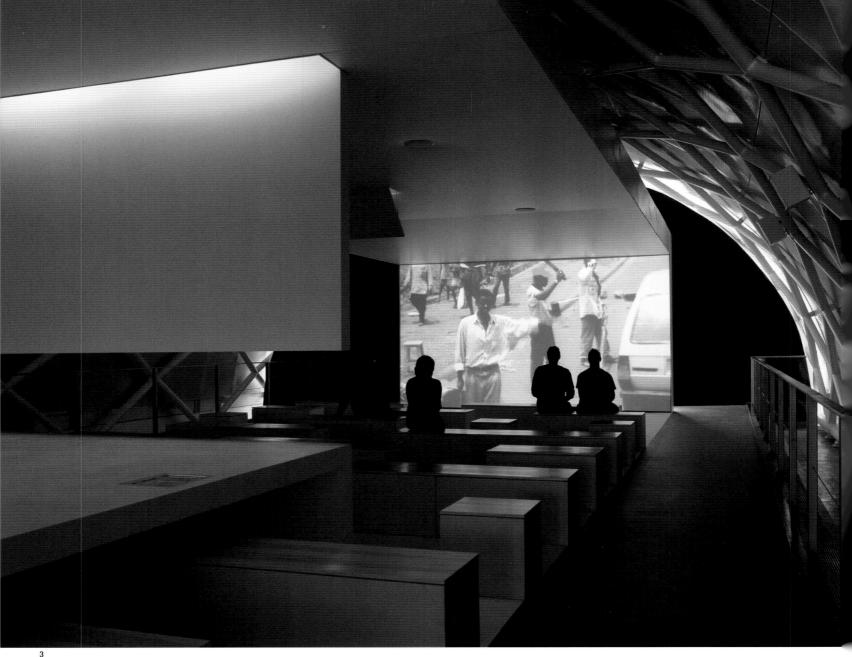

3. The architecture is an
extension of the film,
drawing the viewer in.

4. The proportions are
determined by the 16:9
ratio of the screen that
fills the end wall.

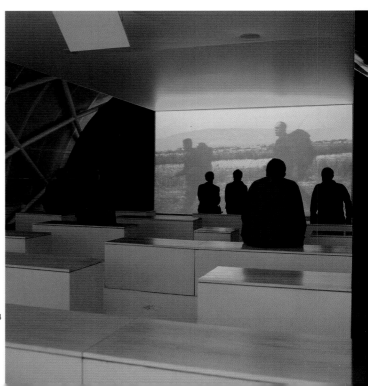

4

1

2

3

1. Magazines and
newspapers were
displayed on blue-black
walls to lend the
impression that they
were floating in space.

2–3. Avoiding the
inherent problems
of traditional vitrine
display, most of the
artefacts were mounted
at angles on the walls.

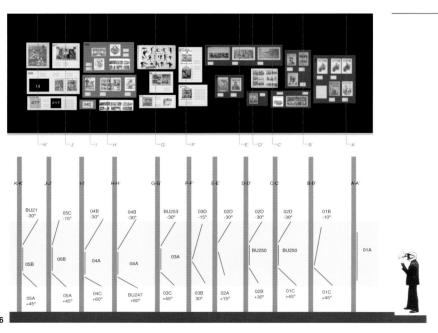

4

The Rise of the Picture Press: Photographic Reportage and the Illustrated Press 1918–1939

International Center of Photography
New York
USA
Julie Ault and Martin Beck
2000

This scholarly temporary exhibition traced the fascinating history of how photography made its way into illustrated magazines in the years from 1918 to 1939. The material on display in *The Rise of the Picture Press* was largely magazines. Conventionally these, like rare books and manuscripts, are displayed in vitrines so that visitors can inspect them closely. Inherent are problems of lighting (and other environmental controls), reflections and the gradual degradation of the glass or Perspex surface during the course of the exhibition.

Here, however, in keeping with the progressive character of the International Center of Photography in New York, the approach to display challenged accepted norms and looked afresh at the nature of viewing and perception.

4. Information text panels were set out as if part of a magazine grid.

5. Ault and Beck adopted Herbert Bayer's 1930 diagram of the framework for viewing surfaces as an initial point of reference.

6. Preparatory renderings of the elevation and section of the Wall 1 display.

Julie Ault and Martin Beck's strategy emerged from two points of reference. One was Herbert Bayer's 1930 diagram of the field of vision. His conceptual framework for viewing angles of surfaces was adopted and used to construct rational display angles derived from the experience of the viewer.

For Ault and Beck, Bayer's experiments coincided with their observations of the everyday display of magazines at kiosks or newsagents, where the angle of the front cover faces the potential customer. Intuitively the vendor orients the display to attract maximum attention for each product, and the magazines and newspapers on sale are invariably placed at angles that would be unconventional in terms of museum display.

Bringing these two ideas together, and recognizing the historical coincidence of Beyer's diagrams and the impact of print media on everyday street life during the 1930s, Ault and Beck designed a scheme of angled display panels to present the magazines, and concentrated them on two large continuous walls in the institute, thereby deliberately densifying the exhibition.

This density and visual impact was further developed by the use of contrasting colours on the gallery walls. Blank ones were painted pale yellow-green, and the walls on which the magazine panels were installed were very dark blue-black, creating the impression that the panels were almost floating in space.

Text panels, written by the institute's curator, were set out typographically in accordance with a magazine's grid layout. The relationship between text and image in the exhibition was similar to that in a magazine – both were positioned according to an organizational 'construction grid' that was articulated from floor to ceiling with painted lines.

Material that had to be protected for reasons of conservation was laid out in vitrines, which were either free-standing or bracketed off the wall. Key images, scaled up to the size of the wall, made an impact that challenged the intensity of the print.

5

6

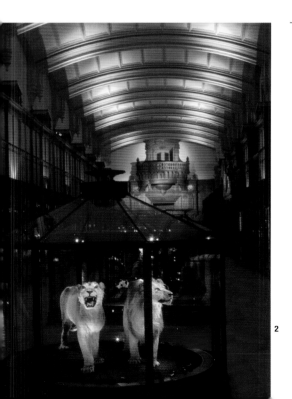

1

Grande Galerie de l'Evolution

Jardin des Plantes
Paris
France
Chemetov and Huidobro
1994

1. Freed from the traditional glass cases, African animals roam the 'active floor'.

2. Lions in one of the carefully restored original glass cases.

3. Cross-section through the gallery.

The renovation of the Grande Galerie (Jules André 1877–89) in the Jardin des Plantes by the architects Paul Chemetov and Borja Huidobro, with René Allio (décor) and Roberto Benavente (cases), is characterized by deft handling of the existing fabric, and the clarity with which the display communicates the diversity and richness of the animal kingdom. A new basement, dug to provide temporary exhibition space, revealed original, stone masonry that completed the image of this remarkable museum, and which is revealed and enhanced by the Grande Galerie. At the heart of this installation a great top-lit atrium offers a sectional experience of the building that juxtaposes the shadows of the heroic foundations with the lightness and rigour of the glazed rooflights.

These were modified to provide a pattern of daylight that changes periodically during the course of the day. This deftly complements an otherwise artificially lit space, and establishes a theatrical character for the exhibition as a whole. The monotonous rhythms of traditional museum display are replaced by a lyrical structure that explores inherent patterns of light and dark to enhance the atrium and the encircling galleries of the existing space.

The permanent exhibition houses around 100 fish, amphibians and reptiles, 450 birds, 350 mammals and more than 1,000 invertebrates. At the heart of the space is a magnificent procession of animals that seem to roam across a stage-like mezzanine, which the architects refer to as an 'active floor'. This is full of movement and dramatically divides the section of the building. Beneath it the display describes the life of the oceans: a shadowy, artificially lit floor speaks of origins and, appropriately, is immediately adjacent to the timber-clad entrance to the gallery. From this level a stair slides underneath the extraordinary, floating skeleton of a whale, down into the temporary exhibition space.

Above the active floor, with all its allusions to Noah's ark, a further two levels of galleries are dedicated to the theme of evolution. Original cases have been carefully restored; others are almost invisible and are crisply lit with fibre optics. Large animals, like the giraffe, have been removed from their cases and seem to gesture over the balcony to the floor below.

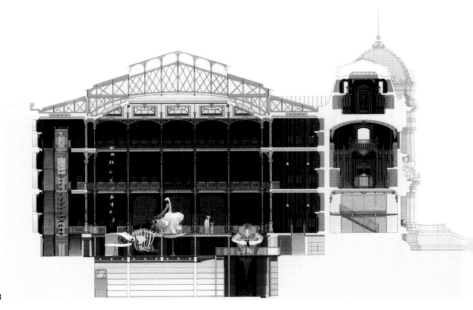

2

3

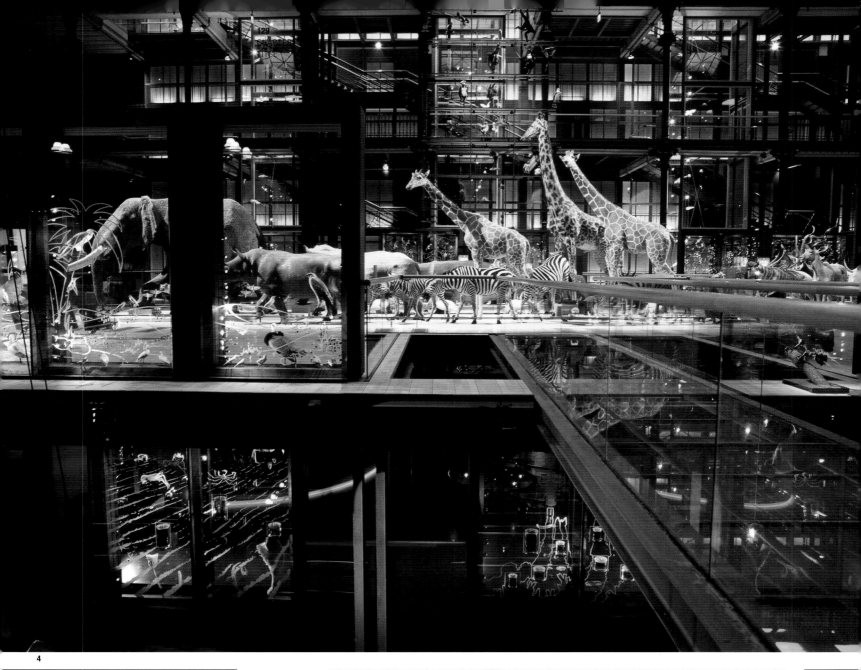

4. View across the stage-like platform of the 'active floor'. The layering of the display, and subtle shifts in the intensity and colour of the lighting, reveal a coherence in the overall narrative.

5. Ground-floor plan, showing the procession of African animals in the centre.

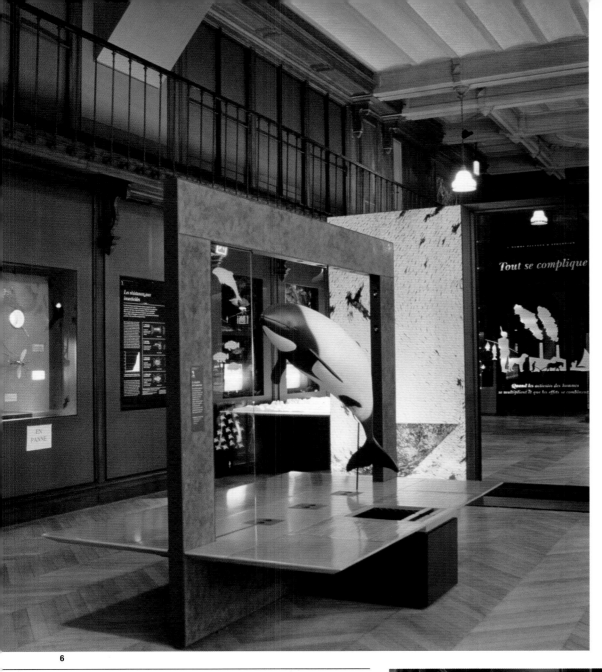

Attempts to bring collections like this 'to life' tend to make use of interactives, simulations and reconstructions. Here, by contrast, the display is technically uncomplicated. While short video clips play alongside the animals, the power of the display is in its imaginative approach to placement and in exploring movement in the context of the existing building. For visitors of all ages the simple, strategic distribution of the exhibits vertically through the hall is a direct and effective way of communicating something essential about the animal kingdom. Their imaginations are immediately engaged as the procession of great mammals sweeps across the mezzanine floor, as birds and flying reptiles are given a sense of lightness and are ingeniously displayed, in the air and adjacent to the delicate structure of the circulation wing. In this way the body of the museum is transformed into a rich metaphor of the animal kingdom itself; and the animals themselves come to life – not through specially developed software, but through a creative involvement with visitors.

6. In this display on the marine level a sense of movement is created by using modern display apparatus, which enables the whale to appear to float.

7. Sheep display on the second-floor balcony. Carefully managed contrasts in lighting levels enable individual animals to be spotlit without interrupting the continuity of the overall display.

8. The African animal procession forms the focus of the main hall.

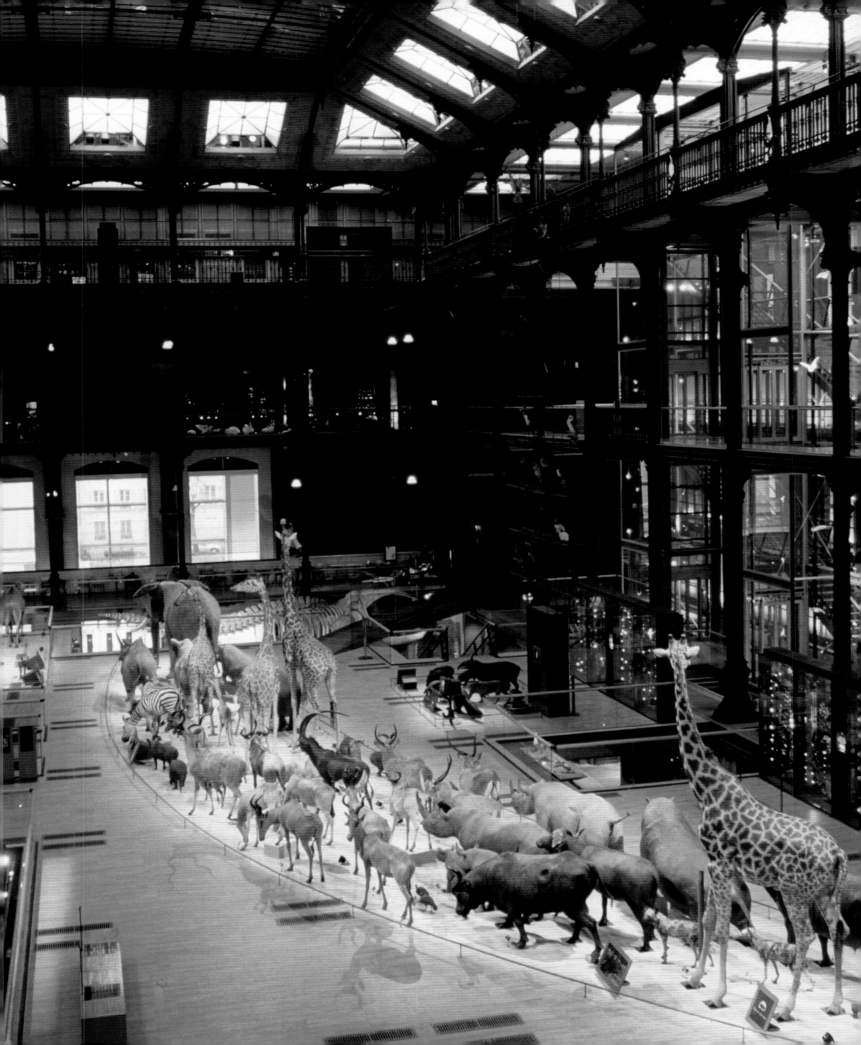

1

Addressing the Century
100 Years of Art and Fashion
Hayward Gallery
London
UK
Zaha Hadid Architects
8 October 1997–11 January 1998

1. Theatrical lighting animates three-dimensional displays.

2. Display podium constructed between Galleries 2 and 3.

3–4. Sections of the upper and lower levels of the gallery.

This temporary exhibition explored the creative relationship between art and fashion during the twentieth century, from Matisse to Issey Miyake. It was divided into five sections that were organized thematically, but also concentrated on works from particular periods.

The first section in the lower galleries, Decoration, The New Century, featured Parisian designers like Paul Poiret and painters such as Raoul Dufy. It explored the revolution in fashion design that took place in the early decades of the twentieth century, when collaborations between artists and designers pioneered styles that were characterized by flowing lines and decorative detail. The next theme was Function, The Post-War Years. Located in the upper galleries, it looked at the experimentation and vibrancy of the 1920s; during this period artists like Fernand Léger in Paris, Oskar Schlemmer in Germany and the Russian Constructivists created costumes and designs for the stage. The third section, Fantasy, Dreams in Hard Times, focused on the French fashion scene of the 1930s; this was dominated by Elsa Schiaparelli, who collaborated with Salvador Dalí, Meret Oppenheim and Leonor Fini.

Returning to the lower galleries, Performance, The Years of Reinvention covered the radical ideas about fashion and garments that were inspired by the conceptual and performance art of the 1960s. Finally, Convergence, Post-Modern Times focused on the 1990s and the total blurring of boundaries between art and fashion. In this final room of the exhibition, garments, both wearable and unwearable, were used to stage a new dialogue and vitality between art and fashion.

The design of the installation was uncomplicated technically, but was particularly astute in its dialogue with the fabric of the building, which has a challenging presence both sculpturally and materially: five galleries of different heights are split on two levels, and one of the three lower-level galleries is raised and accessed by a permanent ramp. Two exposed-concrete staircases provide a vertical link. Every exhibition at the Hayward works with this robust framework, building new walls and display apparatus as necessary.

Where feasible, the installation exposed the existing structure, opening up visual links across galleries, and emphasizing the thematic

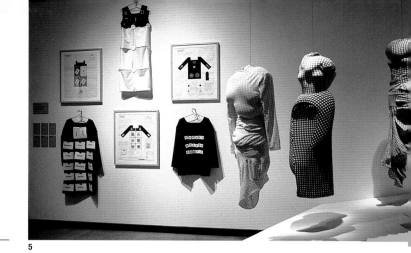

5

5. A collage-like display of drawings, wall-hung garments and suspended mannequins.

6. Exploded axonometric diagram of the whole exhibition.

7. Gallery 3: uncomplicated but effective display comprises wall-hung garments, wall drawings and figurative elements in the foreground.

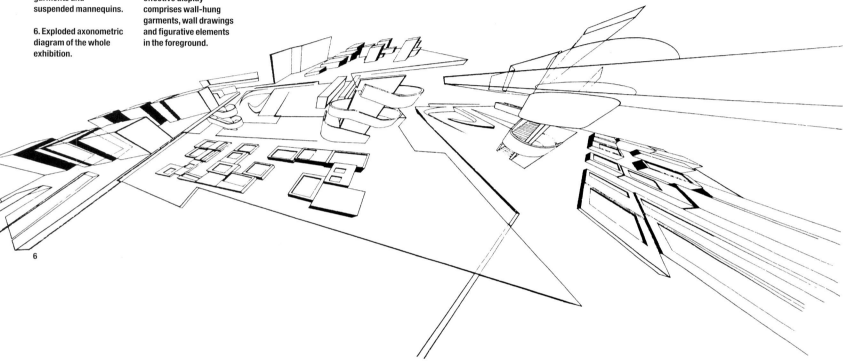

6

7

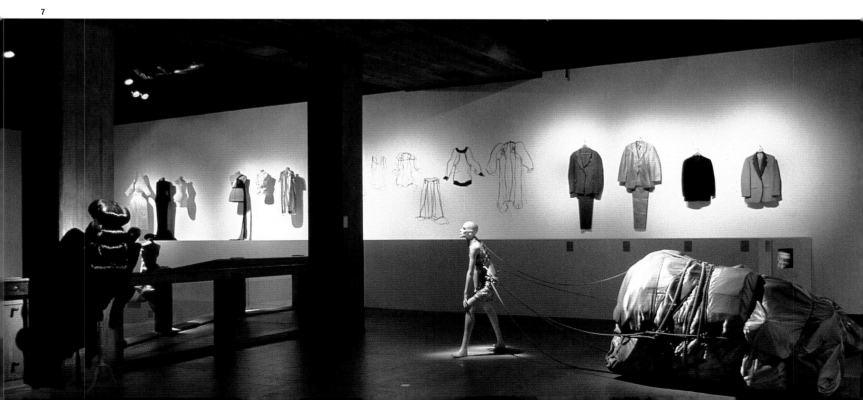

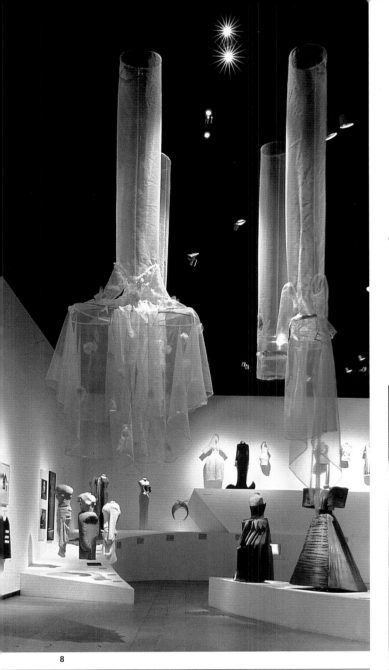

8

9

8. Gallery 2 was dramatically hung with suspended cloths.

9. View from Gallery 1 towards Gallery 2.

10,13. Details showing the landscape of display cases, and its relationship to the walls carrying text.

11. Detail of Gallery 4. Display cabinets were angled to emphasize movement and facilitate viewing.

12. Upper level, looking towards Gallery 4.

10

continuity of the show and intended overlaps between topics. At the same time its openness gave a sense of movement and the opportunity to view others moving, as the exposed galleries became almost stage-like. This sense of theatre was reinforced by the dramatic treatment of light and dark: walls were either black or white, and lighting levels fluctuated across spaces. Even wall washes contrasted with spotlit bodies and the shadowy landscapes of dark podia.

This physical and visual movement, highlighted with extraordinary colour, embodied a sense of performance — a common theme that unites the worlds of art and fashion. This was further underlined in one of the lower galleries, for example, where a great sweeping podium looked almost like a catwalk. Elsewhere the dark forms of cabinets were twisted with a choreographic sensibility, and empty dresses, sculptures and mannequins were staged to seem as though they were taking part in a frozen performance.

Another theme in the design of the exhibition was, of course, the human body. Reference to it appeared in many guises: fashion illustrations, photographs and filmed performances

11

contrasted with the empty dresses, and with the suits and clothes displayed on mannequins and tailor's dummies. Further, in the Dressing Rooms visitors were invited to feel and try on clothes specially created for the exhibition by young artists and designers,

Engagement with material innovation, as a recurrent theme in the progress of art and fashion, was made abundantly apparent, not only by exposing the garments themselves, but through the collage-like layering of exhibits where drawing or painting, mannequin and accessories, were juxtaposed to explore overlaps — issues of process and making. In this sense, the neutral value of the exposed concrete in the gallery interior makes it an ideal surface against which to play dramatic colour or delicate texture.

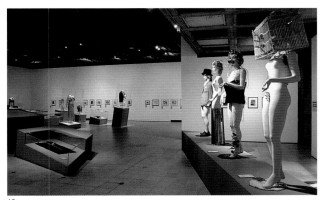

12

13

1

2

5 LIGHTING

Lighting design concerns human comfort. Together with questions of air quality, temperature and humidity the illumination of the exhibition environment plays a vital part in the visitor's experience. Lighting conditions affect the way in which an exhibition structure is perceived, the effectiveness with which it communicates, the rendering of form and colour and the legibility of graphics. Exhibition lighting is best understood contextually – that is, not as an application of abstract principles but more with direct reference to the scale of exhibition space, its orientation (and where appropriate, the availability of natural light) the materiality of wall and floor surfaces, the variety of incident and reflected light and, most importantly, to the nature of the exhibited artefacts themselves.

Generally, the lighting environment of an exhibition space tends to be balanced between natural and artificial light. While this raises problems related to conservation (incident Ultra-Violet (UV) light has cumulative, damaging effects for a range of light-fugitive surfaces, particularly coloured and painted materials) the compromise relates to the overriding need to create a comfortable visual environment. This

1–2. *Au delà du Spectacle*, Pompidou Centre, 2000–2001. In this display artificial lighting is considered for both day and night effects. In each case the table appears to float as the surface is highlighted.

3. *Au delà du Spectacle*, Pompidou Centre. Light, colour and graphics were combined to create animated signage.

4–5. *Au delà du Spectacle*, Pompidou Centre. In lighting techniques borrowed from the theatre a beaded curtain was frontlit to create a translucent veil behind *Michael Jackson and Bubbles*, by Jeff Koons, 1988.

involves avoiding obvious problems of glare (discomfort experienced by the visitor when parts of visual field are excessively bright in relation to general surroundings), colour distortion (typically from yellow incident light) and discomfort brought about by reflections (off glass and polished surfaces or vitrines). At the same time, in order to be most effective, visual comfort requires a creative variety of lighting

conditions, avoiding the monotony of an evenly distributed, artificially lit environment.

There is a tradition in museum and gallery design that explores the use of natural light. In the past this has tended to develop a museum architecture of deep reveals and articulated roof sections, which block direct sunlight, reduce the amount of light from the brightest parts of the sky and filter damaging UV light.

3

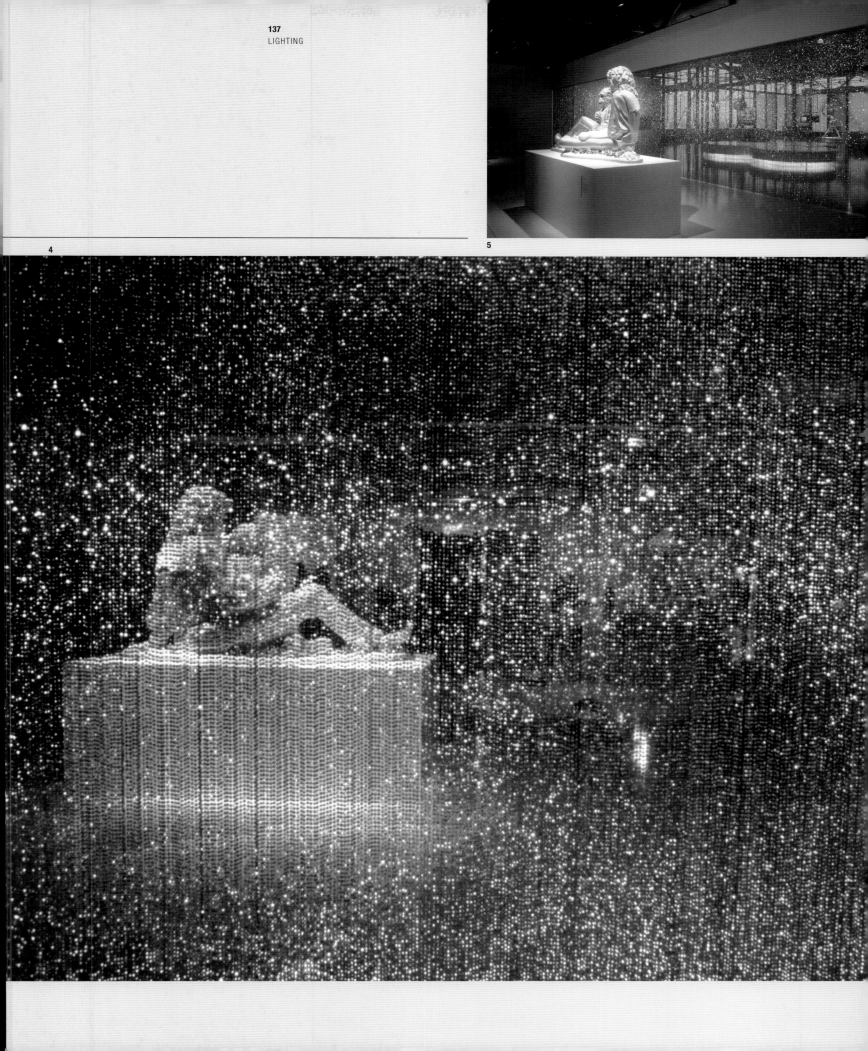

4

5

7

The character of artificial light, on the other hand, is less dependent on architectural invention. Rather spatial enclosure can be effectively reinvented using artificial lighting effects and, as exhibition design increasingly borrows from theatre and film technique, so creative artificial lighting strategies play an ever important role in the spatial definition of exhibitions: the ambiguous, shadowy landscape of *Brazil: Body and Soul* at the Guggenheim, New York (see page 142) illustrates particularly well the dramatic spatial potential of this kind of lighting. In *Au delà du Spectacle*, at the Pompidou Centre, 2000–2001, lighting techniques borrowed from theatre were used to drive the theme of the exhibition, an exploration of the relationship between art, theatre and spectacle.

There is an ever-improving range of light fittings available for contemporary exhibition design and, in general, a variety of light sources and differentiated lighting patterns will enhance the experience of an exhibition, as well as solve practical issues relating to glare, reflections and the inevitable drop-off of light intensity with distance from the source. The selection of

6, 8. *Great Expectations*, **Casson Mann, Grand Central Station, New York, 2001. The walls were transformed with coloured light washes that set the stage for the giant light table – both exhibition stand and source of illumination.**

7. *Brazil: Body and Soul*, **Jean Nouvel, Guggenheim, New York, 2001–2002. The interior was painted black so that light appeared to be almost carved out of the sculptural backdrop.**

9. At *Great Expectations* **projections, coloured light washes and period chandeliers created a varied landscape of illumination.**

specific fittings will depend on the nature of the artefact and overall design strategy, but generally colour rendition is an important consideration. In this sense fluorescent lamps are effective and are also energy efficient. However, the difficulty of maintaining their light quality when dimmed makes the most common lamp type a tungsten halogen, especially low-voltage models. These have an excellent colour rendering index and the source is relatively small. Though easily dimmed, this is best avoided since the colour of the light tends to yellow. Increasingly, low-voltage tungsten halogen fittings are augmented by fibre optics, particularly in exhibition cases, where issues of ventilation and controlled environments are particularly pronounced.

Increasingly, exhibitions involve digital projection. Over the past few years the tradition of using slide projection has diminished on account of radical improvements in the technology of digital projections. The brightness now achieved by digital projectors has reduced the traditional requirement for low ambient lighting levels, and the effective reduction of contrast levels by lighting interference is further

reduced by the use of black or dark grey projection screens.

This exploration of digital projection has become increasingly widespread and effective. Design group Imagination have used projections on a variety of surfaces including, particularly ingeniously, household objects at their stand for Ericsson (see page 50). Their work here is not about the exploration of technology for its own sake, but the adoption of technology in order to successfully communicate the brand image. Similarly, Casson Mann's adoption of projected graphics and coloured light washes in the installation of British design *Great Expectations* at Grand Central Station, New York, inspires new directions in communicative techniques. The display centred around a 50 metre (164 foot) long, illuminated table, designed to catch the attention of rushing commuters and, to quote the designers, 'stop them in their tracks'.

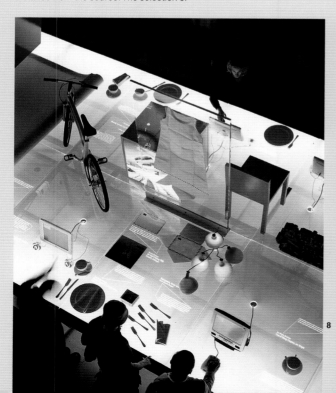

8

9

Light Show

Tate Modern
London
UK
Imagination
2000

Tate Modern commissioned Imagination to design a light show to mark the launch of the new gallery of modern art in 2000. The show was seen by 4,000 invited guests at the launch party, and was also broadcast live by the BBC.

The light show to accompany the opening of Tate Modern in London was to be 'simple and surprising'. And it had to be effective seen from the north bank of the Thames, where there would be crowds of onlookers and representatives of the media.

The strength of the show developed by Imagination, in conjunction with the artist Michael Craig-Martin, was the connection between the lighting and the formal mass of the building itself. Tate Modern's masonry has a primitive, monolithic solidity and the gallery is perched above the shifting rhythms of a tidal river. The light show enhanced the primary massing of the building elements and so, against the night backdrop, emphasized the sculptural richness of its mass against aqueous, reflected light.

Lasers picked out, and drew outlines of, first the chimney stack, then the two-storey light box on top of the brickwork. Together these two shapes formed a giant cross on the axes of the building. A colour wave of light from 50 arc-wash luminaires spread out towards the glass light beam. Then blocks of rippling colour, again drawn by lasers, progressed up the chimney creating a wall of different colours, and larger more fluid swathes of different-coloured light washed gently out across the face of the light box, echoing the movement of the Thames. The four-minute opening sequence culminated in the illumination of the 'Swiss light' at the top of the chimney, which acted as a beacon to signal that the gallery was open.

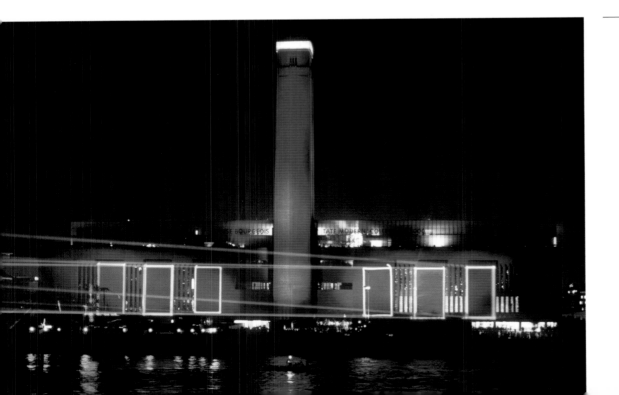

1

Brazil: Body and Soul

Solomon R. Guggenheim Museum
New York
USA
Jean Nouvel
12 October 2001 – 29 May 2002

1. Display cases on Ramp 1.

2. View from the top ramp looking down to the ground floor.

3. Plan of the display on Ramp 3.

4. The towering Baroque altar in the rotunda lobby dominated the exhibition.

2

Brazil: Body and Soul was an investigation into the development of the visual culture of Brazil during two of its most critical phases: the Baroque and the Modern. The exhibition displayed distinctive works from each period, and in doing so posed questions about the possible continuities and underlying dialogues between them. One theme was the ongoing encounters between indigenous production and different cultures – from the conflict of colonization, to the inspiring cross-fertilization with Europe in the 1920s and 1950s, and the global influences that inflect contemporary production. In particular, the exhibition showed the influence of African culture on Baroque production (from the early seventeenth through to the late eighteenth centuries). Several artists from this period were of African descent and Afro-Brazilian artists form one of the principal aesthetic currents of the twentieth century.

The body of work recognized these shifting influences as much as it did the continuity and identity of that which is Brazilian. What was interesting was the undoubted subtext: the potential reading, despite expectations, of a constant migration and transformation of an

indigenous way of making, of seeing light, material and colour that still remained Brazilian. The contemporary work on show illustrated how these vital traditions have continued to influence Brazil's artistic production, how Brazilian art has remained 'grounded'.

The introduction to the exhibition was an examination of the 'outsiders' view' of Brazil in the Age of Exploration, and included major paintings by seventeenth-century Dutch artists. The structure of the ramp display was broadly chronological.

Overall, the objects on display were extraordinarily varied, in scale and historical period. The Baroque section featured a particularly rich collection of polychrome wooden religious sculptures, private home altars, processional images and paintings. Modern works included a variety of paintings, sculptures, costumes and artefacts.

The display requirements for each object were potentially complicated, and the result could have been a rather tedious anthology, a catalogue of adequately displayed exhibits. However, Jean Nouvel's interpretation avoided this obvious pitfall and recognized the special

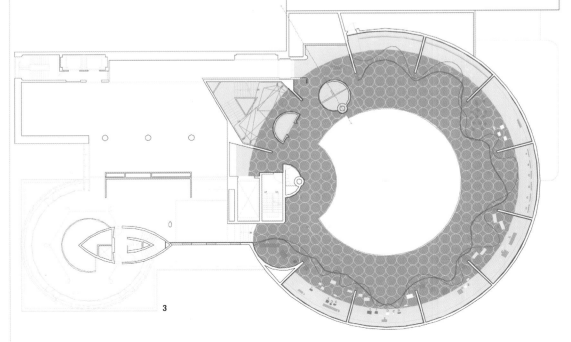

3

4

6

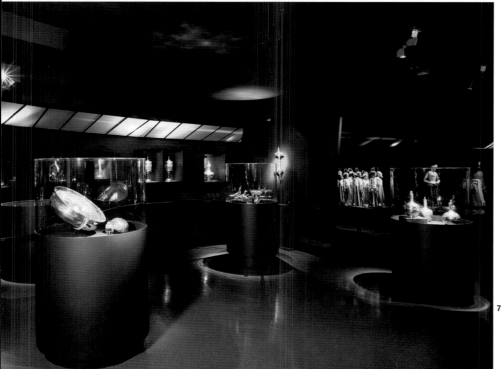

7

6. View of the Baroque display on Ramp 4. In the darkened galleries the theatrically lit objects seemed to float.

7. Silver and jewellery in display cases on Ramp 3.

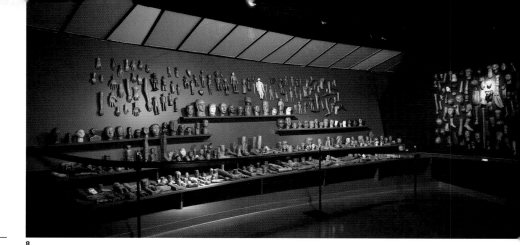

8

qualities of light, materiality and colour as elements to draw the objects together. The installation was inspired by the very particular brand of theatricality in Brazilian Baroque, and a coherent experience was constructed by working from a darkened space.

The lower levels of the Guggenheim Museum in New York (which housed the Baroque exhibits) were painted entirely in black, transforming the building, which is ordinarily characterized by Modernism's clean, sweeping lines and natural light, into a mysterious darkened theatre. Each object was spotlit against this dematerialized background so that its form, colour and textures were emphasized. The overall exhibition was as much to do with a fascinating topography of shadow and light as it was with the exhibits themselves.

The character of Brazil was dramatically announced in the display (for the first time in a museum setting) in the rotunda lobby of the extraordinary, recently restored Baroque altar from the monastery of São Bento in Olinda (north-east Brazil). Its highlighted, gilded forms expressed the rich material and spatial innovation that characterized the exhibition as

8. An installation of *ex votos* on Ramp 4. The lower levels of the museum were transformed into a darkened theatre.

9. *Takape* and *Comb*, by the artist Tunga, Ramp 6. The lighting of the contemporary displays was more conventional.

10. *Phantom*, by Antonio Manuel, in the contemporary section, Annex 5.

a whole. It stood luminous against the shadows of the black-painted interior, and its enormous scale drew the eye towards the blackened rooflight, which was washed with an array of red and yellow light. Reminiscent of bole, the traditional ground for a gilded surface, the colours had an immediate resonance with the altar, whose presence filled the entire void of the hall like a gateway to the exhibition.

The style of the altar was echoed in the sinuous curves that formed a black-painted barrier separating the displays from visitors, and dividing the ramp along its length. The space of the ramp, a strong architectural element that is normally rather rigidly ordered by its peripheral structure, was cleverly structured with light. Objects were grouped as clusters and were either on black podia or wall-mounted on discreet brackets. The shifting relationships between them and the rear wall created an informal sequence of clusters along the ramp. Some objects were tight against the wall's surface, others were held away from it, and occasionally the display engaged with the entire width of the ramp: for example, religious artefacts were suspended above the visitors'

passage. There was a distinct staging of the works: thematic groupings were carefully arranged, in a way that guided interpretation. On one occasion, large-scale figures from a painted work were highlighted to look like onlookers.

The extensive use of strong spotlights meant that objects seemed to float, an effect that successfully captured their spiritual content. This was particularly effective in a display of Baroque painted panels, each of which was held in a frame and supported above the floor. Their distance from the wall gave these heavily framed objects the appearance of lightness – fittingly, since the oil-glazed panels were concerned with the metaphysical, and the representational values of light.

The contrast with the Modern could not have been more marked. On the upper levels of the ramp displays were more conventional, and works were washed with a more even light against a white or blue-grey wall. This difference reflected not only the chronological break between Baroque and Modern but, because of the juxtaposition, also spoke of the dialogues and potential continuities in Brazil's artistic production through the ages.

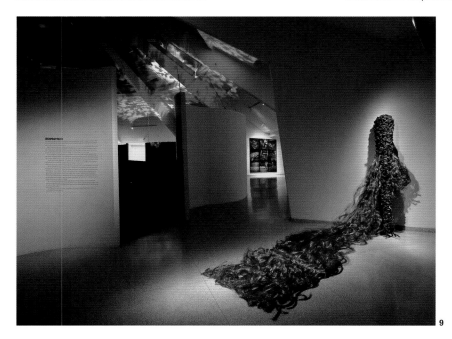

9

10

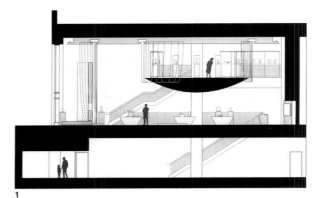

1

Steuben Flagship Store

New York
USA
Ralph Appelbaum Associates
2000

The Steuben flagship store in New York brings exhibition design and retail display into close proximity, in terms of both material detail and a new approach to customers/visitors. In contrast to the unapproachable formality of its predecessor on Fifth Avenue, the new store makes the culture of Steuben immediate and apparent, responding flexibly to changes in the seasons and in the product portfolio. It appeals to a new generation of buyers.

The company's extraordinary collection of crystal and glassware has the character and fascination of an artwork display and, appropriately, Ralph Appelbaum explains: 'Our main job was to stay out of the way and let the glass be dominant.' Reinforcing the dialogue between retail and fine art, the basement space houses an actual gallery, sponsored by Steuben. The culture of the company is further communicated through educational videos.

1. Section showing the mezzanine, main sales floor, and basement art gallery.

2. Along the wall on the main sales floor, the glass sits inside lit slots, where it can be viewed from various angles.

3. The mezzanine is surrounded by a moveable curtain and hangs from steel supports for a floating effect. The space features museum-style cases that house one-of-a-kind pieces.

4–5. From left: plans of the main level and mezzanine.

Given that glassware is on display the nature of light, both natural and artificial, and the quality of material surfaces was particularly significant in the design. Two bays of windows to the street, 7.6 metres (25 feet) high, open up the interior dramatically, and fill it with light filtered through a veil of scrim. At night, a computer-generated program projects multicoloured lights off the convex underbelly of the mezzanine. The store is constantly animated by light, and colour is refracted from every piece of glass.

Most of the display features are modular and movable to provide the flexibility for seasonal displays to be installed. Scrim curtains are suspended from ceiling tracks to allow uncomplicated backdrops to be created, or to alter the spatial definition without disruptive building. Tables are finished in various surfaces and textures, and some incorporate plasma screens and illuminate the glassware from inside. Their nature can be changed to match a season or selection of products. In contrast to these sparkling displays, other walls and shelves are lined with deep-blue, faux suede.

The mezzanine is reserved for collectors and corporate accounts. Hung on steel supports, its form recalls that of molten glass in the process of being blown and it seems to hover over the main retail area. It can be screened off by a curtain, to develop a sense of intimacy with individual works: around its edge are stainless-steel and glass display cabinets containing Steuben's most important engraved crystal. A more classical arrangement of pedestals occupies the centre of the ground-floor space, and both this level and the mezzanine are connected to the basement gallery by a central stair.

This design changes the relationship between the retail display and the customer. There is a clear crossover between sales area, gallery and museum as the experience of the store is open, educational and visually rich. Along the wall on the main sales floor, for example, the glassware is inside illuminated slots where it can be studied from different angles, and visitors/customers are invited to congregate around the circular display tables and experience it close up. A museum-like educational experience is created in a retail environment.

2

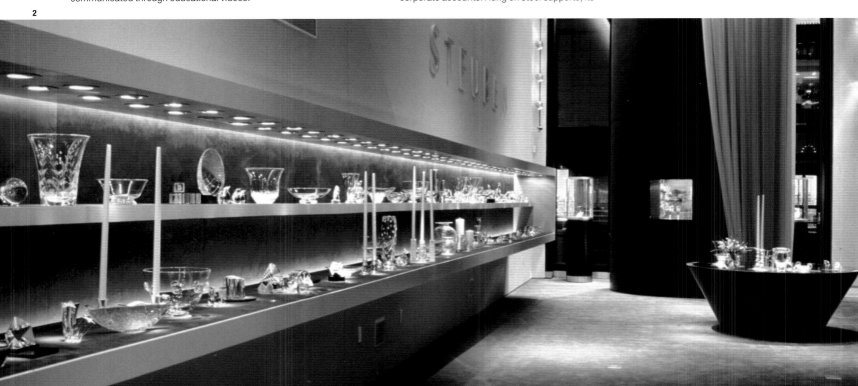

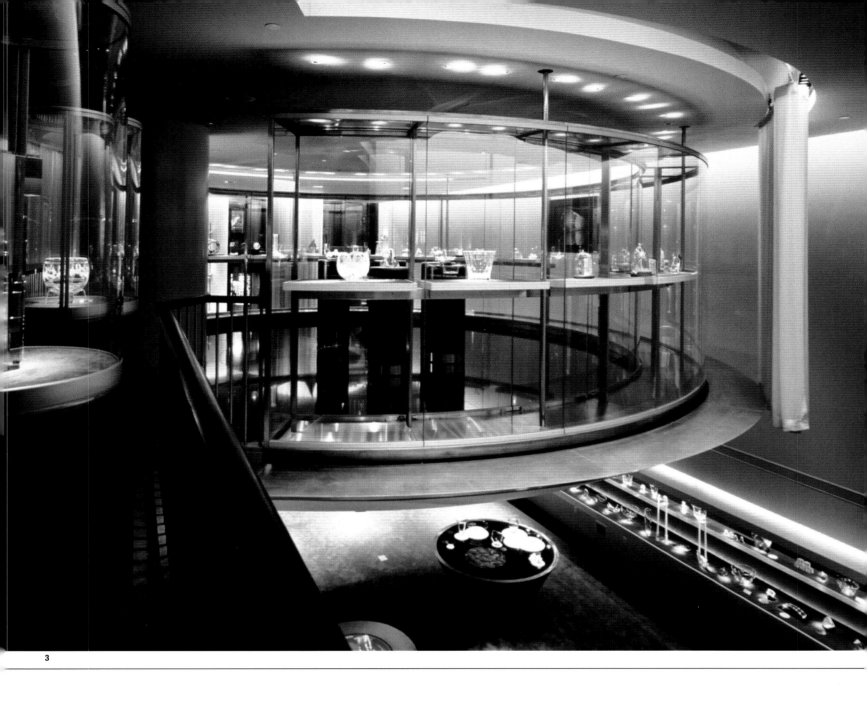

3

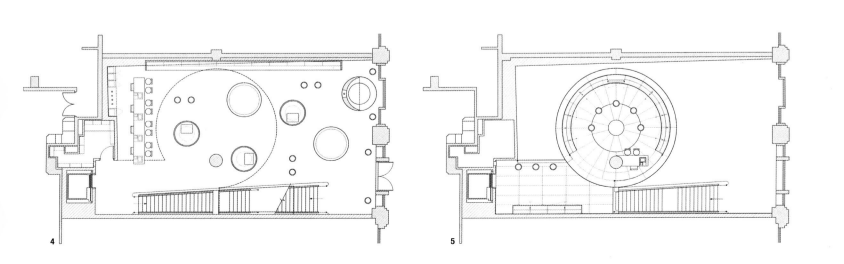

4

5

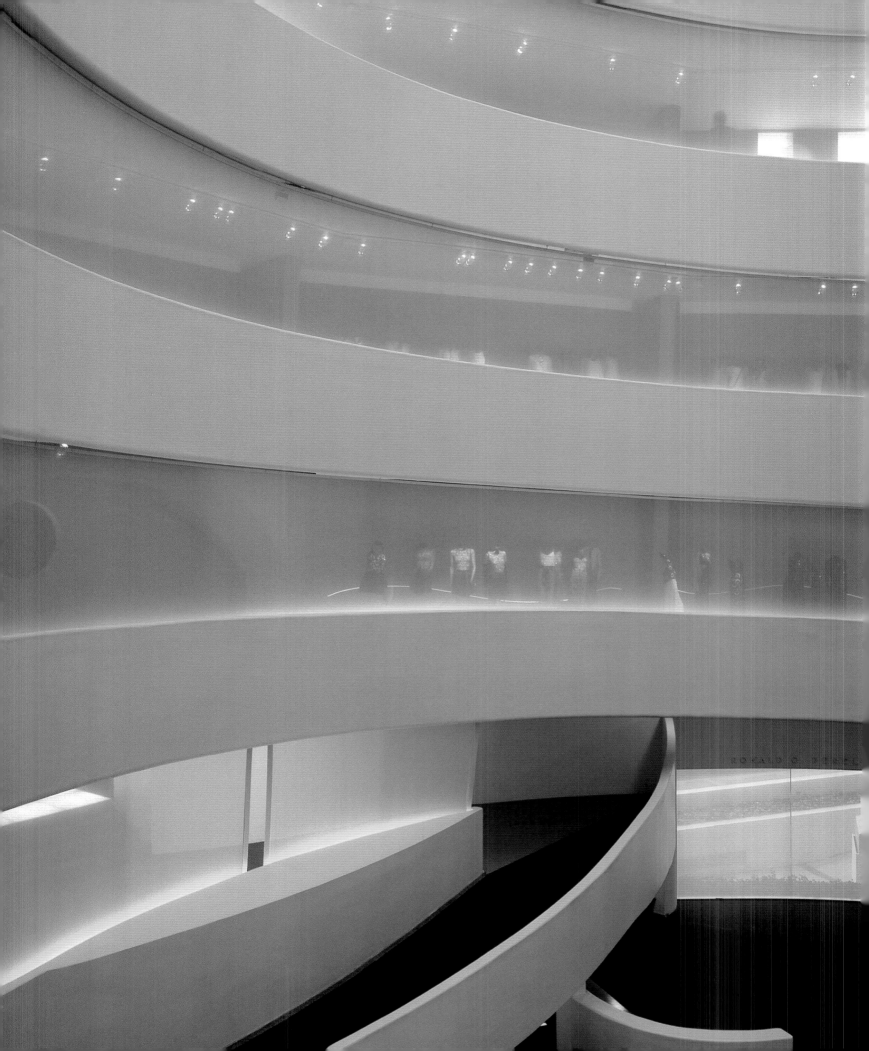

1

3

Giorgio Armani
Robert Wilson

Solomon R. Guggenheim Museum
New York
USA
20 October 2000 – 17 January 2001

Guggenheim Museum
Bilbao
Spain
24 March– 2 September 2001

1. The rotunda was hung with a subtly lit scrim curtain in the Guggenheim, New York exhibition.

2. Scrim wall and display on Ramp 6.

3. Detail of the ground-floor display.

4. Floor-mounted fibre-optic lighting was used to enhance some displays.

Giorgio Armani, produced by the Guggenheim Museum, New York, was a spectacular exhibition dedicated to the career of this designer whose vision altered the world of contemporary fashion. At both of the venues – New York and Bilbao – the installations, designed by the artist Robin Wilson, were theatrical: an array of over 400 exquisitely fabricated and dressed mannequins, spotlit like performers on a stage. Perhaps not surprisingly, they were also marked by a remarkable elegance, a rich materiality and an inventive play of colour, light and shadow. The exhibitions explored subtle and inventive ways in which settings can complement and bring out the style of individual collections.

At the Guggenheim Museum, New York, perhaps the most striking of the stagings, the rotunda lobby, was treated with particular skill. At all levels the gaps between the ramps were infilled with a translucent scrim curtain that brilliantly emphasized the formal qualities of the architecture and offered only a subtle glimpse of the collection behind it, as though the exhibition were a kind of shadow theatre captured on its surface.

Along the ramp there were mannequins, each individually made for the clothes it was wearing, and garments from various periods were hung in narrative clusters and spotlit from a ceiling track. The material and colour of the backdrop varied to set off particular clusters. The floor, identical in colour, seemed to fold up the wall, with only its surface finish changing at the point where it became the backdrop. Elsewhere, the lighting was altered to enhance the garments: for some, floor-mounted fibre-optic lighting danced like long grasses along rear walls, creating patterns of movement against the dark background.

4

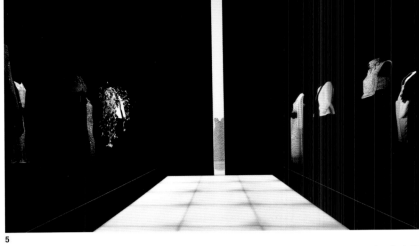

5

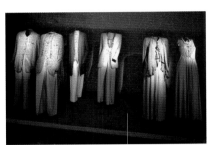

6

7

5. The High Gallery light-box 'runway' on Ramp 1.

6. A 'cracked-mud' effect flooring, with a backlit vinyl background on Ramp 3.

7. Display of film costumes and custom designs for celebrities, Annex level 5.

8– 9. Stripe-effect light-box platforms added drama to this display on Ramp 4.

10. Silver 'mud' effect wall treatment and underlit perimeter in the Tower 7 display.

At the level of the upper ramp the scrim broke away from the edges of the walls and was stretched on tall frames to create curved, semitransparent screens, the colour of which provided a neutral background to the collections at that level.

In several rooms in the tower galleries colour and light were used to different effect. For example, the green in the fabric used in one collection was emphasized and used for the screen that framed the front of the space. The screen appeared darker against the illuminated mannequins beyond, and its design contrasted with the relative informality of the collection. The most striking of a number of lighting sources was a strong light that washed up the wall from the skirting level. This emphasized the stage-like qualities of the floor, which was dislodged from the walls, raised and textured.

The architecture of the screen was reflected in a regular rhythm of recessed ceiling fittings that provided a general level of illumination that was, in the usual manner, augmented with floor and wall washes. The mannequins in the foreground were illuminated more strongly than those in the background, emphasizing the depth of the stage – an effect that was further enhanced by light flickering over undulations in the textured floor. Dark-grey walls created a neutral background for dashes of colour in the clothes; their tone was close to that of the garments and as a result mannequins placed

adjacent to the rear wall looked like the dimly lit figures of anonymous onlookers.

A similar formal arrangement was used for the evening collection. Here, however, two rows of mannequins were set out on either side of a luminous floor. Walls and the podia on which they stood were black, and were thrown into darkness. In the rear wall, on axis, a narrow vertical slot opened and focused attention on one gown. With all the illusion of theatre, there was a sense of a silent architecture of shadows, as though the evening wear was set against the night sky. In contrast to the spotlit clothes, a gentle background light emerged from the floor, which was treated as a light box. In this space there were only clothes and light and shadow,

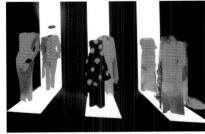

8

9

10

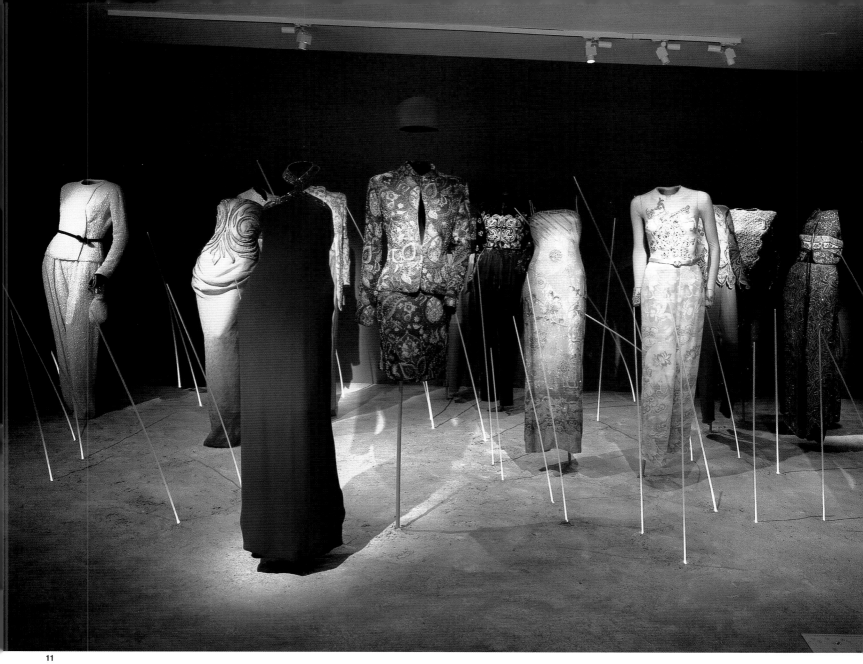

11

11, 13. Fibre-optic 'grasses' swayed among the garments on Ramp 5.

12. Backlit vinyl backdrop on Ramp 2.

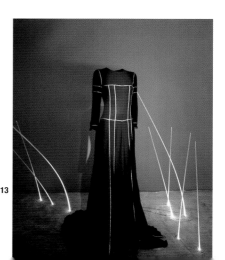

12

13

14. Giorgio Armani directs the crew during the installation at the Guggenheim, Bilbao.

15. Installation of suspended mannequins at Level 3, Guggenheim, Bilbao.

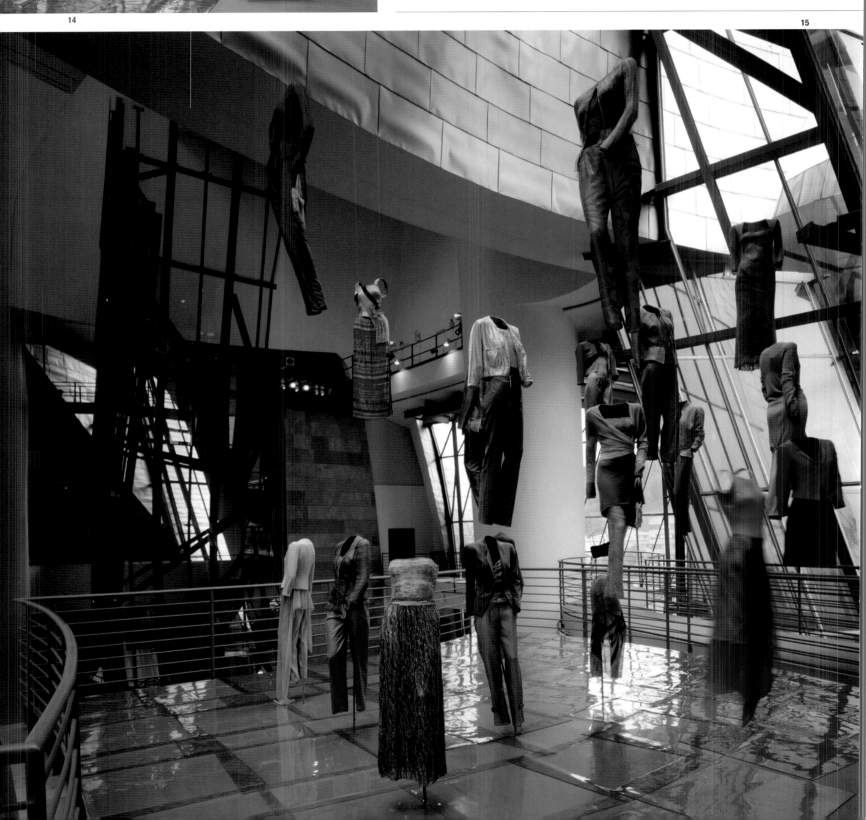

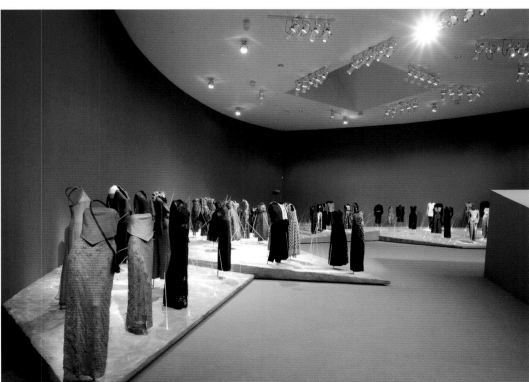

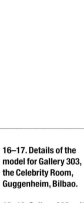

16–17. Details of the model for Gallery 303, the Celebrity Room, Guggenheim, Bilbao.

18–19. Gallery 302, with its central, raised display structure, Guggenheim, Bilbao.

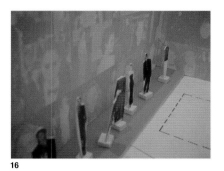

16

17

18

a germane interpretation for a collection that is about variations in black and white.

The character of the New York exhibition remained intact in subsequent venues, but inevitably the architectural conditions required considerable amendments to be made to the original plan. At the Guggenheim, Bilbao, the installation was mostly on level 3. Here, while the proportions of some galleries were fairly conventional, others were more challenging.

In effect, exhibitions on this level are organized around the cascading spaces of the atrium hall. The gallery rooms that surround it vary between conventional enfilade arrangements and those that take on the formal character of the external architecture. Over time, all these rooms have been effectively screened from the shifting natural light of the hall. This meant that the journey around the Armani exhibition, where visitors engaged with the atrium several times, was measured by a rhythm of open and closed spaces.

The hall was further exploited to house one of the more original displays: a group of mannequins, suspended at various heights, occupied a large balcony. The installation had all the movement of the soaring architectural structures that framed it, and was spotlit to fill the wall of the adjacent gallery with intriguing shadows.

19

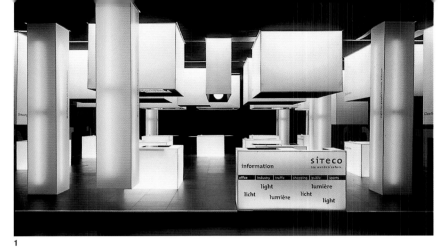

1

SITECO

Light and Building Fair
Frankfurt
Germany
Atelier Brückner
2000, 2002

1. The exhibition's transparent and translucent approach demonstrated the new self-confidence of the company.

2. Graphic light structures made product groups easy to identify.

Temporary trade stands need to communicate brand characters, and must attract, and retain the attention of, visitors. In the past designers have tended to focus on elaborate displays and racks of brochures, perhaps together with a relaxation area. In line with new retail trends, however, the emphasis has shifted from 'display design' to designing an experience. This visitor-focused approach integrates the nature of the welcome, the choreography of the time spent on the stand and the packaging of material that visitors take away into the overall image of the branded environment. The memory of the visit is all-important.

Designing a stand for lighting devices poses a particular challenge that concerns scale and is also especially relevant to the display of contemporary digital equipment. For this, the design has to mediate between the scale and anonymity of the hall and the more intimate environment required for effective close-up inspection of the product portfolio or catalogue. It has to be sufficiently striking to compete in the main arena, but must also create a localized experience that retains visitors and effectively communicates the brand character.

At the SITECO stand Atelier Brückner developed an imaginative image of a kind of luminous landscape which worked effectively with the darkened background of the trade hall. Using the idea of light and dark, and assuming a simple formal vocabulary, they created an archipelago of translucent boxes that travelled across the dark floor of the stand and invited visitors to walk through them. More boxes hung from concealed fixings in the ceiling, making a constantly changing 'crystal cave'. It was not considered necessary for visitors to be able to inspect them; instead, the technical performance of the luminaires was illustrated by the variations, over time, in the colour and intensity of the light boxes.

Once on the stand, visitors found that the dramatic archipelago was in fact primarily a display of the brand portfolio – digital projections provided a virtual catalogue on the surfaces of the floor-mounted boxes. Graphics, projections and display modes were carefully integrated: empty cabinets flanking the stand held large-scale translucent graphics let onto glass. In this way the name 'SITECO' seemed to be immersed in the light of its products.

2

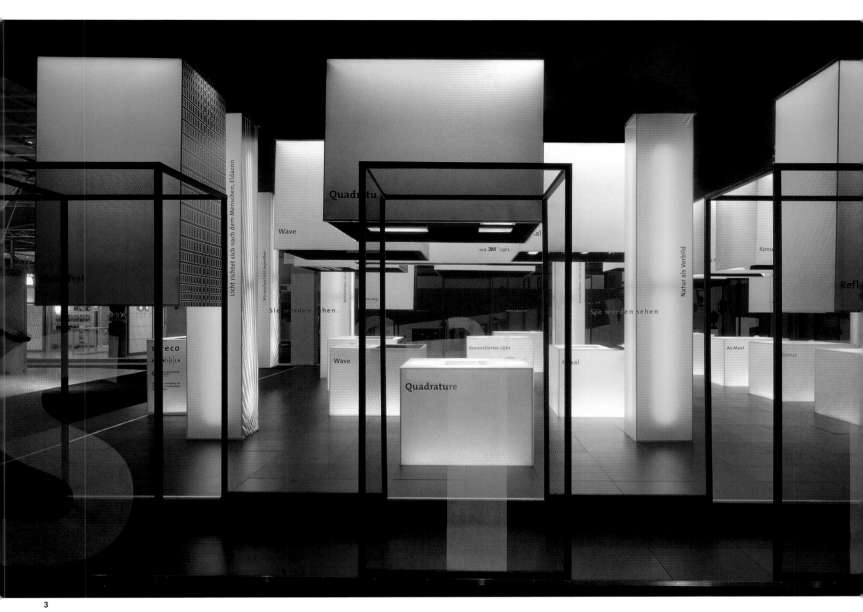

3

3. Fully functional products, lowered down from suspended light cubes, could be operated by media panels integrated in the floor-level cubes underneath.

4. Light choreography was periodically changed to attract visitors.

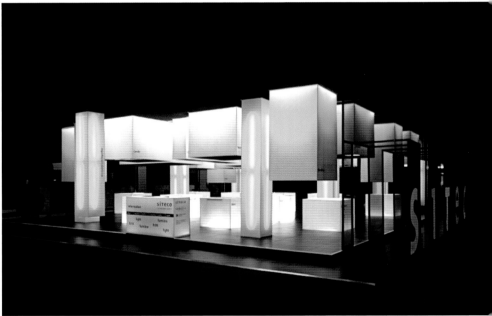

4

Halls of Vertebrate Evolution

American Museum of Natural History
New York
USA
Ralph Appelbaum Associates
1996

1. In the Hall of Saurischian Dinosaurs skeletons were re-articulated to reflect current scientific thinking and were 'freed' from cases for greater visitor accessibility.

2. In the Hall of Mammals and Their Extinct Relatives the science of cladistics is explained via floor diagrams, node panels and skeletal displays.

3. Plan. 1. Hall of Saurischian Dinosaurs, 2. Hall of Ornithischian Dinosaurs, 3. Mammals and Their Extinct Relatives, 4. Orientation Center, 5. Hall of Vertebrate Origins.

4. In the Mammals Hall equine evolution is shown at right, with mammoths beyond. The new halls are light and airy, with restored fenestration replacing the 1950s black-box renovations.

For the Halls of Vertebrate Evolution in the American Museum of Natural History, New York, Ralph Applebaum Associates orchestrated the renovation of six major exhibition halls, and created a new interpretative environment for the world's greatest collection of fossil vertebrates. The new halls, comprising 465 square metres (50,000 square feet), are joined in a single, floor-wide loop, and combine the atmosphere of a classical exhibition of vertebrate palaeontology with contemporary video, graphic and interactive elements.

The journey through the halls is one of an unfolding and varied narrative. The displays in this 'museum within a museum' include theatre presentations, an evolutionary pathway, fossils that can be touched, labels written for children, computer interactives and a highlights tour of the collection's outstanding specimens.

Representatives of all the major groups of vertebrates, from jawless fish to dinosaurs and mammals, are displayed with their closest evolutionary relatives. Visitors can walk round mammoth and mastodon skeletons as well as the dramatically mounted Tyrannosaurus rex and Apatosaurus. Although the focus is on

1

2

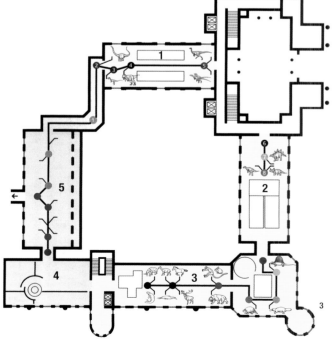

3

4

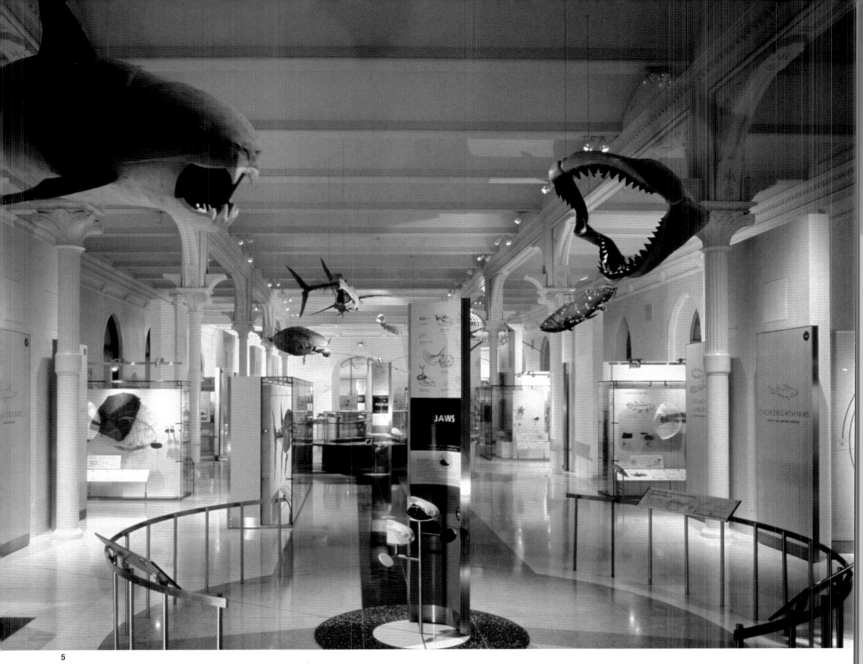

5

6

5. Vertebrate Origins
is the first in the
evolutionary cycle, but
was the last hall to open;
it represents the
culmination of the
design, with suspended
specimens and
restoration of the Calvert
Vaux architecture.

6. Extensive information
is compressed into
discrete graphic
'packages'; here they
describe various
aspects of a hard-
shelled mammal.

7. Detail of a node panel,
with a 'touchable' model
of the new evolutionary
feature being discussed.
Behind it, a wall-sized
diagram depicts the
evolution of various
dinosaurs.

fossils, footage of their living relatives and artistic re-creations add a further dimension. The exhibition halls are interrupted with orientation spaces (especially useful for school groups).

Skeletons are generally in the open rather than in cases, and the exhibition breaks with the typical chronological organization, relying on a classification method known as cladistics to group fossils by shared physical traits. 'We wanted to lay the exhibit out as if you were moving along a family tree rather than a time line,' Ralph Appelbaum states, and suggests that the key was to provide visitors with a 'compelling narrative'. At various points shared characteristics – from grasping hands to three-toed feet – are described and illustrated by specimens. An evolutionary path is traced, both literally and figuratively, through the halls.

The exhibition is characterized by a sense of accessibility, quite unlike the experience of a typical fossil collection. This is in part a result of the design, the generosity of the layout and the transparency of barriers, but it is also because of the way in which information is handled – in hierarchies from text panels, to computer stations, to curators describing the fossils.

1

6 COMMUNICATION, COLOUR & GRAPHICS

Contemporary exhibition design is concerned with forms of communication that are inclusive and that integrate issues of access: all visitors, regardless of disabilities, should be able to gain equal benefit from exhibitions. This is simply a way of thinking about public places and it will affect initial strategic decisions as much as it does their detailed resolution. In this context, the creative use of graphics, colour and sound can be key to creating effective displays and a legible structure.

Graphics, colour and sound play an important role in inclusive design. With growing emphasis on visitor experience, all three are combined to communicate effectively, to convey character and to enhance the experience of an exhibition. While there will always be material that demands subdued graphics, neutral colours and quiet, this traditional museum and gallery display now tends to be substituted by more creative and colourful arrangements, as boundaries between cultural and commercial display blur. Increasingly, multi-media displays, either on screens or projected, synthesize these traditional areas of exhibition design, enhancing the communication of information.

1. *Cities on the Move*, OMA, Hayward Gallery, London, 1999. Graphics set onto the faces of cantilevered boxes take on an architectural character.

2–3. *Les Années Pop*, Pompidou Centre, Paris, 2001. A neutral background (left) is used to offset delicately coloured exhibits, while on the right, colour, light and surface create a sculpted landscape pitched against the Paris skyline.

Moving and interactive display technologies use familiar forms of contemporary entertainment to convey information and increasingly challenge conventional dialogues between installation and graphic design. On the one hand a word, an emblematic colour or a logo can be elaborated in three dimensions to engage walls of enclosure and so, like a kind of figurative architecture, become spatial. On the other hand, animated, projected graphics can form a constantly shifting pattern of information and images that can respond to visitor comments and movement patterns.

Whether real or projected, the power of graphics will depend on the effective play of scales of typeface, image and colour in the setting of the installation and in relation to the exhibited artefacts. There is much creative work relating to this field and it was the focus of, for example, the exhibition *Art et Publicité* held at the Pompidou Centre, Paris, in 2000.

In contrast to the dynamic fragmentary spaces and graphic treatment in *Cities on the Move* at the Hayward Gallery, London, the simple visual impact of graphics and advertising artwork in *Art et Publicité* had an appropriate

dialogue with the scale and proportion of the installation.

The play of scales and horizons of graphics and colour will affect the way the visitor moves through and approaches the exhibition and, as in any form of display, effective visual communication will depend on levels of illumination. This affects colour rendition and subsequently contrast levels between a text and its background (in general terms the clearest visual band is between 750 and 2000 mm (30 and 78 inches) above floor level. Text and objects that require more detailed study are best located within a narrower band of 1200 to 1600 mm (47 to 63 inches)).

Like graphics, the use of colour in exhibition design will depend on the context, the nature of the exhibition, the scale of space and the lighting strategy. In a similar way, the traditional dark or subdued tones and material coverings of museums and galleries are slowly giving way to livelier colours in more experimental displays. In this sense, and arguably rightly so, 'cultural' display appears conservative alongside commercial exhibitions, where colour is often a key component of a brand character. At the

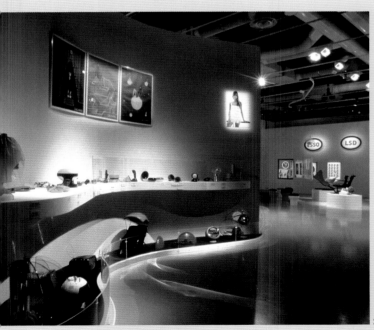

2

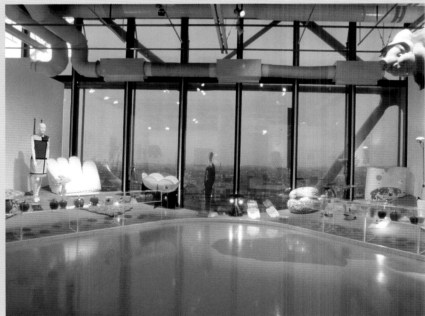

3

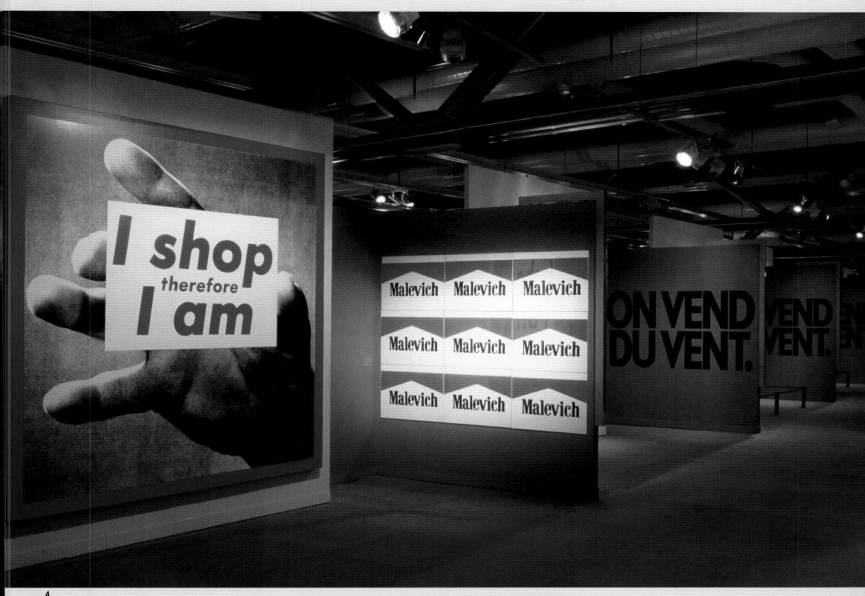

4

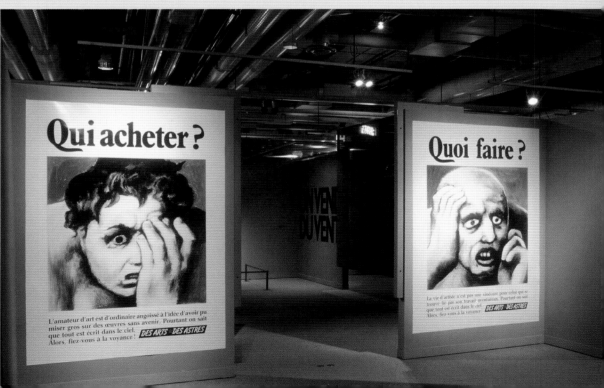

4. *Art et Publicité*, Pompidou Centre, Paris, 2000. The simple rhythm of the dividing walls created an appropriate display for large-scale advertising work.

5. *Art et Publicité*. The clarity of the graphic communication is here enhanced by the muted tone and simple structure of the installation.

5

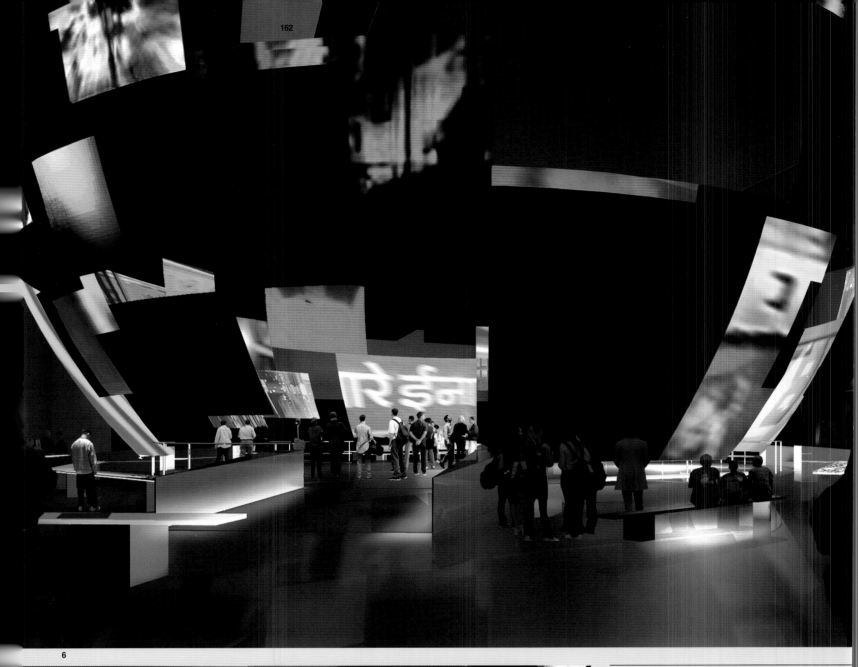

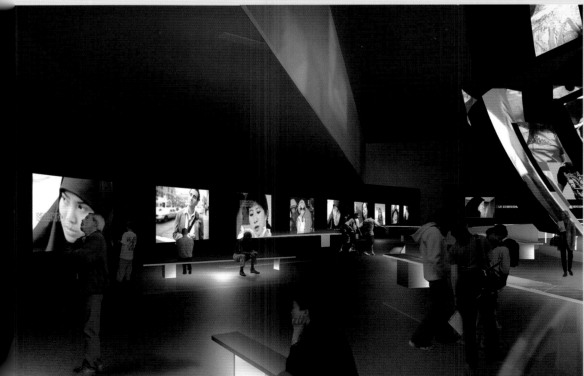

6. *Voices*, Ralph Appelbaum Associates, Barcelona Forum, 2004. This exhibition explored aspects of human communication using an iconic sphere that represented images of cultural diversity in a spectacular display of light, colour and sound.

7. At *Voices*, in addition to the central sphere, global languages were celebrated using speaking tables and perimeter projections.

same time, museums and galleries are keenly sensitive to the dialogue between colour and the exhibited object: inevitably the use of colour for, say, an exhibition of paintings (of almost any sort) offers less room for experimentation than a display of museum artefacts or even photography. In each case the use of colour should be judged against its relevance to the given exhibition and the objects on display. The predominance of the off-white modern gallery interior, for instance, would seem, because of its perceived neutrality, more a matter of convention than necessarily always appropriate: a dark work is not necessarily best seen against a light surface.

Of course colour can also be used more independently of exhibits to enhance a particular spatial topography or to draw attention to key elements within an exhibition. This was particularly well-judged in *Les Années Pop* at the Pompidou Centre, Paris, 2001, an exhibition devoted to design of the 1960s. Here, use of colour and graphic treatment was adapted in accordance with each particular display setting. In a commercial environment, a brand will invariably be linked to a colour that

8. Kodak display, Photokina, Atelier Brückner, Cologne, 2000. The familiar colour code on the Kodak film box inspired the exploration of colour as the theme of the installation.

9. At the Kodak display, circulation routes were marked using Kodak-coloured pathways, while three-dimensional graphics identified themed displays.

often becomes key to brand experiences. In one particular example, Atelier Brückner designed the Kodak display at Photokina (Cologne, 2000) taking colour as a quality, product and orientation principle for a 6,000 square metre (21,500 square foot) trade stand. The colour programme was the content of the stand and the means of orientation within it. Developed from the colour code on Kodak's film boxes, as a symbol of the quality of Kodak products, solid blocks of colour formed pathways through the stand, intentionally referring to Kodak's originality and innovation.

Like colour, sound is a vital element of a visitor's experience of an exhibition. Despite the proliferation of audio-visual displays, sound itself remains a relatively underexplored aspect of the exhibition experience. In part, this is because it is relatively difficult to contain – rather than produce – sound environments, particularly for temporary exhibitions. As a result, installations that require specific acoustics are isolated from other areas of the exhibition, using acoustic lobbies to provide a passage where sounds fade in and out. The openness of the *Voices* exhibition in the

Barcelona Forum (2004), designed by Ralph Appelbaum Associates, challenged this convention: the exhibition, which explored a variety of aspects of human communication, was anchored by a large iconic semi-sphere, (12 metres/39 feet high with a diameter of 30 metres/98½ feet) that hosts an informative and emotional audio-visual component about human communication and cultural and linguistic diversity. The perimeter of the space is defined by a series of projections that present spoken languages around the world and statistical information about each of them. Between the perimeter wall and the curved wall numerous tables speak to visitors about the world of communication and the ways in which people and languages come into contact. The sense of difference between the local spoken language and the visual impact of the whole theatre of language effectively deals with the principal theme of the exhibition, celebrating cultural and linguistic diversity.

1

Outdoor Systems, Indoor Distribution
Neue Gesellschaft für Bildende Kunst
Berlin
Germany
Julie Ault and Martin Beck
June–July 2000

**1. The main gallery
space was like a long
corridor, with a large
image at one end.**

2. Gallery model.

**3. Rendering of the
gallery space with the
supergraphic floor and
walls colour scheme
imposed on it.**

Outdoor Systems, Indoor Distribution explored boundaries between installation art and exhibition design. An experimental temporary exhibition, it was a product of Julie Ault and Martin Beck's ongoing engagement with concepts of space and urban form. It drew on their experience of Los Angeles, and looked at the ways in which particular spaces are negotiated as integral parts of an urban metabolism.

Realized at the Neue Gesellschaft für Bildende Kunst in Berlin, the installation was about the conception, articulation and enactment of space, and how this plays itself out in the fields of architecture, urban development and design: 'We conceived the exhibition as a model, as if the space itself would be a testing ground for how certain spaces can be constructed, and how that process can be shown within the format of an exhibition.'[1]

The entrance to the gallery was like a long corridor, with the far wall on which an introductory text was located visible through a large, glass screen. The flanking wall beyond was lined with wallpaper that depicted the city, emphasizing the central theme of the exhibition.

The heterogeneous field of displays was held together in part by the coherence and visual impact of the painted floor, which extended throughout the long gallery and was continued up the wall surface. Its strong lines effectively drew the fragmentary space together as a pattern of movement, and its colours inflected visitors' perception of the gallery. The pattern was derived from an aerial photograph of a complex highway interchange in Los Angeles: 'Reminiscent of optical/spatial experimentation begun in the 1960s (later termed super graphics), the treatment metaphorically superimposed the gallery's space with the space of an interchange, which suggested continuous movement throughout.'[2] To communicate this, an image of the intersection was placed underneath Perspex on a table-like structure near the entrance with two further wall-mounted panels nearby.

The shifting colours of the floor set up an effective background for the materiality and more neutral tones of the corrugated packaging card that was used to make several display surfaces. A large sheet of this propped against a wall located a cluster of images – some were

2

3

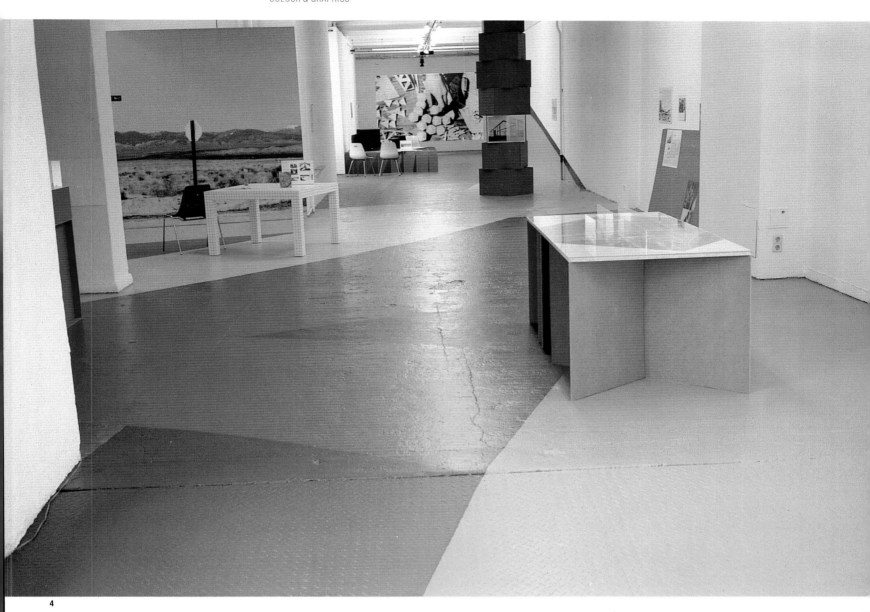

4

4. An image of the highway intersection that inspired the colour pattern on the floor and walls was displayed on a table near the entrance.

5. Detail of the video monitor and enlarged image on the end wall of the gallery 'corridor'.

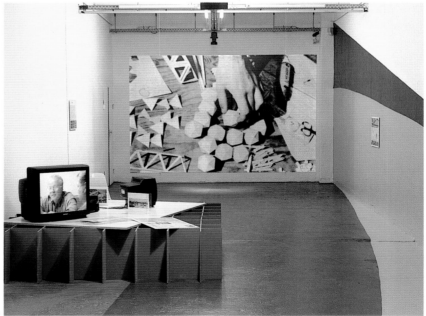

5

Outdoor Systems, indoor distribution ist das Resultat unserer längerfristigen Beschäftigung mit spezifischen Konzepten von Räumlichkeit und der sich daraus ableitenden Formen in den Bereichen Stadt, Mobilität, Architektur und Wohnen. Gleichzeitig beschäftigen wir uns mit dem Ausstellungsraum und Ausstellungsdesign und wie bestimmte Präsentationsformen Betrachtungsprozesse steuern.

Obwohl viele der ausgestellten Elemente unserem gegenwärtigen Lebensmittelpunkt Los Angeles entstammen, hat das Wissen um Berlins Zustand als eine Stadt, die von weitreichendem Neu- und Wiederaufbau (und vom gleichzeitigen Ausstellen ihrer selbst) bestimmt wird, die Entwicklung und Gestaltung dieser Ausstellung beeinflusst. Der die Stadt Los Angeles prägende Prozess ständiger urbaner Expansion, wie er hier fragmentarisch abgebildet wird, und die anhaltende Veränderung Berlins, in die hinein diese Ausstellung vorübergehend projiziert ist, stehen sich als Metaphern aus Stadtentwicklungsprozessen gegenüber.

Überlagerung und Gegenüberstellung – Techniken, die herkömmlicherweise mit Montage in Verbindung gebracht werden – wurden von uns angewandt, um innerhalb der Vielfalt des gezeigten historischen und zeitgenössischen Materials Dialoge zwischen den einzelnen Elementen aktiv werden zu lassen. Die Ausstellung kann in ihrer Gesamtheit als ein metaphorisches Puzzle zu Produktion und Konsum von Räumlichkeit verstanden werden.

Outdoor Systems, indoor distribution is an outcome of our ongoing engagement with particular concepts of space and their consequent forms: urban, transit, architectural, and residential. We are equivalently engaged with exhibition space and design, and with display choices which affect viewing processes.

While many of the exhibited ingredients are derived from our recent living environment of Los Angeles, alertness to Berlin's status as a city engaged in extensive (re)construction, as well as in exhibiting itself, has influenced the shaping of this show. The steadily expanding urban condition of Los Angeles represented in fragmentary manner herein and the ongoing transformation of Berlin into which this exhibition is temporarily projected are juxtaposed as metaphors of development processes.

We have employed superimposition and juxtaposition – techniques generally associated with montage – to activate dialogues between elements within the diversity of historical and contemporary materials on display. In its entirety, the exhibition may be understood as a metaphoric puzzle about production and consumption of space.

– Julie Ault, Martin Beck

6

7

6. Introductory text was imposed on a transparent, glass screen at the entrance to the exhibition.

7. Collage-like wall display.

8. A column of corrugated cardboard boxes.

8

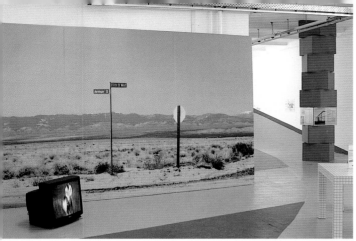

9

10

within its frame, but others were placed adjacent to it on the wall. Ault and Beck's observations of complex boundaries at an urban level seemed to be underscoring a display technique that used the edges of this everyday material to articulate a kind of boundary or edge between the exhibits placed on either side of it. Between the exhibited panels visitors read a third space that crossed the boundaries, or edges, of the card.

The same material was used to make a column of boxes that was loosely stacked to one side of the main passage. If the sheet of card was to do with the wall, this combined the floor and ceiling as active elements in the space of display. An image set onto the column, and located at the horizon of the first box, was like a foreground to, or fragment of, a large-scale graphic panel that occupied the rear wall of the space. The same image appeared, as though mirrored, on a second face of the column and was echoed, as a projection of a similar dimension, on the flank wall. Similar juxtapositions occurred throughout the exhibition, and promoted an active visual engagement with the display space that was

9. A vast desert landscape was juxtaposed with floor-mounted video terminals.

10. Images projected onto the column on the right of the image were echoed in the projection onto the adjacent wall.

11. The gridded table and everyday moulded plastic chairs formed the intimate base for small Perspex-mounted displays.

ultimately driven by a structured dialogue between collage-like fragments.

Beyond the column was a table, and what appeared to be a setting for conversation. This surface read like a panel of the wall itself, as loose display panels and a monitor were set onto it. In contrast to this montage board-structure, another table was made entirely of a white, gridded surface and was more object-like. Flanked by two simple chairs, the arrangement was almost domestic in character. The table formed the base for small exhibits, mounted in Perspex, that stood vertically like everyday wear-resistant information – a display motif that was repeated through the exhibition.

The intimacy of the table was juxtaposed with the vast desert landscape that filled the adjacent wall. Between the two was a floor-mounted monitor with exposed wires and video players, a casual 'arena' to inspire curiosity about the meaning of this unconventional display. Uncovering its relevance required creative involvement with the exhibition and its content – a movement, questioning and openness that is quite distinct from the regimented learning experience of more narrative-based work.

Ault and Beck explored the boundaries of display technique to re-present their observations of urban topographies. Unconventional spatial arrangements provoked a thematic dialogue between the objects on display. Diverse elements of the fabric – wall, floor, table, column or even service pipes – were brought into play using a range of permanent and temporary techniques, 'images, films and videos, graphics, publications, fixtures, photographic backdrops, and texts, which were manipulated, superimposed, and put into dialogue',[3] to speak directly and precisely of the nature of this particular aspect of contemporary urban environments. In so doing, the exhibition challenged the conservatism of conventional gallery display and recovered the experimental in exhibition design.

11

2

Experience Music Project

Seattle
USA
Frank O. Gehry Associates
2000

1 Overall wire-frame
axonometric of the
building's external
envelope, which is
based on a crushed
electric guitar.

2. The Sky Church
performance area.

3, 5–6. Exhibition areas
were installed into the
building's dynamic
forms.

4. Plan at entrance level
showing the complex
internal spaces in which
the displays had to be
accommodated.

The building that houses the Experience Music Project in Seattle was designed by Frank Gehry using the CAD system CATIA, originally developed for the design of aeroplanes. A cluster of irregular spaces contains galleries dedicated to the recent history of largely American, modern popular music, and the colourful and exuberant exterior of the museum was apparently inspired by the shapes and colours of guitars, and the rhythms of the music.

The galleries are organized in part historically and in part thematically. Themes range from the Guitar to Hendrix, through Punk to Hip Hop, and trace the multifaceted aspects of rock and roll. Each section is a montage of biographical notes, artefacts, pictures, videos, narratives and other memorabilia. The galleries combine conventional displays with innovative, interactive communication devices, multimedia exhibits and hands-on electronic music. The entire experience is integrated with the museum's website (www.emplive.org).

The specially developed Museum Exhibit Guide (MEG) is in a double-height space, the Sky Church, located off the entrance foyer. This is designed to be a place where artists gather and

exchange ideas, and write and make music. It houses multiple speakers, projection and elaborate lighting rigs, and a giant video screen capable of playing six music videos at once. A lightweight, custom-designed PDA runs Microsoft Windows CE, and opens up layers of information, video and sound, associated with visitors' interests as they select what they want to see and hear.

MEG makes infrared contact with display cases. It has an interface similar to a web browser and downloads information. Once a selection of narratives, and audio and video information has been studied a further page offers a menu of numbered items that correspond to the relevant section of the exhibition. Visitors are able to bookmark pages to replay a particular selection elsewhere in the museum, in the Digital Labs on the lower floor or, later, on the museum website.

Among other attractions is the Sound Lab on the upper floor, where visitors use interactive technology to play electric guitars, keyboards or drums, and are able to create their own music. At On Stage anyone with enough enthusiasm can then perform the music to a fictive audience.

3

4

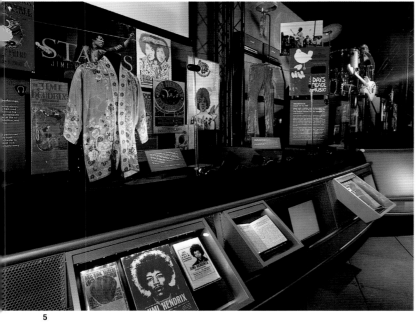

5

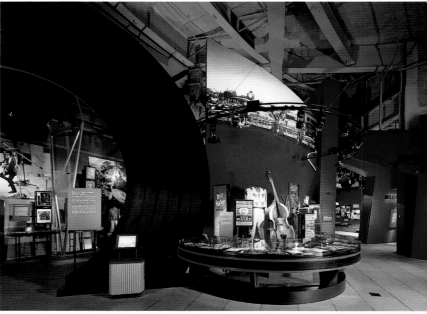

6

1

2

3

1. The ground-floor Internet café welcomes visitors and captures their attention with the dynamic content of the video screens.

2, 6. Colour and imagery were used to denote different product groups.

3. Two- and three-dimensional elements were derived from the same creative concept.

4

5

Samsung Brand Showcase

Moscow
Russia
Imagination (USA), Inc.
2003

Imagination's work with Samsung has evolved over time to fit a shifting brand message. What is particularly interesting is the coherence of their approach to design throughout the company's projects. In each case there is little sense of a 'house style'. Rather, each project interprets the character of the brand message, and looks to supply the sometimes complex information, in new ways.

People gain this information through participatory engagement with the installation: by doing something – and not always doing something that is functional. For example, software drivers might be specially compiled to give them a goal to achieve, and through perhaps unrelated pathways the information will be learnt. Imagination interpret the experience of learning about the Samsung product as being the result of creative, thought-provoking and sometimes playful interaction.

4–5. Concept sketches from the original proposal.

Samsung Brand Showcase, Moscow, is situated in the heart of the city, in an existing building that was converted from the ground to the fourth floor. The Russian electronics market was relatively open at the time, and in recognition of the strength of the Samsung brand in this context a radically new approach to display was proposed: this was to be a brand-immersive experience with no sales pitch. Visitors would simply engage with the brand in an uncomplicated way, unhindered by sales staff or information panels, and would be given no opportunity to buy.

The organization is simple with each floor dedicated to a product division or grouping, and members of the public are invited to touch the products and interact with the software. Emphasis is placed on getting people to connect with the brand and understand what sets the Samsung range apart from similar ones.

The vertical circulation through the displays is clear, and the journey unfolds from the top down. Visual links open up between floors through a fluid space. Design elements vary but have a common language at each level; and each floor is broken up with ribbon-like surfaces that fold to form a range of furniture-like elements and transparent spatial partitions. These structure the space in the form of display cabinets or work surfaces, or housings for lighting, screens and graphics. The language is familiar and intimate – on the threshold of the domestic.

Colour plays an important role in identifying each product range. Selected from the Samsung palette, strong ones distinguish the floors from each other and are also used in blocks to emphasize the threshold to each display. Selective areas of brand colours are effectively set against the white ribbons and a canvas-like white background. In this way colour is used spatially, to draw visitors across the space from one product range to the next.

On the exterior of the building, branding is combined with local information. For example, the temperature, time, football scores and traffic news are combined with product listings and animations of consumer groups.

6

1

2

Museum for Communication
Berlin
Germany
hg merz architekten
1997–2000

1. The large top-lit atrium acts as a main reception hall, where visitors are welcomed by robots.

2. 'Topic roads' provide the framework of the exhibition.

3. A display on mobility on the first floor, with luggage in the foreground. An 'exploded' stagecoach can be seen suspended in the background.

This permanent museum exhibition, housed in Berlin's former main post office building, documents the development of modern communication systems and is therefore primarily structured around a historical narrative. However, the display is not a straightforward chronological record. Rather, it is organized around a number of themes such as culture, politics, technology, everyday life and society, and aims to create a context for an important phenomenon of contemporary life: simultaneous communication.

The redeveloped building is, in effect, the largest exhibit, and the project carefully retains a reference to its existing fabric and original layout. At its heart is a generous top-lit atrium that acts as a main reception hall. The galleries that line this space provide access to the main collection halls, whose original character is reinforced with new furniture and display apparatus. In this sense, the existing structure and a rather formal approach to layout serve not only as a simple and clear means of communicating the historical themes, but also as an effective backdrop to a number of 'topic roads' that provide the framework for the

exhibition. Open movement along and between these roads allows diverse correlations between views and topics, and individual experiences of the simultaneity the design achieves between historical fabric, exhibited artefacts, contemporary furniture and display technologies.

The theme of the exhibition is first communicated outside the building with a sound-collage on the façade and a permanent, changing collage of words, in neon, above the entrance. This spirited approach to communication continues in the atrium itself where robots, or *postillons du directeur*, welcome visitors. One of the key spaces in the museum is the Festival Hall. The theme here is acceleration, and this is communicated in a playful manner with fragments of an 'exploded' stagecoach suspended from the ceiling, to express a sense of speed and movement. A similar approach to communication underpins the design of interactive displays, but elsewhere the focus is on conveying information. Finally, there is an 'animating' level where visitors are invited to enjoy experiences and gain insights by designing their own activities.

3

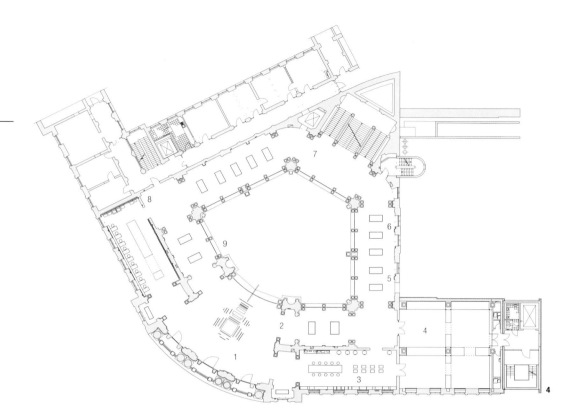

4

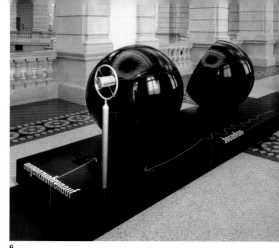

6

7

5

4. First-floor plan
1. Stagecoach, 2. Topic road, 3. Exhibition Hall 2: Art of Writing, 4. Exhibition Hall 3: Acceleration, 5. Private and Public Communication, 6. Self-projection: Institution and Nation, 7. History of Communication, 8. Exhibition Hall 1: Institution and Nation, 9. Acceleration: Industralization, Globalization, Mobility

5. Ground-floor plan
1. Neon writing, 2. Loudspeaker stations, 3. Audio welcome, 4. Information bar, 5. Audio bar, 6. Communications gallery, 7. Visual welcome, 8. Atrium, 9. Worlds of sounds, 10. Tin phone, 11. Smoke signals,

12. International code of signals, 13. Conductor, 14. Acclamation machine, 15. Pause machine, 16. Whispering bowl, 17. Hat-pulling machine.

6. Modern display apparatus, such as these tin telephone balls on the ground floor, reinforce the character of the original host building.

7. Unusual steel tubes are used to display some of the objects and images.

1

Power Up, Reassembled

UCLA Hammer Museum
Los Angeles
USA
Julie Ault
2000

1–2. Collage-like displays emphasized the affinities between the artists' work.

3–4. The exhibition was extended out from the walls using boxes and platforms of varying sizes.

5. Video terminals were interspersed with the artworks.

Organized by the artist and exhibition designer Julie Ault, *Power Up, Reassembled* was originally at the Wadsworth Atheneum in Hartford, Connecticut, in 1997, and then at the UCLA Hammer Museum in Los Angeles, in 2000. It brought together two artists, Sister Corita and David Moffett, who are not obviously related either historically or formally. Sister Corita was a Catholic nun who lived and worked in Los Angeles. Donald Moffett is a New York-based artist, who contributed significantly to the gay liberation and gay activist movements. Corita became known for her screen-prints, working with serigraphs, greeting cards, publications and posters, while Moffett works in a variety of media. In organizing and designing the exhibition, Ault explored the process of exhibition-making as an artistic medium: 'I regard conceptualizing the exhibition's structure and designing its aesthetic atmosphere as an artistic practice.'[1]

She selected Corita and Moffett for the exhibition because of the social commentary in their works, and because of similarities in their working methods – for example, the use of strong graphics as a means of making political messages accessible to a wide audience. It is not surprising that the exhibition used colour and graphics as key three-dimensional elements that metered its pace and spatial structure.

Ault observed that juxtaposition, graphic design and contextualization were key strategies in the work of both artists and explored these working methods in the design of the exhibition: 'These strategies also convey

2

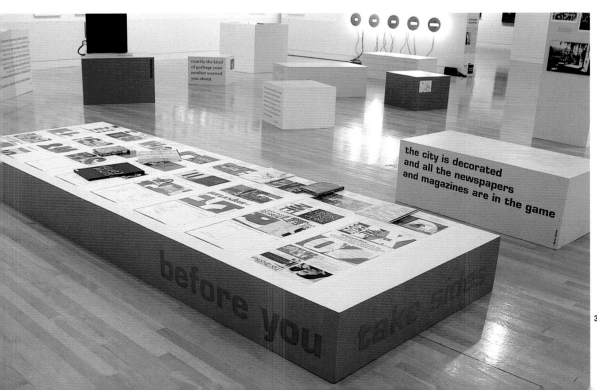

3

4

5

6

principles of a practice that set the stage for and determine the many particulars of this exhibition and how it looks.'[2] In this way *Power Up, Reassembled* became a visual expression of the compositional methodology of the artists, and the resulting display extended the texture and presence of their works: 'Both [artists] have used cut-and-paste techniques to make new unified wholes and to communicate visually. *Power Up* has been shaped correspondingly. Cut-and-paste methods involve taking something out of one context and through recasting, producing another.'[3]

The display was extended from peripheral walls into the body of exhibition space using simple, 'rectilinear box-like forms painted in combinations of white, yellow, light blue, and red. Ascribed with multiple functions, these structures were at once pedestals, platforms, seating, furnishings, sculptural elements, and display surfaces.'[4] Likewise, videos were situated in the midst of visitors. Here there was a political intention of social inclusivity that reflected the artists' productions.

Characteristically, there was also a creative exploration of spatial relationships between

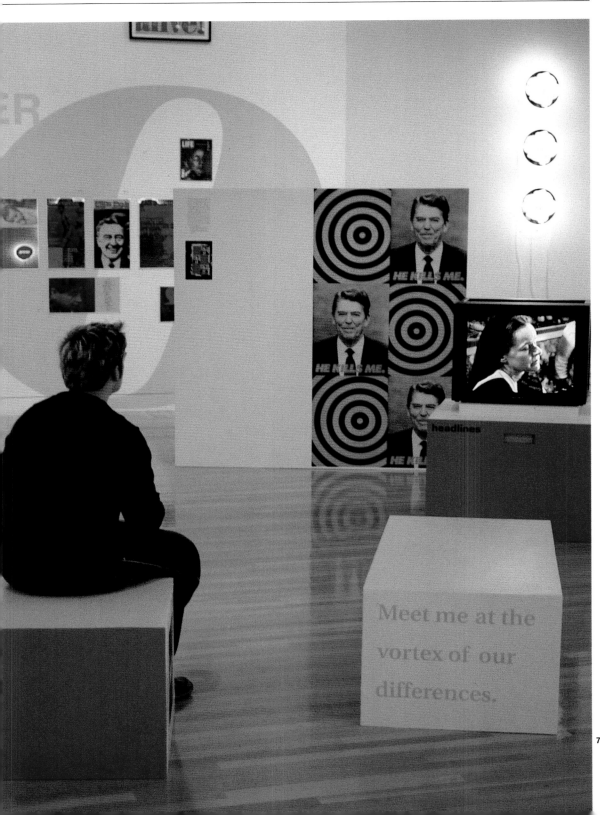

7

displays – between the boxes and adjacent surfaces or between wall and floor (for example, Footnotes and Headlines, a book made by Sister Corita, was displayed on a wall, and colour copies of each page were laid out nearby on the floor). Collage-like, chance affinities and tensions emerged between the works as a consequence of such display methods.

The resulting exhibition was an impressive display of graphics and colour that resonated with the nature of the artworks. Ault also integrated background material – texts and other fragments – uncovered during her research into Sister Corita and Moffett. In effect, *Power Up, Reassembled* was a dialogue between three artists, where Ault's creative practice concerned the placement of the material in order to create a third artwork, a constructed place, formed out of reciprocal tensions between the works of the other two artists. The exhibition challenged 'any clear cut notion of separation between objects, exhibition and the outside world,' and was 'intended to deepen the rich legacy and interplay of art, design, history, politics, and social relevance.'[5]

6. A cut-and-paste approach was taken to the design of the exhibition.

7–9. The exhibition used colour and graphics as key three-dimensional elements to create an impressive and encompassing display.

8

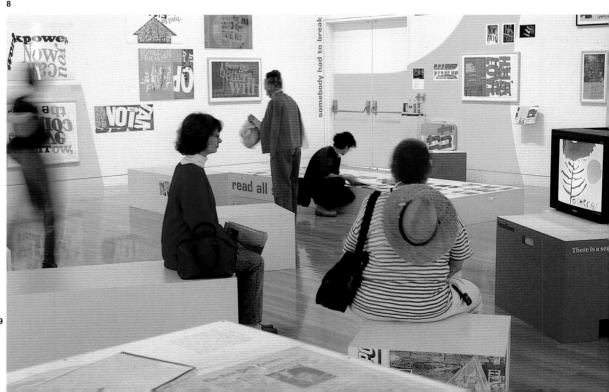

9

1

2

3

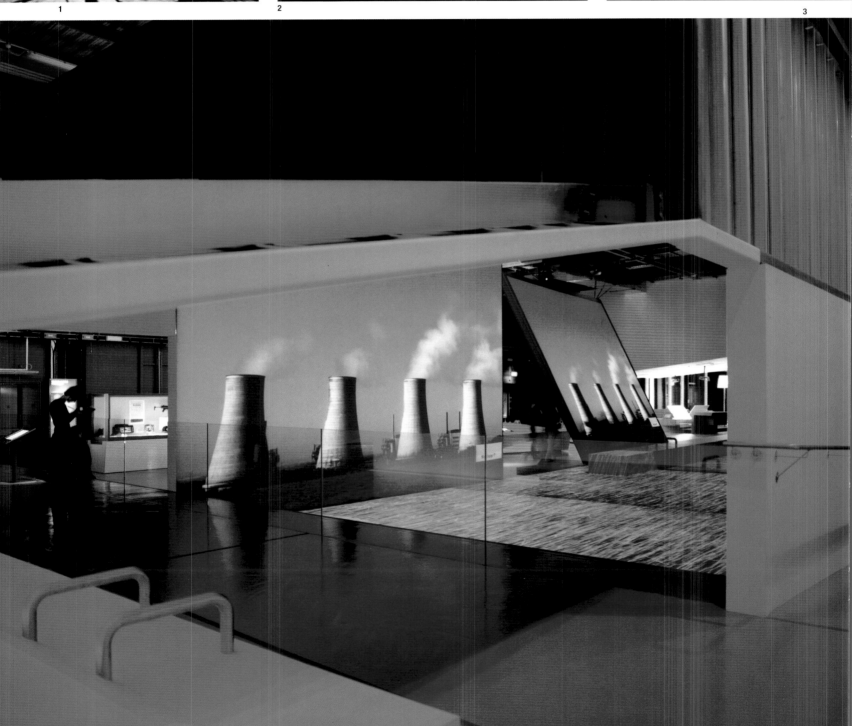

Sparking Reaction

Sellafield Visitor Centre
Cumbria
UK
Casson Mann
2002

1–3. The Core is a rectangular enclosure physically defined, to an extent, by a number of free-standing walls, but completed by the virtual boundaries of a series of 8 by 6 metre (26 by 20 foot) projections.

4. The desire for people to engage with written text – an essential component of an issues-based exhibition – was the starting point for the concept.

5. The projections, designed by Nick Bell, consist predominantly of text that is revealed and concealed in a series of animations devised to intrigue and thus engage the viewer.

Sparking Reaction, at the Sellafield Visitor Centre in Cumbria, is a ground-breaking, interactive exhibition that was established to stimulate the debate about nuclear energy, in particular electricity generation and the role of nuclear power within it, and to present scientific information in a balanced and impartial manner. The initiative, which includes a website, was part of a rebranding of British Nuclear Fuels as the public perception of nuclear energy was seen to be the most important issue facing the industry. The exhibition was developed for BNF by the Science Museum, London, who retained complete editorial control over the content.

Casson Mann structured this permanent exhibition using simple screens and minimal planes, colour and lighting. Artworks and a range of interactive exhibits are combined with an immersive cinema, large-scale projections with more conventional display cabinets.

Written words are at the heart of the concept, and at the centre of the exhibition a space appropriately named the Core houses an installation of large-scale animated text and images that are projected onto the floor and containing walls. The scale of these moving

4

graphics is such that they merge with the architecture of the setting so that the graphics themselves take on a three-dimensional character. They articulate a range of comments, some of which are controversial given the context of the exhibition, but which at the same time underline the intended openness of the nuclear debate: 'The voices calling for an end to nuclear power are increasingly those of hard-

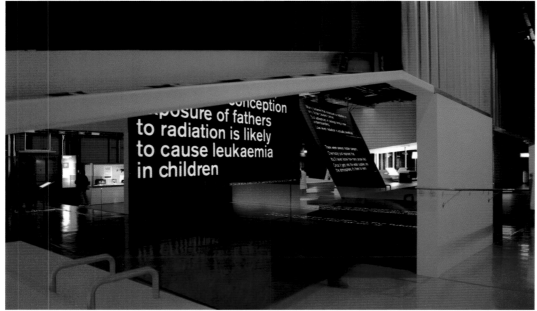

5

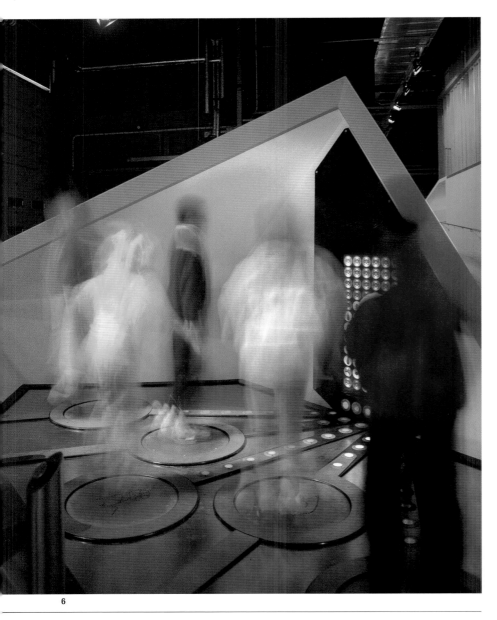

6

6–7. Steel polyhedral forms house interactive exhibits: the colour is a friendly encouragement to get involved while the vibrancy of the fluorescence and angularity of the forms are an edgy reference to the subject.

8. The final space, Think On, has a more familiar appearance to remind visitors that the issues being discussed affect their lives.

9. Plan of the exhibition: the purple steel polyhedral forms can be seen at the top and bottom.

headed analysts, not simply of idealistic environmental campaigners' is juxtaposed with 'Nuclear power is one of the most economic forms of energy production'. The graphics include feedback from visitors, gathered in the interactive Immersion Cinema (the first of its kind in the UK). This was created within a large, steel, drum structure recycled from a previous exhibition. An interactive film incorporates games and activities; it also records the public's votes and choices, which can be projected into the Core.

Flanking the Core are two subject zones: Powering Your Future and Weighing the Risks. These contain a series of steel, polyhedral forms, finished in ultraviolet reactive paint and lit with ultraviolet lights, that house interactive exhibits and database terminals.

The final space, Think On, looks like a domestic lounge. A square, carpeted surface is formed to create a long sofa and two armchairs. A central table holds two angled tablets onto which are projected virtual newspapers. Visitors are encouraged to make comments and read the latest news on the electricity debate.

7

8

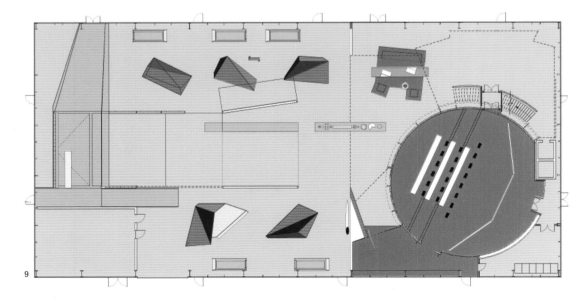

9

Footnotes

Introduction
pages 6–17
1 Serota, N.: *Experience or Interpretation: The Dilemma of Museums of Modern Art* (London: Thames and Hudson, 1996), p.26
2 Ault, J., and Beck, M.: *Critical Condition* (Cologne: Kokerei Zollverein, 2003), p.322
3 Ibid., p.323
4 Ibid., p.390
5 D'Harnoncourt, letter to Stevens, cited in Omer, *The Art of Installation II*, pp.29–30. Quoted in Staniszewski, Mary Anne: *Power of Display: A History of Exhibition Installations at the Museum of Modern Art* (Cambridge, MA: MIT Press, 1988), p.111

6 Taken from Meijers, D.: "The Museum and the 'Ahistorical Exhibition'" in R. Greenberg, B.W. Ferguson, S. Nairne, eds: *Thinking about Exhibitions* (London: Routledge, 1996), pp.7–21
7 Ault, J., and Beck, M.: op cit., p.261
8 Ault, J., and Beck, M.: op cit., p.261
9 Serota, N.: op cit., p.55
10 Ralph Appelbaum, quoted in *Artnews*, November 1997, pp.138–141
11 Ralph Appelbaum, quoted by Juanita Dugdale in *Communication Arts*, May/June 2001, p.50

United States Holocaust Museum
pages 26–29
Ralph Appelbaum, quotes taken from *Artnews*, November 1997, pp.138–41

Orange Imaginarium
pages 56–61
Quotes taken from *Imagination: A Profile* (2003), pp.12–13. See also www.imagination.com

Les Immatériaux
pages 72–73
1 See Jean-François Lyotard: 'Les Immatériaux' in R. Greenberg, B.W. Ferguson, S. Nairne, eds: *Thinking about Exhibitions* (London: Routledge, 1996), pp.159–75
2 Ibid., p.169

Outdoor Systems, Indoor Distribution
pages 164–67
1 Ault, J., and Beck, M.: *Critical Condition* (Cologne: Kokerei Zollverein, 2003), p.380
2 Ibid., p.380
3 Ibid., p.381

Power Up, Reassembled
pages174–77
1 Ault, J., and Beck, M.: *Critical Condition* (Cologne: Kokerei Zollverein, 2003), p.367
2 Ibid., p.375
3 Ibid., p.375
4 Ibid., p.275
5 Ibid., p.375

Selected further reading

Ault, J., and M. Beck: *Critical Condition* (Cologne: Kokerei Zollverein, 2003)

Barker, E., ed.: *Contemporary Cultures of Display* (New Haven and London: Yale University Press in association with Open University, 1999)

Bennett, T.: *The Birth of the Museum: History, Theory, Politics* (London: Routledge, 1995)

Berger, J.: *Ways of Seeing* (London: BBC and Penguin, 1972)

Cohen, A.: *Herbert Bayer: The Complete Work* (Cambridge, MA: MIT Press, 1984)

Crimp, D.: *On the Museum's Ruins* (Cambridge, MA: MIT Press, 1993)

Duncan, C.: *Civilizing Rituals: Inside Public Art Museums* (London: Routledge, 1995)

Fondation de France–ICOM: *Museums without Barriers: A New Deal for Disabled People* (London: Routledge, 1991)

Greenberg, Reesa, Bruce W. Ferguson and Sandy Nairne, eds: *Thinking about Exhibitions* (London: Routledge, 1995)

Schubert, K.: *The Curator's Egg: The Evolution of the Museum Concept from the French Revolution to the Present* (London: One-Off Press, 2001)

Karp, Ivan and Steven D. Lavine, eds: *Exhibiting Cultures: The Poetics and Politics of Museum Display* (Washington, DC: Smithsonian Institution Press, 1988)

Staniszewski, M.A.: *Power of Display: A History of Exhibition Installations at the Museum of Modern Art* (Cambridge, MA: MIT Press, 1988)

Malraux, A.: *Museums without Walls*, trans. Stuart Gilbert and Francis Price (London: Secker & Warburg, 1967)

McClellan, A.: *Inventing the Louvre: Art, Politics, and the Origins of the Modern Museum in Eighteenth-Century Paris* (Cambridge: CUP, 1994)

O'Doherty, B.: *Inside the White Cube: The Ideology of the Gallery Space* (Santa Monica: Lapi Press, 1986)

Index

Project credits

In order of appearance in the book. Designers and other consultants are indicated by *italics*

Ford Journey Zone
Millennium Dome
London, UK
Imagination Ltd
www.imagination.com

United States Holocaust Memorial Museum
100 Raoul Wallenberg
Place, SW
Washington, DC 20024
USA
www.ushmm.org
Ralph Appelbaum
Associates
www.raany.com

British Galleries
V & A (Victoria and Albert
Museum)
Cromwell Road
London SW7 2RL
UK
www.vam.ac.uk
Exhibition design: Casson
Mann
www.cassonmann.co.uk
Graphic design: Rose-Innes
Associates
Lighting design: Richard
Aldridge
Architects: GA Associates

Frank Gehry, Architect
Solomon R. Guggenheim
Museum, New York
1071 Fifth Ave (at 89th St)
New York, NY 10128-0173
USA
www.guggenheim.org
Frank O. Gehry Associates
www.foga.com

Guinness Storehouse
St James's Gate, Dublin 8
Ireland
www.Guinness-
storehouse.com
Imagination Ltd
www.imagination.com

Expedition Titanic
Hamburg, Germany
Atelier Brückner with Götz,
Schultz, Haas–Architekten
www.atelier-brueckner.de
Client: Voyager Titanic
Exhibition GmbH,
Düsseldorf
Producer and Operator:
Voyager Titanic Exhibition
GmbH, Düsseldorf
Curator: Holger von Neuhoff
Historians: Claes-Göran
Wetterholm, Günther Bäbler
Light Design: Rolf Derrer
Sound Design: The Audio
Factory GmbH, Hamburg

Ericsson
CeBIT
London, UK
Imagination Ltd
www.imagination.com

Eureka 'Our Global Garden'
Eureka! The Museum for
Children
Discovery Road
Halifax HX1 2NE
UK
www.eureka.org.uk
Imagination Ltd
www.imagination.com

Orange Imaginarium
Explore At-Bristol
At-Bristol
Harbourside
Bristol BS1 5DB
UK
www.at-bristol.org.uk
Imagination Ltd
www.imagination.com

Hall of the Universe, Hall of Planet Earth
Rose Center for Earth and
Space
American Museum of Natural
History
Central Park West
79th Street
New York
USA
www.amnh.org
Ralph Appelbaum Associates
www.raany.com

Energy Gallery
The Science Museum
Exhibition Road
London SW7 2DD
UK
www.sciencemuseum.org.uk
Exhibition design: Casson
Mann
www.cassonmann.com
Graphic design: Nick Bell

Olympic Rendezvous @ Samsung Electronics
Imagination (USA), Inc.
www.imagination.com

Les Immatériaux
Centre Georges Pompidou
Place Georges Pompidou
75004 Paris
France
www.cnac-gp.fr
Jean-François Lyotard and
Thierry Chaput

Lucent Technologies Centre of Excellence
Nuremberg, Germany
MET Studio Design
www.metstudio.com

Wired Worlds
National Museum of
Photography, Film &
Television
Bradford, West Yorkshire
BD1 1NQ
UK
www.nmpft.org.uk
MET Studio Design
www.metstudio.com

Jean Nouvel
Pompidou Centre, Paris
Address/website as before
Jean Nouvel
www.jeannouvel.fr

The Weather Project
Tate Modern, London
Bankside
London SE1 9TG
UK
www.tate.org.uk
Olafur Eliasson
www.olafureliasson.net

The Samsung Experience
Time Warner Center
10 Columbus Circle
3rd Floor
New York
USA
www.timewarner.com
Imagination (USA), Inc.
www.imagination.com

Hall of Biodiversity
American Museum of
Natural History, New York
Address and website as
before
Ralph Appelbaum
Associates
www.raany.com

Stuttgart in the Second World War
Stuttgart, Germany
Exhibition Design:
hg merz architekten
www.hgmerz.com
Prof. HG Merz
Assisted by Gunther Hetzel,
Evelyn Zellger
Overall/master Concept:
Dr. Marlene P. Hiller,
Christian Glass, Stefan Kley,
Benigna Schoenhagen
Graphic concept: Dietmar
Burger
Assisted by Rainer
Haeusler, Barbara
Trautmann
Media concept: Gisela
Zimmermann

Eyes, Lies and Illusions
Hayward Gallery
South Bank Centre
Belvedere Road
London SE1 8XZ
UK
www.hayward.org.uk
Christophe Gérrard, Critical
Space

The Art of the Motorcycle
Solomon R. Guggenheim
Museum, New York
Address/website as before
Guggenheim Museum,
Bilbao
Abandoibarra Et. 2
48001 Bilbao
Spain
Guggenheim Museum,
Las Vegas
3355 Las Vegas Blvd South
Las Vegas, NV 89109
USA
www.guggenheim.org
Frank O. Gehry Associates
www.foga.com

DIA: Beacon, Riggio Galleries
Dia Art Founation
3 Beekman Street
Beacon, NY 12508
USA
www.diacenter.org
Robert Irwin and Open
Office

American Folk Art Museum
45 West 53rd Street
New York, NY 10019
USA
www.folkartmuseum.org
Ralph Appelbaum
Associates
www.raany.com

Wellcome Wing
Science Museum, London
Address and website as
before
Exhibition design: Casson
Mann
www.cassonmann.co.uk
Graphic design: Graphic
Thought Facility
Lighting design: DHA

Crimes Against Humanity
Imperial War Museum
Lambeth Road
London SE1 6HZ
UK
www.iwm.org.uk
Exhibition design: Casson
Mann
www.cassonmann.co.uk
Graphic design: Graphic
Thought Facility
Lighting design: DHA
Film: October Films

The Rise of the Picture Press: Photographic Reportage and the Illustrated Press 1918–1939
International Center of
Photography
1133 Avenue of the
Americas (at 43rd Street)
New York, NY 10036
USA
Julie Ault and Martin Beck

Grande Galerie de l'Evolution
Jardin des Plantes
57 Rue Cuvier
75005 Paris
France
www.mnhn.fr
Chemetov and Huidobro

Addressing the Century: 100 Years of Art and Fashion
Hayward Gallery
Address/website as before
Zaha Hadid Architects
www.zaha-hadid.com

Light Show
Tate Modern, London
Address and website as
before
Imagination Ltd
www.imagination.com

Brazil: Body and Soul
Solomon R. Guggenheim
Museum, New York
Address/website as before
Jean Nouvel with Martine
Arrivet and Jean Charles
Zebo
www.jeannouvel.fr

Steuben Flagship Store
667 Madison Avenue
(at 61st Street)
New York, NY 10021
www.steuben.com
Ralph Appelbaum
Associates
www.raany.com

Giorgio Armani
Solomon R. Guggenheim
Museum, New York
Address/website as before
Guggenheim Museum,
Bilbao
Address/website as before
Robert Wilson

SITECO
Light and Building Fair
Frankfurt, Germany
Atelier Brückner
www.atelier-brueckner.de
Client: Siteco
Beleuchtungstechnik
GmbH, Traunreut

Halls of Vertebrate Evolution
American Museum of
Natural History, New York
Address/website as before
Ralph Appelbaum
Associates
www.raany.com

Outdoor Systems, Indoor Distribution
Neue Gesellschaft für
bildende Kunst
Oranienstrasse 25
10999 Berlin-Mitte
Germany
Julie Ault and Martin Beck

Experience Music Project
325 5th Ave. N.
Seattle, WA 98109
USA
www.emplive.org
Design architect: Gehry
Partners LLP
www.foga.com
Associate architect/Exhib
architect: LMN Architects
Lighting consultants:
Lightswitch and Candela

Samsung Brand Showcase, Moscow
Imagination (USA), Inc.
www.imagination.com

Picture credits

Museum for Communication
Leipziger Str. 16
D-10117 Berlin
Germany
Exhibition design and art concept: hg merz architekten – Prof. HG Merz, Uwe Münzing Assisted by Hannes Bierkaemper, Cornelia Wehle, Elmar Holtkamp, Gero Beer
www.ghmerz.com
Overall/master Concept: Museum for Communication Berlin – Dr. Joachim Kallinich, Sigrid Philipps M.A., Lioba Naegele M.A. Graphic concept: Dietmar Burger Assisted by Alexander Mueller Media concept: TC Studios, Hans Werner Milpetz Neon writing: Diction and Conception, Bruno Nagel Sound collage: Prof. Ulrich Suesse Robots concept: Ralph Kuenzler Technical Realization: IPT/Frauenhofer Instute for Production Technology Robots dialogue: Gisela

Zimmermann Stagecoach Installation: Stefan Sous Responsible firms/craftsmen: Ausstellungsmanufaktur Hertzer GmbH, BEL-TEC Ausstattungen GmbH, Boehm GmbH, Bucher-Eicher-Digital, Harich GmbH, Neon Botnar GmbH, Fa. EOS, Helmut Loos

Power Up, Reassembled
UCLA Hammer Museum
10899 Wilshire Blvd
Los Angeles, CA 90024
USA
Julie Ault

Sparking Reaction
Sellafield Visitor Centre
Seascale
Cumbria CA20 1PG
UK
www.bnfl.com
Exhibition design: Casson Mann
www.cassonmann.co.uk
Client: Science Museum Graphic design: Nick Bell Lighting design: DHA